The Arts and the Definition of the Human

The Arts and the Definition of the Human

Toward a Philosophical Anthropology

Joseph Margolis

Stanford University Press

Stanford, California

Stanford University Press
Stanford, California

Printed in the United States of America on acid-free, archival-quality paper

Library of Congress Cataloging-in-Publication Data
Margolis, Joseph, 1924–
 The arts and the definition of the human : toward a philosophical anthropology
/ Joseph Margolis.
 p. cm.
 Includes bibliographical references and index.
 ISBN 978-0-8047-5953-3 (cloth : alk. paper) — ISBN 978-0-8047-5954-0 (pbk.
: alk. paper)
 1. Painting—Philosophy. 2. Art—Philosophy. 3. Visual perception. 4. Aes-
thetics. 5. Philosophical anthropology. I. Title.
 ND1140.M338 2009
 750—dc22
 2008018850

Typeset by Bruce Lundquist in 11/13.5 Adobe Garamond

for Coco,
amazed together

Contents

Preface

A YOUNG FRIEND OF MINE who lives and works in Madrid and who knows my published views very thoroughly recently sent me the draft of a longish paper of his in which, rather generously, he reviews some themes of mine, featuring in particular my having said that although *Homo sapiens* is a "natural-kind" kind, human beings—human selves—really have no nature, are no more than artifacts, histories, hybrids of biology and culture, the sites of certain transformed powers peculiar to human possibility. That single idea is as close to the pivot of my best intuition as anything I can think of. It was indeed the unmarked focus of a book my young friend had reviewed, as well as the somewhat more explicit but still decentered focus of the book before you now, a notion translated into the puzzles of the art world, very far removed in an academic sense—but not really—from the moral/political topics of the earlier book.

I can't say that I've chosen this conception of the self for my own; it's nearer the truth to confess that it's captured me, as I imagine will be clear enough when you read on. It's been shaping my thought over the span of an entire career, deployed I realize in every philosophical niche that has caught my interest. So that now it's a broadly unified conception, still somewhat elusive, which, though hardly orthodox, I've tried to demonstrate is a most resourceful replacement for many a canonical philosophy able to command a sizable fiefdom.

I've been at these inquiries too long to be unaware of my direction. I've been retracing my steps back from the distinctive compartmentalizations of philosophical topics that hold sway in our time and that have put

too much of twentieth-century philosophy in danger of irrelevance and thankless inflexibility. I cannot see how, for instance, the conceptual questions of moral and political life can be separated from the questions posed by the fine arts, or for that matter, how the work of the philosophy of science can rightly be very far removed from the discoveries of the philosophy of art (and vice versa). Each of these inquiries reflects our limited understanding of a limited sector of the world reviewed without any reliable sense of where the true beginnings of such an understanding lie: they are inseparably embedded in the passing uncertainties of historical life itself. I rely on the recuperative idea of the "human" to provide a holist bond for all our inquiries, otherwise unable to collect the world as legibly one. We don't know—we have never known—what "all our inquiries" includes, beyond the obvious scatter of "all."

Hegel, whom I very much admire, realized very early on that in his own age he could hold the entire world together as an intelligible unity, if he viewed it (against Kant) as the self-transforming structure of an all-encompassing "mind" or *Geist* absorbed in its own evolving understanding of "itself"—incomplete in all its reflections but manifested *in us*. So he treats *Geist* as if it were present everywhere—and yet indissolubly one. I regard this as a daring metaphor for the matched intelligibility of the world and the informing power of encultured human inquiry that, thus deployed, continues at the same time it replaces something akin to Kant's transcendental constructivism. Hegel offers instead a historicized alternative that avoids the extremes of Kant's realist conception of a closed system. Here, we are caught in Hegel's extravagant metaphor of Absolute *Geist*: a power implicit in our finite and historicized cognitive competence capable of grasping the infinite fulfillment of our finite powers—rightly read, however, as the invention of the latter (*Encyclopedia Logic*, §§49–50, 95).

If this is a fair reading, then I admit to having taken Hegelian instruction. But I don't believe we need any literal *Geist*, and I don't believe we can afford any such an extravagance now, at least beyond the scruple that admits that our competing conceptual pictures of the world are no more than salient fragments that collect under the canopy of encultured thought, by which we understand the world inseparably from understanding ourselves and understand our understanding ourselves inseparably from understanding the world. That, a sort of demythologized *Geist*, is what I mean to signal in the most oblique of ways. The theory of the arts, like the theory of the sciences, is and cannot help being opportunistic in this regard.

I am more impressed with the narrative discontinuities and discontinuous diversities of *geistlich* unity than Hegel seems to have been. Human agents, I would say, require a functional unity for their individual careers, though, even there, the regulative and seeming constitutive requirements of personal unity tend to outstrip the experienced discrepancies of actual agency and memory. In any event, whatever is required here hardly seems to oblige us to read the unrolling of collective cultural life or history as completely coherent or as narratively one. The matter was profoundly disputed between Sartre and Foucault, for instance, under Hegel's shadow: if we yield here, as it seems we must, then surely our retrospective accounts of the unity of individual agents will be subject to the vagaries of the reflexive interpretation and reinterpretation of encultured life itself.

In that sense, Hegel's conception of dialectical logic must win out over whatever longings he may have had that matched the ambitious closure Kant claimed to find in the body of scientific knowledge—the prize of Kant's transcendentalism. History confirms that history is itself perspectived, remembered in small bursts compatible with sleep and uncertain memory and the overlay of new experience and changes in our habits of understanding. It's in this sense that the cultural world is determinable but not determinate, plural and diverse, never completely coherent or closed, hospitable to conflicting ways of understanding what we acknowledge to be the same events and artifacts of a shared world.

The theory of the fine arts defines the most convincing space in which the implications of this strange sort of tolerance—so alien to the theory of physical nature—take center stage. Yet if we follow the implicated argument, the supposed unity of the natural sciences is at risk as well, always the belated construction of the same encultured world in which the discrepancies just admitted hold sway. I should like to think that that is what Hegel intended to make clear: that is, in accord with whatever is required for the intelligibility of our lives, how we spontaneously impose a narratized meaning on our running experience of the evolving world. We cannot reach closure in finite time, and we cannot expect that whatever telic convergence we find at any time will hold fast as history itself unfolds. That seems to be the natural import of what Hegel's theory requires. But if it is not, then I dare say my reading of Hegel is better than what Hegel himself intends—or what a large part of the academy claims to find in Hegel. In that case, I declare that the contrary is preposterous! I understand, of course, that admitting this much places me under a serious debt.

Somewhere, I shall have to try to explain the unity and difference between the natural and the human sciences—but not now.

What follows, then, is an exercise in what may be called *philosophical anthropology*: the effort to hold on to a sense of *geistlich* unity in what otherwise risks the unacceptable scatter of an autonomous "philosophy of art" or "aesthetics," or a "philosophy of mind" or a "philosophy of science," as these disciplines are now construed. I invoke the advantage of a holist stance without actually providing a full philosophical defense or a complete articulation of the corrective discipline I have in mind. You will be the judge of its incipient virtue.

These are telltale admissions, I don't deny. But they are freely acknowledged, and in any case, they are perfectly obvious. I've been searching for a way to restore, within the terms of English-language and Eurocentric practice, the natural unity of philosophy and its characteristic disciplines, which until recent times always qualified the best philosophical work, regardless of doctrinal persuasion. I've recovered the obvious, I suppose: the need for a fresh analysis of the human condition, which, as I see matters, affords a sense of the common conceptual space of every inquiry and commitment.

I begin eccentrically then with a reinterpretation of the Socratic elenchus for our time, the start of an attempt to bring our modern sense of the historicity of the human to bear on our continual rereading of the ancient philosophical tradition that lacked a sustained notion of what strikes us now (quite literally) as our encultured "second nature." We cannot recover the holism needed unless and until we resolve the conceptual strain between the appeal of the idea of historical existence and the ancient grip of what is said to be changelessly real. (That, as I see matters, *is* the true point of a modern reading of the Socratic elenchus.) Still, beginning there, I have in mind defining the whole of the cultural world (if possible) and, within it, the strategic puzzles literature, painting, and music pose regarding our nature and identity—ourselves, as the acknowledged creators and principal creatures (or creations) of our artifactual and hybrid world.

You may say that the argument that follows is a piece of metaphysics—a piece of the metaphysics of art if you please—cast in the Hegelian spirit. But the term "metaphysics" has been diminished, in America and Europe, so that it is often read as flagging presumptions of a privileged knowledge—which is to say, made indefensible. Metaphysics is neither privilege nor nonsense nor the dismissal of privilege or nonsense; but I'm

prepared to run with the current fashion, if fashion is not allowed to judge its own credentials for the rest of us. I therefore coopt, in choosing my subtitle, the fashion of an earlier age—which comes to the same thing as "metaphysics" but is less quarrelsome for the moment—the designation "philosophical anthropology," by which I mean quite literally a theory of *human being* drawn from the "hybrid" sources of biology and historical culture, *not* the reduction of philosophy to anthropology.

Here I mean to draw out, by close attention to certain central problems in the philosophy of art—notably, puzzles bearing on the complexities of perceiving artworks— the need to admit certain strategically placed features of human being that are normally ignored: for instance, why the analysis of physical nature cannot be expected to admit (from its usual vantage) what it nevertheless must finally admit. If my holist intuitions are correct, then the fact that every science is a human science, that the powers of human inquiry are artifacts of cultural life, itself shows the way to a recovery of the unity of the sciences within the novel (the generally neglected) terms of cultural life. By such a discovery, the philosophy of art becomes the natural ally of, and even something of a mentor for, the theory of science and mind and similar disciplines. I see the effort as a preparatory labor for a novel theory of the unity of the sciences; but I have no wish to make this the principal issue of my philosophical anthropology. I see it gathering strength by indirection, and I count on another occasion to bring it into full view. So it is enough to say that ever since Hegel's critique of Kant, the principal conceptual puzzle of the modern world that we identify as metaphysics and philosophical anthropology concerns the unity of physical nature and human culture, or the unity of the search for universality and the admitted discontinuities of contingent historicity. But Hegel already perceived that, too.

This helps to explain why, in exploring the salient questions of the philosophy of art, I find myself obliged at every turn to take account of the holist corrections that now seem seriously, even dangerously, neglected. Proceeding this way, I admit I've produced a heterodox sort of recovery: that is, by construing artworks as a diverse kind of human "utterance." Nevertheless, the conceptual space occupied by the philosophy of art is hardly more than a small neighborhood within the continent of human culture: it cannot be analyzed separately from the rest of that huge world, although you will look in vain—well, almost in vain—for an account of what it is to be a human person, or self, in any recent standard

English-language philosophy of art or philosophy of mind, or philosophy of science for that matter. If you concede the point, you will already have caught my purpose in speaking of "philosophical anthropology" or, alternatively, of the "metaphysics of culture."

If you concede the point, then consider the present effort an attempt to sketch how things appear in one strategically placed philosophical specialty—a schema ready, should it prove promising, to be applied as well in other subdisciplines. It means to exhibit the analytic power and advantage of invoking a *geistlich* unity in answering selected questions in the philosophy of art without yielding to the fatal extravagances of any literal reading of the merely heuristic notion of an encompassing *Geist*.

Put more slimly, I try to show how essential it is to the theory of art to fashion a conception of reality that indissolubly unites the analysis of physical nature and the analysis of human culture. The idea is ignored in recent Anglo-American philosophies of art: it is its recovery that I take to be the principal theme of "philosophical anthropology." It's the recovery of a salient "interest," as the postmodernists say, but it's a recovery justified by its demonstrable advantage—which is what metaphysics and philosophical anthropology come to. It's more a matter of restoration than of revolution, though, in our extremity, it's hard to tell the difference. For my own part, it defines the best conceptual space in which the radical constructivism linking the subjective and objective aspects of cognition and intelligence that Kant and Hegel bequeath our modern age stands any chance of reintegrating the disparate parts of the Eurocentric world.

J. M.
June 2008

The Arts and the Definition of the Human

Prologue
The Definition of the Human

IF YOU TAKE THE LONG VIEW of the career of Western philosophy, you may be forgiven for yielding to the fiction that its continuous history confirms a legible thread of discovery spanning the speculations of the Ionians and Eleatics and our more baffled inquiries at the start of the twenty-first century. It hardly matters whether you believe the tale or trust it as an economy that cannot finally be toppled. In either case, I shall need your patience. I have the pieces of an imaginary history that yields a more than plausible sense of the entire human world by way of a sequence of conceptions that were never construed in quite the way I recommend. I *trust* that history, though I don't believe it to be strictly true.

Canonical history has it that Plato and Aristotle sought to reconcile changing and changeless being in the spirit of the Ionians and against the excessive strictures of Parmenides' dictum, which appears to make no allowance for the changing world though it addresses it insistently. If that dictum had never been contested, the whole of science and our grasp of the human condition might have remained hopelessly paradoxical—in the Eleatic way. I accept the usual reading, therefore, as the sparest narrative (fiction or not) that might be true. Except for two caveats: the first, that the actual lesson of the best work of classical philosophy could never have been formulated within the horizon of the Greek world anyway; the second, that what Plato and Aristotle accomplished in their heroic way remains distinctly uneasy, unfinished, uncompelling in their own time, just at the point they manage to harmonize the opposed notions of the changing and the changeless— that is, the point at which they simply compromise with Parmenides.

The intuitive evidence is this: If there are two distinct worlds—the one changing, the other changeless—it is hard to see why the changeless world would ever be needed to ensure the presence of the other; and if its own intelligibility presupposed that change "is" necessarily what it is only relative to what is changeless, then how could that be demonstrated if we ourselves are confined within the changing world? If our world is a fluxive world and we have no inkling of the changeless world—beyond Parmenides' dictum, or conjectures like those spawned in the *Republic* (provided by disputants who admit they do not know the changeless world), or like Aristotle's faulty paradoxes ranged against those who affirm the fluxive world—then the classical contribution must be more limited than history affirms. Otherwise, read more generously, the matter may have required conceptual resources the Greek world never dreamed of— possibilities discovered only in a later age.

If the changing world were not (not known to be) in need of a changeless stratum, we would hardly need to admit that human nature must itself be changeless or depend in some ineluctable way on a changeless world. That would already be a gain sizable enough to challenge two thousand years of quibble effectively. The world of the arts and culture in general, bear in mind, makes no sense except as a historied world; and such a world hardly appears in a legible form much before the end of the eighteenth century. Imagine that!

Plato and Aristotle seem to recognize Protagoras as the arch-foe of Parmenides—Plato in the *Theaetetus*, Aristotle in *Metaphysics* Gamma— where the arguments against Protagoras's relativism are singularly thin and uncompelling; though they are, it should be said, very nearly the whole of contemporary objections to modern forms of relativism.[1] At this point in my story, it's not the championing of relativism that counts but defending the coherence of the flux—*not* chaos, not the sheer absence of all order, but the discursibility of the changing world itself. Here Protagoras is surely more interesting than Heraclitus; read anachronistically, "Man is the measure" is very much ahead of its time, an idea at least as advanced as any the post-Kantians hit on—except for the small fact that like Plato and Aristotle, Protagoras lacked our modern conception of historicity, the historied nature of thought itself. But I admit straight out that to remedy the lack harbors no subversive intent at all: nothing that would undermine, for instance, the splendid achievement of the natural sciences or the coherence of the unnumbered single world in which we live our hybrid lives. The

recovery is meant only to provide a picture of a wider spread of conceptual resources than are usually acknowledged—an account, so to say, in which the theory of the arts and the sciences will be seen to be closer cousins than the usual idioms would be willing to admit.

I want to suggest that the narrative outcome of the classical phase of Western philosophy lies more with abandoning Parmenides' constraint altogether—placing it under a charge of irrelevance and arbitrariness—than with reaching a verbal compromise (any compromise) in the way Plato and Aristotle seem to have found impossible to avoid.

The truth remains that their best compromise could never reach what was needed to catch and hold the minimal distinction of the human world. You'll say that's hubris, but it's not; though to admit it signifies that we live in a conceptual desert deprived for more than two thousand years of a proper understanding of the sui generis history of human being. Of course, *we* see ("ontologically") the human world *in* Plato and Aristotle and Protagoras—and even Parmenides. But strange as it may seem, the Greeks never understood what it was they saw, if since the end of the eighteenth century and the start of the nineteenth, what emergently was always metaphysically present in the human way was first made conceptually palpable in the work shared by Kant and the idealists, especially in the work of Hegel. I think it is no accident that the discoveries I have in mind are coeval with the fledgling labor of the philosophy of art, which in Kant shows every prospect of losing its way, even as Kant turns from nature to art,[2] until the philosophy of art moves on from Kant to Hegel. The change requires two distinct moments: one, to displace invariance with the flux of history—which means displacing Kant himself; the other, to fill the space of change with the specific resources of cultural constitution, that is, language, *Bildung*, self-consciousness, freedom, effective and creative action—which means embracing Hegel's dialectical intuition (if not his actual doctrine). There's the point of the story.

In short, the upshot of the contest between Plato and Aristotle and Parmenides is not so much the classic compromise they wrest from Parmenides (which has dominated Western philosophy down to our own day) as it is to experiment with the complete abandonment of the invariances of thought and being by exploring the new vision that begins to find its voice (and conceptual adequacy) in the late eighteenth and early nineteenth centuries—in, say, its first full incarnation in Hegel's encultured and historicized empiricism, that is, in Hegel's phenomenology.[3]

The Greeks were simply disadvantaged, struggling in Parmenides' shadow, because they lacked the conceptual resources that might have helped them escape—as those resources helped Hegel in his own attempt to escape the corresponding fixities of Kant's transcendentalism. They lacked what we now realize is a novel conception of the regularities of ordinary cultural life—with which perfectly ordinary people are now acquainted, without exceptional training—just the reverse of what would be true of the Platonic Forms, or "what is" in Parmenides' sense, or the essences of natural things directly grasped by *nous*, or the powers of transcendental understanding or of pure phenomenology in Husserl's sense,[4] or anything else of such a crazy kind. Hence, I suggest the Greeks were literally unable to construct an adequate account of what it is to be a human being—beyond, say, the rather comic biology Plato offers in the *Statesman* or, more earnestly though by the same sort of fumbling, in the quasi-divine biology of Plato's *psyche* and Aristotle's *nous*.

We learn that if *we* mean to define what a human being is, we must somehow settle first the ancient question of the conceptual or, more grandly stated, the ontological linkage between the changing and the changeless. For, of course, Parmenides' conception of thinking is inseparable from his conception of being (or reality), as is true in a more ingenious way in Kant and the post-Kantians. I need to assure you here that in speaking of the "ontological," I have no intention of invoking any privileged sources of knowledge or assurances about any secret changeless order of reality indiscernible by ordinary means, without a knowledge of which we could never confirm the validity of our beliefs. Once we give up all such baggage, "metaphysics" or "ontology" is little more than a benign abstraction from the world we claim to know. Nothing quarrelsome hangs on the term.

If this line of thinking leads us well enough out of the ancient labyrinth, then we may claim to have grasped the defect of classical philosophy: the fact that, for the Greeks, faute de mieux, human nature must embody a changeless (or necessary) structure of its own that could account, in principle, for the intelligent grasp and application in thought and act and productive labor of the changing world. The Greek solution is no more than a deus ex machina that falls back to its compromise with Parmenides. It misperceives the sui generis nature of the human, which is fluxive and artifactual or hybrid. That, at any rate, is my charge.

If this is a fair assessment, it is a stunning truth that affirms that an adequate conception of the human—in a sense we now think impossible

to ignore—cannot have been philosophically available before (or much before) the end of the eighteenth and the beginning of the nineteenth centuries. Alternatively put: the concepts of historicity and enculturation—on which, as I suggest, the very prospect of grasping the unique features of "human being" and the whole of the human world (including the arts) depends—may be, indeed *are*, the gift of a very small interval of discovery confined within the span of Western thought, fashioned a mere two hundred years ago. By now these notions belong to the entire world, of course. But I draw your attention to their first appearance in order to remind you that the definition of the human is itself a historicized undertaking subject to the evolving conceptual resources and saliencies of human thought itself; also, in order to feature the radical difference between the immense flexibility of Hegel's dialectical picture of human history and the stubborn rigidities of Eleatic influence on both classical philosophy and our own.

Plato is surely the best of the ancient critics of the ideal Forms and what we take to be the Parmenidean claim. The discussion (in the Dialogues) of the soul has very little point, for instance, if separated from the theory of the Forms. Aristotle's conception of *nous* seems to have no biological basis at all, is little more than a transparent device designed to shore up the Eleatic theme; in both his biological and ethical tracts, there is a noticeable slippage from the essentialized invariances of science and morality.[5] All this begins to explain the deeper joke of the *Republic* as well as Plato's patience with the inconclusiveness of the early Dialogues and the question-begging fixities never completely dispelled in the best work of Aristotle's attractive empirical rigor.

I am moving here, I assure you, in the direction of defining the human. I have chosen an oblique route partly to dramatize the fact that the Greeks did not understand the human in the same way we do; though, reading them, we instantly translate into our own idiom what they actually say, so we often fail to see the enormous difference between our respective views. If you doubt this, just consider, closer to our own world, that Kant very nearly abandons the human altogether in the strenuous analysis of his "transcendental subject." There actually is no sustained analysis in Kant of what is merely or essentially human, although, of course, Kant's rational agents are forever occupied with human concerns! Literally, Kant's transcendentalism makes it impossible to define the specifically human, though there's evidence enough that he anticipated returning to some sort of reconciliation between the mundane and the transcendental aspects of the human mode

of being.[6] Certainly, in his *Aesthetics*, Hegel pointedly takes note of the alien quality of what Kant offers as his abstract picture of a "human agent," which, Hegel suggests, cannot fail to disable the entire undertaking of explaining the creation, criticism, use, and appreciation of the entire world of art.[7] He's right, of course. We lose our grasp of the arts if we lose our grasp of history and the artifactual formation of the human.

My own impulse is to infer by association that Aristotle's treatment of the polis as the proper setting for grasping the philosophical import of more than Greek ethics and politics is instantly imperiled by Alexander's attempt to extend the normative role of the classical ethos to an empire meant to bring the Greek and Persian together in a new way, with no attention to those historicizing consequences that Alexander (under Aristotle's sway) could never have understood. Considering the Aristotelian temptations of our own time, the same disquieting lesson, I'm afraid, must surely haunt, say, Martha Nussbaum's "Aristotelian" account of Henry James's novels as well as her UN-oriented attempt to universalize Aristotle's conception of the virtues.[8] You cannot, however, determine the normative in practical life by empirically statistical methods of any kind. You begin to see the need for an important correction here. A place must be found for historical forces. There are no such forces in Aristotle's *Ethics* or, conformably, in Nussbaum's.

Moral judgment, like the exercise of taste and the practice of art criticism, is not a discipline that can be convincingly pursued on the basis of abstract descriptions: it requires the engaged perception and experience of the very specimen phenomena that are to be judged. Kant and the "Kantians," therefore—and at least the "Aristotelians," if not Aristotle himself—are plainly wrong. There you have the essential clue to the difference between the natural and human sciences—a fortiori, the paradigmatic lesson of the logic of the fine arts. (Allow this anticipation, please, to count as a piece of earnest money against the small liberties I've been taking.)

I see no way that Kant's hoped-for reconciliation between the empirical and the transcendental could possibly succeed, unless Kant would have been willing to abandon the quasi-divine powers of his own transcendental subject. He was, finally, unable to historicize his account of the human condition along the lines, for instance, that Johann Herder recommended and Hegel found congenial. It is, in fact, in Hegel's innovations that a truly modern conception of the enculturing formation of the human "subject" (self, agent, person) begins to dawn in a way that still fits contemporary

intuitions. Yet a very large swath of twentieth-century philosophy actually opposes the adoption of the defining themes of historicity and enculturation, which, beginning approximately with Hegel, are inseparably tied to every philosophically viable account of the human.

You realize that the speculative theme I am pursuing has been battered, throughout the history of philosophy, from the vantage of at least two profoundly opposed strategies of analysis. One favors appropriating the divine, or what seems close to the divine, in our earthly world: what belongs to Parmenides, Plato, and Aristotle; the medieval world; Kant and the post-Kantians; and more recently, thinkers as diverse as Husserl, Heidegger, Levinas, and some of the British idealists. The other prefers description and explanation in terms restricted to the inanimate physical world: what belongs to the reductive and eliminative convictions of the unity of science program, positivism, the radical forms of neo-Darwinism, computationalism, and other manifestations of what may not unfairly be called scientism.[9]

The first is persuaded that the human *cannot* be defined in terms restricted to the natural world; the other, that an adequate definition *can* be rendered in terms sufficient for the entire inanimate and subhuman world. So, one way or another, language, culture, history, agency, creativity, and responsibility are rightly seen to be, in principle, no more than complexifications of basic states and processes that need no conceptual supplementation drawn from the cultural world itself.

Both strategies fail, in the plain sense that the human is entirely natural, as natural (or naturalistic) as anything we might otherwise specify; yet, in being natural, the human is also sui generis, uniquely competent in ways that cannot be conceptually captured by categories that initially refer to anything less (or more) than what the distinctive processes of history and culture immediately display. That is what the Greeks and Kant lacked or largely lacked, although, of course, they were able to refer to (but not to analyze) what *was uniquely human in a naturalistic but sui generis way.* If you think of natural language as the exemplar of the cultural, you see the problem at once—although the proto-cultural among subhuman animals may be reconciled with the proto-linguistic forms of animal communication.

· · ·

Let me change direction here. I don't really believe Plato ever championed the doctrine of the Forms. He was not, in my opinion, a closet

Eleatic or Parmenidean—or a Platonist—of any kind. On the contrary, his best work, which I associate with the Socratic elenchus, shows very clearly that he was fully aware—was perhaps worried, puzzled, enchanted all at once by the fact—that the "Socratic" inquiries, paradigmatically addressed to the definition of the virtues, proceeded in a fluent way without relying on strict invariances or necessities of any substantive kind. But they did so, apparently, without ever achieving their appointed purpose. I take Plato's continually testing and retesting the powers of the elenchus to be a sign of his interest in the possibility of abandoning the Parmenidean constraint altogether; but it's the classical world itself, of course, that makes any breakthrough impossible.

The Forms are never featured in the early Dialogues; and when they begin to appear—at first, as one says, under the mode of absence, in fact even more strikingly in the *Statesman* than in the *Republic*—they are perfunctorily dismissed in a burlesque of the elenctic process itself. In the *Statesman* (a dialogue never easily placed), Plato pointedly returns to the elenchus, once it is explicitly conceded that we don't know the Forms at all—though we admit we must decide (there's the point) on a rational way to rule the featherless bipeds we know ourselves to be! Hence, Plato reverses or replaces the inquiry begun in the *Republic*: he assigns the instructor's role to an Eleatic Stranger, under the terms of an expressly diminished elenchus, though Socrates remains in attendance. This way of reading the *Statesman*, of course, goes completely contrary to Gregory Vlastos's influential ordering of the Dialogues.[10] But it makes perfect sense.

Plato, I suggest, returns repeatedly to test the mettle of Socrates' subversive practice, which is itself a daring transformation of the original Parmenidean elenchus. It seems he cannot discharge the Greek longing for invariance, but he obviously sees that invariance is neither required nor accessible in a fruitful discussion of the moral/political virtues. Still, Socrates never really succeeds in defining any virtues. If only Plato had had Hegel's conceptual resources, say, regarding the *sittlich* nature of the virtues themselves—in effect, a full conception of what a culture actually is—he might have penetrated to the heart of his own fascination with those ordinary modes of discourse that begin to yield a grasp of valid norms and encultured competences without invoking any changeless order whatsoever. *That* I take to be the convergent meaning of Plato's perseveration and Hegel's conceptual breakthrough. Both depend—the first, uncomprehendingly, the second, with stunning clarity—on a conceptual strategy that draws on

the pre-philosophical fluencies of ordinary practical life. Hegel seizes the advantage; but Plato seems forever baffled. Both abandon Parmenidean fixity—whatever Parmenides' true intentions may have been.

Plato's scruple leads him to an impasse, which he reenacts again and again without apparent comprehension. But he surely senses that the "secret" of the human world, which eluded Western philosophy for more than two thousand years, must lie somehow in the elenctic process itself. Plato *has* an inkling of its exemplary importance, but he has no idea of what he's found. So he clings somewhat disfunctionally to the remnants of Parmenidean fixity. Hegel, of course, invents a dialectical model of a conversational critique bridging opposed (so-called contradictory) tendencies within, or between, the salient options of historical life. He appears to resolve the Platonic impasse by an evolving series of transformative reconciliations that preserve as well as possible the normative claims of the contending customs and traditions that confront us. Hegel accepts the initial validity of the norms of *sittlich* life within the flux of history; he therefore has no need for invariances of any substantive sort or for any changeless ground of normative validity. He finds the elenctic mechanism already in play in the human reconstruction of human history. There's the grand solution that eluded Plato, the breakthrough of the most daringly modern of modern conceptions. It also explains, of course, why Hegel has no need for the contortions of Kant's *Critique of Judgment* in ensuring the linkage between the play of imagination in artworks and the intimate bearing of art on the formation and direction of moral sensibility: Kant was obliged (in the opening passages of the third *Critique*) to disjoin altogether the judgment of aesthetic taste (or beauty) from any contamination of conceptual subsumption (that would have directly associated the aesthetic with the scientific and the moral), and then reversed himself regarding the relation between art and moral sensibility in the second part of the third *Critique*. Hegel saw at once that the aesthetic and the moral were inseparable within the *geistlich* holism of the cultural world.

At times Hegel seems almost besotted with his own device. He invents his "discovery" of the rational self-understanding of the whole of endless history: at its best, it's a heuristic instrument of the supplest possibilities; at its worst, it's the march of God in the world. But *we* need not pretend to grasp Napoleon's or Alexander's "world-historical role," as Hegel claims to do, in order to appreciate the novel advantage of his conception of history. Both the Socratic elenchus and Hegel's dialectic must

be fitted, *in* evolving time, in essentially the same way, to emerging history. Plato senses the goal but never masters the process. Hegel masters both but loses something of the reflexive sense of the human limitation of just such an understanding. The briefest overview of the continual near chaos of the actual evolution of the modern state—for instance, according to something not unlike Michael Oakeshott's well-known summary[11]—would soon persuade you of the completely contrived nature of Hegel's picture of the entire course of history, whether in politics or the arts. Hegel confronts us with the profoundest contingencies as if they were all ineluctable necessities of Reason. Doubtless, he knew the difference.

He knew he was transforming Kant's entire vision in a radical way—by historicizing it, by reading Kant's system as less than necessary. He knew he was completing Plato's elenctic dream. But he had no patience with the piecemeal scatter of a merely human understanding of history. No more did Jean-Paul Sartre, of course, more modestly—as Foucault complains.[12] Hegel relies, as does Plato, on the entrenched stabilities of societal life. But viewing them in terms of the distinctive explanatory structures of cultural history, he takes them at once to provide a ground for normative validation as well; whereas Plato, viewing social practice as mere convention and contingency, never finds a sufficiently strong reason to replace the Forms by human practices as such. Plato never realizes that what is provisionally normative in our practices is not merely discernible but actually part of the formative forces that determine the very mode of human being.

In any event, I view the elenchus and the dialectic as two closely related strategies of inquiry that are (1) presuppositionless; (2) *sittlich* (in a generous "anthropological" sense); (3) free of Parmenidean infection of any kind; (4) lacking any formal or criterial method; (5) cast as forms of discursive reason; (6) inherently incapable of claiming or validating any uniquely correct analysis of whatever sector of the world they choose to examine; (7) committed only to what, as a practical matter, is adequate to our salient interests from time to time—or committed in such a way that theoretical inquiry is seen to be dependent on, or derivative from, or internal to, our practices of discursive inquiry; (8) applied to what is intrinsically interpretable without end; (9) unable to discover in any simple or direct way the objective (or telic) structures of the independent world; (10) hence, applied to what is culturally constituted or constructed relative to our evolving experience of the world; (11) applied to what is local, contexted, not strictly universalizable, validated in *sittlich* ways; (12) historicized and known to

be such; and (13) insuperably phenomenological, that is, grounded in and restricted to our encultured experience of the world (in something closer to Hegel's than to Husserl's sense).

All this counts as a summary of the sense in which I view Plato's use of the elenchus (more in promise than in fact) and Hegel's dialectic (viewed as more tentative, more plural, more provisional, more contested at every turn, more discontinuous, too, than Hegel may have supposed at times) as bearing in a decisive way on the definition of what it is to be a human being or what counts as the human world.

If the tally holds firm, then two important lessons may be drawn from it without delay: one, that both the Greek and Kantian accounts have almost no grasp at all of the metaphysics of the human or cultural world as such; the other, that the cultural world, however embedded in physical nature and for that reason not adequately described or explained in physical terms alone, has no fixed structures of its own of any kind, is subject to the flux of history at every point of interest, and yet confronts us (contrary to Plato's worry) with all of its evolving, perfectly legible stabilities—the regularities of *sittlich* practice. Both Plato and Kant retreat to the safety of proposed invariances: Plato, possibly less tendentiously than Kant, since Kant requires fixity in order to secure his conception of the closed system of the first *Critique*, whereas, paradoxically, Plato sees no way at all to save the elenchus he assigns to Socrates. There's the abiding failure of the first two thousand years of Western philosophy! Bear that in mind, please. For the saving lesson *is* the conception of historied culture—which surely generates the principal part of any valid moral theory or valid theory of the arts; very probably also, any valid theory of science. Viewed from our own vantage, the force of the entire clue makes itself felt in the *recency* of Kant's failure to have hit on an adequate inkling of the historicized and artifactual nature of human being. The extraordinary distortion of philosophy's canonical history begins to dawn.

. . .

Before I press any part of my own answer to the "secret" of the human (a perfectly open secret by this time), let me add to our elenctic company a third voice closer to our own than either Plato's or Hegel's, that catches up the intuitive directness of the first (without Eleatic temptations) and yields to the historicizing effect of the second (without properly acknowledging the explicit role of history). This third voice illuminates, obliquely again, certain

inherent limitations in the "method" of cultural analysis, which counts as little more than an improvisational "meander" shared by the apt members of a particular culture in a way that entrenches (consensually but not by criterial means) their collective understanding of the world they share.

In this way, they (that is, we) become aware of the *determinable—* never fixedly *determinate—geistlich* ground on which all their inquiries and commitments ultimately depend: especially what, by various strategies (elenctic, dialectical, now meandering), prove to be legible and supportable in the way of diversity, extension to new cases, correction, transformation, opposition, sheer scatter, *and* normative standing. Sophocles's *Antigone* offers an elenctic example at least as telling as the Socratic practice, perhaps even closer to an understanding of cultural history than the Dialogues could claim, since in the play one and the same society acknowledges the valid but contingently competing priorities of throne and family.[13] *Antigone* may be the clearest specimen text we have, against the backdrop of which Socrates and Hegel may be seen to subscribe to the same conceptual resources. For without an incipient sense of history (better, historicity), the central conflict would have had to be assigned to the cosmic order itself—a palpable scandal. At any rate, that is a judgment we find ourselves drawn to, viewed from a contemporary vantage.

Plato fails because he neither vindicates nor overthrows the Parmenidean dictum. Strictly speaking, the Socratic elenchus is not a method or a rule or an algorithm of any kind. It is only an informal practice that comes out of the fluencies of ordinary conversation. But Plato never seems to fathom (*or* he grasps but cannot defend) the power and sufficiency of elenctic informality against the Parmenidean prejudice that defines rational rigor. That informality will help to define, in turn, precisely what "human being" means.

The same tolerance for transient opposition marks the nerve of Hegel's dialectic, though Hegel, of course, presents his account of history in much too high-blown a way. Hegel was obviously enchanted by the brilliant applications of his "method" to the whole of the *geistlich* world; but historicism could never have assigned his interpretive tales a principled advantage without actually cheating. Any such bias would surely go contrary to Hegel's immense grasp of the contingency of cultural change itself.

Perhaps the theory of Forms began to seem as feasible to Plato as the rationality of *Geist* may have seemed to Hegel—incipiently in the *Meno*, say, where the dialectical play of the elenchus begins to evolve in a new direction.

But Plato surely senses the distinctive power of culturally formed debate, though he cannot see how to free the force of the elenchus from the fixities of Parmenides' strategy. He obviously considers yielding. Yet, as in the *Republic* and the *Statesman*, he never betrays the insuperable contingencies of the cultural world. That is his instinctive scruple. But what of Hegel?

For the moment, I suggest that within the tale I'm telling, Hegel's dialectic is effectively the historicizing analogue of the Socratic elenchus, productively applied to the entire *geistlich* world. Plato has no *geistlich* categories, though he knows the human world as well as anyone. In that same sense, Kant plays a sort of Eleatic role in Hegel's work rather like the role Parmenides plays in Plato's; and both Plato and Hegel share a distinct sense (less than actually incipient in the one, more than fully formed in the other) of how, through its sui generis resources, we may analyze the process of self-understanding in the cultural world. In fact, there actually is a first-rate Kantian who reinterprets Kant's "fixities" along the lines of Hegel's historicizing reform, namely, Ernst Cassirer, who applies the strategy in nearly every sector of scientific and philosophical work,[14] replacing transcendental invariances with provisional (but seemingly fundamental) "symbolic forms" so that we begin to see how an analogous elenctic reading of the Forms might have been available to Plato.

Here then is the gist of the argument thus far, cast in a more familiar light. The ancient quarrel—the quarrel between *physis* and *nomos*—has almost nothing to do with solving the puzzle the elenchus poses. It leads rather to stalemate, as the Dialogues confirm. More than that, the disjunction it offers actually precludes any fresh option that might have construed the relation between those notions differently. The fact is, the issue before us has little to do with specific preferences among the virtues of human-made laws or norms: it concerns rather the right definition of the human as such—at a deeper level of reflection. Once you see that, you see the promise of the modern conjecture that the human is an artifact of cultural history. That is precisely what the *physis/nomos* contest never broaches—in effect, actually disallows.[15]

To this expanding conjecture I now add, as a third exemplar, the voice of the Wittgenstein of the *Investigations* and related texts. Plato, as the author of the Socratic elenchus, confirms the stalemate the Eleatic constraint imposes on the resolution of our puzzle regarding the practical problem of choosing a right form of ethical discipline and political self-rule. It's as if Plato realized we cannot abandon these normative concerns *if* we are

to be the human beings that we are; yet the Parmenidean dictum proves completely powerless—in fact, unsuitable—in helping us find our way. Plato *exhausts* its possibilities! The elenchus seems to have a grip on resolving normative disputes that still remains completely unexplained (as far as Plato is concerned), since it secures (or might secure) its objective without ever invoking the canonical Forms. Plato, we must suppose, grasped the paradox but had no idea of what to make of it. Of course, our understanding of politics and art hangs in the balance; there's the pivot of the matter.

Hegel offers an incomparably richer sense of how to apply the categories of cultural life to cultural life itself—to grasp what Plato misses: that is, the fact that the objectivity and validity of every such application are *reflexive* and culturally constructed, at once empowered and constrained by the historicized conditions that account for the construction of the "human" as well. Plato loses the very possibility of sharing anything akin to Hegel's insight—which, in its own age, goes well beyond the Kantian and Fichtean lessons—wherever Plato invokes the myth of recollection. That alone, I would say, was a frank admission of failure. Recollecting, of course, is also in its own way a myth of self-understanding—except that, as in Chomsky's "Platonism," the self that we finally fathom (if we do) is never the familiar creature of historically formed habit and practice—ourselves! In the Dialogues, the myth of recollection is simply a philosophical wave of the hand—capitulation to Eleatic fixities. In Chomsky, it has proved to be the admission of a failed (perhaps impossible) analysis and the return of the still-opaque encultured world to the distant visions of contemporary scientism.[16] For what Plato, Kant, and contemporary scientisms lack is, precisely, Hegel's phenomenology of culture—that is, what moral theory and the theory of art cannot afford to be deprived of.

None of this entails, for Hegel, the recovery of the changeless or the necessary. Hegel, I would say, is the first philosophical master to map a comprehensive account of our understanding of human culture and ourselves along historicized lines. Hegel's dialectical resolution of evolving, *geistlich* "contradictions" provides a sort of abstract template (an elenchus of sorts) for identifying the freewheeling interpretive possibilities that cultural history requires. Hegel's interpretive practice is a better and more adequate instantiation of any would-be mode of self-examination than the Socratic elenchus; although, by virtue of the tally given a moment ago, I treat Plato and Hegel as fellow investigators of the sui generis distinction of human being.

Only when we have such a tally firmly in mind can we see what Plato was attempting to capture. Plato confirms the inherent limitations of classical thought, which he sometimes seems on the verge of breaching. Certainly, the *Theaetetus* introduces, within the Eleatic milieu, the possibility of analyzing and explaining the nature of our world in terms that eschew every form of invariance. But the analysis founders on too easy a refutation of Protagoras: Plato is forced back to the Eleatic constraint.

Hegel masters in a particularly commanding way the main themes of the advance required; although he also encumbers his study of the essential categories in a way that makes it difficult to free his innovations from the peculiar architecture of his own huge vision. Our world is admittedly "Hegelian," because we can hardly claim to recognize the human condition if we refuse the fine-grained distinctions of historicity and enculturation. But contemporary philosophy would never be willing to be governed by Hegel's extravagances: the prospect of a fresh analysis of the arts and sciences hangs in the balance.

Wittgenstein is particularly instructive here—remarkably spare—because, by an unexpected turn of events, his self-trained intuitions recover important strands of the Hegelian conception of cultural life without addressing history at all and without (it seems) an actual acquaintance with Hegel's texts—*and* indeed, against his own mentor's (Bertrand Russell's) deliberate effort to erase all evidence of "Hegelianism" from British philosophy!

Wittgenstein's notions of *Lebensform* and *Sprachspiel* seem to have developed partly in tandem with his continuing attention to the *Tractatus* (say, from 1929 to the work on the second edition).[17] But a good part of the motivation for these "later" conceptions has more than a little to do with the paradoxes and limitations of the *Tractatus* itself—and with what Wittgenstein took to be the misguided labors of the academic philosophy that actually spawned his earlier effort. The fact is, Wittgenstein's "method" in the *Investigations* was never a method at all: it was a gifted, even brilliant, "meander" (a kind of elenchus, if you please) that worked its spell very quietly—plausibly, transiently, always in surprisingly effective and untried ways, always informally, without the use of any academic armature, and never in search of any fixed structures of thought or world. Russell and Frege may have been poor substitutes for Parmenides, but they proved to be Wittgenstein's philosophical demons.

All seems to be in flux for Wittgenstein within the human *Lebensform*:[18] the conceptual concatenations he identifies in his surefooted way

plainly follow no preappointed path. Indeed, many seem as much invented as discovered. What he offers is peculiarly congenial to practical life itself. We find ourselves heartened by the discursive resources of the unanticipated meander he leads us through. Put another way, Wittgenstein never finds fixed structures in our language games, though he remains confident that we can find our way easily enough to the "bedrock" of our form of life: we are supported by the human pace of the variable rate of change we find among our habituated practices. There is no settled conceptual path that leads from one example to another. Curiously, the same is true of Hegel's grander dialectic, though, of course, Wittgenstein's "meander" is sparer in the way of disturbing our cultural ecology. But it's also true that Wittgenstein has no theory of the flux of the cultural world—and Hegel does.

If you press the point, you see at once the sense in which Kant *couldn't* have been an incipient Hegelian: the insistent claims made by the author of the second preface to the first *Critique* require conceptual closure among the set of his transcendental categories that could never have honored the historied status of every would-be set of such categories. By parity of reason, Hegel could never have been the "right-wing" Hegelian he is made out to be. And Wittgenstein's *Lebensform* must be a Hegelianized version of Kant's transcendentalism if we insist (with Newton Garver, for instance) that it is a Kantian thesis.[19]

Our complicity, our validation in effect of what Wittgenstein offers, is essential here, because, of course, we are as "well informed" as he, being apt speakers of the language. (Construe all this as a sign of a more spontaneous elenchus to replace the uncertain Socratic original, informed by its own reflections on our *sittlich* ways without any reference at all to Hegelian convictions.) We are made agreeably aware that we simply never noticed certain discursive linkages in thought and action, which Wittgenstein brings to our attention, which often help clarify otherwise intractable academic puzzles, and which define unexpected conceptual alignments that promise to extend their application (without apparent artifice) in ways we sense will doubtless keep us from many a philosophical blunder. (But we do all this without the pretense of applying rules.)

We begin to grasp the *plural* possibilities of our habits of thought and action and, as a consequence, a fresh sense of the adequate stabilities of our pre-philosophical discourse—a contingently evolving culture that reciprocally spawns and responds to Wittgenstein's own meander. We realize that we've been relieved of the least Parmenidean twinge! We need only replace

an outmoded conceptual fixity with the discursive fluencies of encultured self-discovery. The key to recovering Socrates lies through Hegel—a Hegel shorn of his own excesses, as by way of the critique offered by figures like Marx, Nietzsche, Dilthey, even Dewey and Heidegger, that brings us back to the *geistlich* world Plato and the Sophists explore in their tantalizingly innocent way. In this sense, Wittgenstein is himself an artifact of the "cunning of Reason."

What I mean is we are never sure—in fact, we are inclined to doubt—that what Wittgenstein displays *are* actual structures he's discovered in our language or associated practices of thought at least. What he shows us rather is that our "form of life" builds on, supports, incorporates, and abandons by pieces the transient, potentially useful, not altogether ephemeral concatenations of the kind he tracks. He shows us by unexpected example the *determinable* possibilities of having mastered our cultural resources, *not any determinate structures in any parts of that culture.* There seem to be no fixed structures at all. He shows us by his own assurance how far we might go in envisioning the whole of our "everyday" world as a tolerated flux of graded stabilities that have no need of fixity! (Plato might have found in this an incipient answer to his own worries.) Nevertheless, in admitting that, we are not bound to concede that there's no use in formulating different theories—many throwaway theories—of the conceptual order of our actual world.

Wittgenstein's improvisations provide the key to how such theories begin to take form. They even show us how the grandest philosophical visions tend to become too fixed, too abstract, too intolerant of change—they even show how they stray too far from the bedrock of societal practices—too far to be relied on without risk. Read this way, Wittgenstein's innovation deepens the import of recovering the Socratic and Hegelian strategies. *That* I take to be as close as we can possibly come to an indispensable philosophical discovery about the right way to view morality and the arts and sciences, because, of course, it's no more than a corrective—a "therapeutic"—warning rather than a rule or foundational doctrine. Wittgenstein shows us that our practices are entirely reliable but not entirely determinate. There's the profound puzzle that haunts our every attempt to link the analysis of physical nature and human culture indissolubly. (I take instruction here.)

Wittgenstein is hardly an adequate guide in a "post-Hegelian" world. But it is Wittgenstein, more than anyone else in the recent Eurocentric

world, who shows us how to simplify in the most stripped-down way the superfluous complexity of Hegel's necessary innovation—centered now in terms of our *lebensformlich* "second nature." In short, Wittgenstein provides what amounts to a version of the Socratic elenchus enriched by a "Hegelian" transformation and then brought back, more comprehendingly, to its original spontaneity.

Wittgenstein intuitively hit on the tactic of *Entfremdung* amid what was completely familiar to his audience: the fluxive world of ordinary language and ordinary social habits and activities, viewed reflexively as the public sharing of a contingent cultural practice within whose terms we rightly count on answering all our quotidian philosophical questions about the meaning of what is said and done, our choice of norms in practical and theoretical matters, the continuing coherence of our engagement in a changing world, and what it is to be a human being. Wittgenstein almost never admits the play of history or historicity. Yet, in perfecting what I am calling his philosophical "meander," in the untendentious way he does, he fashions a kind of moderate elenchus under an attenuated "Hegelian" sense of the *sittlich* and the *geistlich*.

In all its forms, the elenchus is the resource par excellence of conceptual improvisation, cast as discovery, within and about the "everyday" world. It can always be overridden for cause, but it cannot be bypassed or ignored. It fixes the sense in which what is "given," as by a kind of *geistlich* phenomenology, cannot be derived from any deeper facultative competence; on the contrary, it affirms that all precision and exactitude derive, consensually, from the very stability of our practical world. (That is precisely what allows us to outflank the Eleatic scruple.) Wittgenstein celebrated the same fact—in a way, "uncomprehendingly"—that is, the Hegelian theme of his entire elenctic meander. Here, for instance, in what may be one of its best-known expressions, Wittgenstein offers in the spirit of his "method": "'So, you are saying that human agreement decides what is true and what is false?'—It is what human beings *say* that is true and false; and they agree in the *language* they use. That is not agreement in opinions but in form of life [*Lebensform*]."[20] I cannot see how this could exceed the cultural flux that eluded Plato.

Wittgenstein is, then, a bit like the author of the Socratic elenchus: he is not entirely aware, it seems, of the full range of the sui generis contingencies of cultural life. Certainly, his characteristic specimens are of a narrower gauge than those of the large world Hegel addresses—or than

those the more radical post-Hegelians might advance along the lines of historicity and the open logic of interpretation. But what is most compelling in Wittgenstein is the sheer simplicity and intuitive force of his "method": it is as open to counterinstance as it could possibly be, even against his own occasional "metaphysical" preferences. Plato, you recall, was probably more conservative than the elenchus required, and Hegel was probably more daring than the dialectic could actually endorse. We need these diverse practitioners—and more—for it is hard to deny, even now, that we are only at the beginning of a proper inquiry into the human.

. . .

Very pretty, you say, but you've missed the mark. What then *is* the human? Let me venture a few clues in accord with my own account of the elenchus—and what I have in mind in what follows. The human is artifactual; socially constituted; historicized; enlanguaged and encultured; "second natured"; real only within some culture's collective life; embodied through the cultural transformation of the infant members of *Homo sapiens*; originally or externally *gebildet*; sui generis; emergent through mastering a first language and whatever aptitudes such mastery makes possible; indissolubly hybrid, uniting biological and cultural processes and powers; capable therefore of hybrid acts or "utterances" (speaking, making, doing, creating) incarnate in the *materiae* of any part of physical nature; self-transforming or internally *gebildet* through its second-natured powers; empowered and constrained by the collective history it shares with similarly emergent creatures; capable, thus, of functioning as a self, a person, a subject, an agent, within an aggregate of similarly formed selves, that is, free and responsible, capable of causally effective (incarnate) initiatives, capable of self-reference, of reporting its inner thoughts and experience in a public way, of understanding the utterances and acts of similarly endowed selves; inherently interpretable and subject to change through being interpreted; not a natural-kind entity but a history, or an entity that has a history rather than a nature, or a nature that is no more than a history—a history determinable but not determinate. All in all, the human is a unique sort of being, you must admit, but an individuated being nevertheless: emergent in part by natural (biological) means and in part by artifactual or cultural transformation—possibly, then, a conceptual scandal or even the living refutation of many a convention of canonical philosophy. Is that enough?[21] Perhaps not quite.

We do not understand ourselves well enough—philosophically—and I cannot hope to put my conception in a more compendious way, given the kind of narrative I've been airing. It would require an entirely new beginning, which may strike you, of course, as a strange complaint. But I can indeed collect some useful questions here, linked to the tally just offered and keyed to what I've been suggesting about elenctic thinking—which may now serve as a place marker for a stronger analysis that I'm about to venture. The single most important question that must be settled concerns whether "human being"—the mode of being of "human beings" (if you don't mind this way of speaking)—is itself, in belonging to the natural world, a "natural-kind" distinction or something else. There's an equivocation there and a puzzle to be resolved.

Heidegger, let me remind you, pointedly affirms that human beings, the plural manifestations of the "human *Dasein*," exist. They appear to be the only beings that do exist in Heidegger's sense; mere "things" (of whatever complexity) do not.[22] Heidegger means by this that *Dasein* is *not* a part of nature, for to be entirely a part of nature is, it seems, to be a mere "thing." For my part, what Heidegger says here cannot persuade us *if he* cannot, or will not, specify some feature or other of being human that could never, without paradox or incoherence or inconsistency, be admitted to be distinct or unique when compared to all else that is "found in nature"—while remaining "natural" itself, subject in every respect to the forces of the natural world. I daresay Heidegger never meets the challenge. Nor, within my reading, does anyone else who follows a similar intuition.[23] Heidegger flirts with the notion that *Dasein* is a kind of ontological "presence" that is not a countable entity at all. But that must be a false lead if he (or we) intends to speak of *Dasein*'s ever acting in its own right—doing or making anything in an intentionally effective way. All speech, art, responsible commitment would have to be abandoned.[24]

I myself take persons or selves to emerge from biological nature—naturally but not by biological means alone, hence not in the way of natural-kind change. The equivocation is resolved by admitting sui generis cultural processes within the bounds of nature.

I concede that *Homo sapiens* is a natural-kind kind; but I hold that (human) selves or persons or subjects are not, though they "exist," entirely in the natural world. I mean by this that "language," "history," "culture," "art," and similar distinctions are not natural-kind distinctions of any kind—which is to say, they are not reducible in natural-kind terms.

Persons are not the mere members of any biological species, though in our earthly world there seem to be no other kinds of persons (unless we admit fictions: legal persons, corporations for instance, that are not human in the precise sense that qualifies the members of *Homo sapiens*).

If I understand him rightly, Heidegger may be forced to admit that *Homo sapiens* isn't "human" or that the strictly numbered members of that species do not exist; or that, in existing, *Dasein* manifests a mode of being beyond all biology and nature. I don't understand this way of thinking, unless it's just an expression of extravagant respect. In my opinion, this signifies that Parmenides and Kant and Husserl and Heidegger (and Levinas, if you allow a lesser addition) may at times be practicing philosophy beyond the pale; and if selected extravagances on the part of Plato, Aristotle, Aquinas, and Schelling must be read literally, then they need not apply either.

No, what I offer in the way of a direct challenge to any theory of what it is to be a human being is this: that all the available evidence points to the fact that the members of *Homo sapiens* are, shall we say, "transformed" into selves or persons in the process of acquiring a natural language and the culturally formed aptitudes that that makes possible. *Homo sapiens* harbors, as such, no selves, in the plain sense that languageless creatures, including wild children, are incapable of self-reference and reporting their inner mental states; *and* that *that* extraordinary ability, unmatched anywhere else in nature, fully justifies our speaking, uniquely, of selves as "second-natured" hybrids—"ontological" transforms, if you don't mind. By this, I mean no more than that the "emergence" of human selves obtains in a perfectly natural way—is a sui generis process, not at all like mere biological evolution or growth. The emergence of selves is, rather, an "artifactual" process in that it occurs only through acquiring a natural language and a natural culture—where language, having evolved at least incipiently from sublinguistic skills, cannot then be explained in any merely biological or other natural-kind terms.[25] There is no algorithm, for instance, that accounts for the emergence of language in the way in which self-replicating proteins are said to have emerged for the first time.[26]

Furthermore, what holds for embodied second-natured selves holds (for logically trivial but momentous reasons) for all the incarnate utterances and acts and creations of such selves. Hence, if selves are sui generis, so are the arts and the sciences and language and history—as well as the descriptive, interpretive, explanatory, and logical resources that we judge to be required in each domain. Most particularly, it means that human

perception is culturally altered, transformed, penetrated—as in the perception of paintings: it is itself a cultural artifact that cannot be reduced in neurophysiological or phenomenalist terms.

It's for these reasons that I characterize a human self as a *hybrid* creature whose native biological gifts are startlingly transformed through a human infant's internalizing the ability to speak the language of its home society. In that sense, a self is itself a cultural artifact. But to say only that is to be prepared to explain in sufficient detail the natural (not natural-kind) process of cultural emergence (enculturation, the "second naturing" of *Homo sapiens*). I see no difficulty there—no more than a familiar sort of empirical ignorance. Furthermore, *hybrid* is meant to signify our successfully obviating both dualism and reductionism with regard to selves and their characteristic forms of "utterance." It is, in short, the simplest, perhaps the only viable alternative we have. Even a confirmed neo-Darwinian like Richard Dawkins admits he sees no way of explaining cultural transmission in terms of genetic processes and any variant of environing physical conditions.[27]

There are, of course, endless questions that would need to be answered if the thesis of the hybrid being (or nature) of human being were adopted. But there is no a priori barrier against its general coherence or the coherence of cognate solutions applied to problems in the theory of science or mind or language or art or morality. I have addressed a good many of these smaller questions elsewhere, and I see no crippling paradox in the offing. I concede that adopting this single theorem requires altering in considerable depth the entire canonical picture of nature and science. But that's hardly a reason for opposing such a change.

Let me add another consideration from another quarter touched on earlier. I am persuaded that the constructivist solution to the paradoxes of early modern philosophy—the paradoxes of Kant's magnificent innovation as well, which reached its strongest and most original form (against Kant, of course) in Hegel's historicism—is essentially the same achievement as that of explicating the concepts of historicity and enculturation. Surely, the first counts as one of the most decisive advances in the whole of the history of Western philosophy; the second counts as the single most important modern contribution to philosophy's conceptual resources and, as a result, to its most radical reinterpretation of the general problem of human knowledge and self-understanding: the key to the elenctic puzzle itself.

But if that is so, even the natural sciences are *constructive posits* of, and within, the constituting forces of history and enculturation: all this, in spite of the alleged fact (the canonical view) that the natural sciences need never, in their descriptive and explanatory work, invoke the sui generis categories alleged to be essential to our understanding of the cultural world.

On the admission of cultural emergence, however, both vocabularies take form *within* (and only within) the terms of a constructive realism (drawn as economically as possible from Kant's and Hegel's analyses). If so, then we cannot defend *any* principled disjunction between the natural and the human sciences, and every science will be a human science: the vocabulary of the physical sciences will then be read as an economy imposed on a more inclusive inquiry, *not* as an independent idiom independently achieved or validated—or validated prior to cultural inquiry. Indeed, I take this to be the neglected lesson of Thomas Kuhn's ill-fated *Structure of Scientific Revolutions*.[28] You begin to see, therefore, just how and why the elenctic process in any of its forms is bound to color the definition of the human. I think this catches the deeper meaning of Kuhn's profound reflection, which (if I dare suggest) Kuhn himself was unable to fathom sufficiently or analyze without inviting conceptual disaster. It marks the sense in which "the human" is natural or "naturalistic" without being "naturalizable" in the reductive sense that runs through so much of analytic philosophy's penchant for scientism—fixed in the very title of W. V. Quine's well-known paper "Epistemology Naturalized" and feared (for that sort of insufficient reason) by so much of contemporary "continental" philosophy.[29]

The lesson of the elenchus is still too elliptical as it stands. Let me put it another way. Parmenides, who originates its dialectical economy, does so in the name of his supposed necessities of thought and of the truth about Being. Plato's brilliant stroke lies in his converting the original strategy into the Socratic elenchus: which is to say, first, that Socrates applies the elenchus only to the changing world, never to "what is" in Parmenides' sense; second, that its argumentative resources are confined to *sittlich* beliefs, whether in logic or method or experience or convention; third, that it centers on questions of normative conduct and character, just those that are likely to yield (we may suppose) to a society's accumulated wisdom; and, fourth, that whatever success it achieves is never more than consensual, persuasive, provisional, endlessly open to revision and diverse conviction and application, grounded in whatever may be given in the practical life of a viable society.

I take that to be the deeper meaning of Socrates' "ignorance"—as pertinent a lesson under the changed circumstances of modern thought as it ever was in its original setting. That is, all our powers of cognition and intelligence are finally, however critically refined, artifacts of cultural history and consensual tolerance. (Socrates knows he has no knowledge, because he knows he has no knowledge of the Forms!)

Modern philosophy since Hegel (as distinct from Kant and Fichte) transformed in a new way (but never abandoned) what we should understand as the grounds of knowing. Hegel may rightly be thought to have anticipated Wittgenstein in holding that the ground of knowledge is not a "proposition" (or "opinion") of any kind but a "form of life."[30] The world of Absolute and infinite *Geist* is, finally, the presumptuous daring of a contingent creature transformed into a being that invents its own realm of freedom, which it treats as a discovery! Hence, knowledge no longer requires foundations or a source of certainty; it requires just what moral and political objectivity require, namely, a constructive grounding in historical life itself. That is precisely what the Greeks could never penetrate, but also what Plato (to his credit) saves in the Socratic elenchus.

It would be a mistake to infer from all this, however, that the post-Hegelian world rejects the possibility of knowledge. Hardly! Its entire purpose is to outflank any such skepticism. It shows, rather, that human knowledge and understanding must take a constructivist turn if they are ever to escape the Cartesian (and Parmenidean) paradoxes. It is in just this sense that, through the "cunning of reason," Hegel's dialectic has become the perfect clue to the larger lesson of the Socratic elenchus—which, of course, Plato could not have fathomed.

If you concede this lesson, you see the sense in which to admit the role of enculturation in the "construction" of the human self is tantamount to admitting the inescapability of a constructive and historicized realism; that to admit that is to abandon every form of fixity and privilege in, say, science and morality; *and* to admit all *that* is to admit that we have lost the a priori right to oppose the compatibility of historicism and/or relativism and a constructive realism—if, that is, it should prove true, independently, that either option of the first pair *was* coherent and viable in its own right.

There's no need to apply these radical options everywhere: it's more reasonable to invoke them wherever they fit best. But once we gain the high ground of the post-Hegelian world, we can afford to let Plato's philo-

sophical stone roll down its hill for the last time. For to be able to bring relativism and historicism within the pale of knowledge *is* to have superseded the Parmenidean constraint once and for all! In that sense, even Wittgenstein's meander may be viewed in a different light. We may ultimately have no other resource than elenctic reason. I think that's true. But the elenchus runs much deeper than we ever supposed. For example—though it counts as more than a mere example—the elenchus introduces an inherent and insurmountable logical informality and provisional diversity that must color every dream of extensional rigor and determinacy of analysis that (up to the present time) has furnished the most admired moments of the whole of Western philosophy. (We are closer, now, to escaping the old hegemonies.)

There remains a considerable gap in the argument nevertheless, a gap that must be filled: not so much in the way of what we might wish to add as a fuller account of our elenctic powers, more in the way of explaining the conceptual relationship between agents capable of such powers (selves, ourselves) and the members of *Homo sapiens* from whom they somehow arise. In the modern world, any tenable answer would implicate some form of evolution or emergence that would avoid the defeated options of dualism and reductionism and therefore would need to admit formative processes ampler than the merely biological. As far as I know, the Greeks never sought to explain the relationship between selves and *Homo sapiens* in evolutionary terms of any kind; they spoke primarily of education and maturation within the telic cycle of the natural creature, though they were attracted very early, of course, to the meaning of cosmic order, which they took human intelligence to resemble.

When Aristotle speaks of man as the "political animal," he obviously treats the political as a fully biologized process, though biology is for him a much more generous category than it is for us. There's the difficulty: the biological or natural is so expansive that it proves impossible to speculate in classical terms about the difference between "our" conception of biology and what we regard as cultural process. Ultimately, both *physis* and *nomos* are subsumed within the pale of nature so that even our being governed by *nomos* (or convention) is, finally, read as being governed by nature. (Compare Vico.) If you insist that the distinction between the two still preserves our distinction between "nature" and "culture," you place yourself under an obligation to deliver an analysis of "custom" or "justice" (or "language" or "art") that would support your claim. It can't be done in Aristotle's terms!

Furthermore, where Aristotle may have been nonplussed along related lines, where he needed a concept of reason (*nous*) adequate to his theory of knowledge, as in the *De Anima*, he simply invents out of whole cloth an ad hoc faculty, more divine than human, for which he never deigns to offer a biological clue—although it is true that he weaves the powers of *nous* (so conceived) together with the powers of biologized perception in an interesting way. Aristotle never regards his device as a sign of failure, although its obvious epistemological compromise would never pass muster within the precincts of Socrates' elenchus.

This entire line of thinking anticipates the sense in which the theory of the fine arts is bound to match the theory of human being: Aristotle's mimesis, for instance, is the perfect counterpart of *nous*. Hence, if we accept the declension of the elenchus along the lines I've sketched, we begin to see the near inevitability with which we must abandon necessity and fixity, begin to view the human world as a hybrid and constructed world, and thereupon find it impossible to avoid exploring the distinction between the physical (or natural) and the cultural—even if in a more radical setting we choose to reclaim the whole of this new unity for nature once again. For we will have done so only within the sparest limits we imagine we could ever imagine.

In fact, there is a very pretty rendering of a cognate thesis formulated in evolutionary terms by Marjorie Grene, drawn from Helmuth Plessner's ingenious theories, which Grene presents as her own "basic [biological] intuition"—that is,

the principle of the *natural artificiality* of man. We become human not just by being born *Homo sapiens*, but by relying on a complex network of artifacts: language and other symbolic systems, social conventions, tools in the context of their use—artifacts which are in a way extensions of ourselves, but which in turn we actualize in our personal lives. It is our nature to need the artificial, art in the broadest sense of that term, or, indeed, poetry in the broadest sense of that term: making and the made.[31]

The breathtaking intuition behind this lovely finding, which Grene shares with Plessner, is that much as with human birth itself, *Homo sapiens*, phylogenetically conceived, is already profoundly *incomplete* in a molar sense, already in "need" (Grene's term) of the forms of cultural transformation. "All" that is missing is the theory of art and cultural artifacts. But that, of course, *is* the whole of what we need. If we isolate the differences between the biological and the cultural and reinterpret Grene's intuition (if I may

coopt her notion thus) in terms of an actual theory of the self, we would find it very natural to treat the self as hybrid and second natured, along the lines already sketched—and along additional lines that have still to be introduced (involving the arts particularly)—*and* we would find (I daresay) the remarkable flexibility and power of the elenctic theme confirmed and vindicated. Bear that in mind, please. It's the motivation of the argument that follows. I capture the entire thrust of this last adjustment by speaking of human "utterance"; that is, what it is that human selves—but not the members of *Homo sapiens*—do and can do by exercising their encultured second-natured powers. The study of the arts is one of the most commanding ways of discovering what this concession entails: what it entails, of course, ensures at least the inadequacy of mimesis; for mimesis (as Kant was aware) is essentially a conceptual instrument for reducing art and its genius to nature. And so I turn in the direction of the arts.

1

Perceiving Paintings as Paintings

IN SPEAKING INFORMALLY of "the visual arts" we may be drawn to objects of perfectly valid but unlikely kinds: for instance, those that belong to landscaping, city planning, decor, couture, decoration, and other forms of design. But academic aesthetics still singles out painting and sculpture without prejudice to whatever else may be included, except that painting and sculpture (categories already too protean for much useful generalization) are assumed to collect the principal specimens of what we have in mind when we theorize about the visual arts; where, that is, the addition of architecture or decor is likely to intrude considerations very far removed from what is usually featured in the best-known philosophical disputes, for instance, regarding pictorial representation. Not always of course, as when we resist treating the Van Eyck triptych, *The Adoration of the Lamb*, as a painting separable from its place near the altar at St. Baaf's. We often think of easel painting as providing a sense of acceptable examples, though not to disallow Michelangelo's Sistine ceiling, Frank Stella's shaped panels, Anselm Kiefer's mixed-media hangings, Chartres' windows, Schwitters's collages, or Mapplethorpe's photographs.

There is no entirely reliable principle of selection here, as if to say we could isolate the decisive philosophical questions about the visual arts if only we kept to the essential specimens. It's more the other way around: interesting questions arise from a motley at hand, and as our sense of what might be worth pursuing comes into focus, the collection of instructive specimens follows suit. Pertinent generalization and pertinent exemplification select one another—"equilibratively"—in every kind of inquiry.[1]

There is no privilege there, except for what a clever mind may lead us to ponder. It has no essentializing or exclusionary force. There is, in fact, no preset path of understanding that we expect to find; we find what we are disposed to find among the possible lines of thought our practices support—rather like the *unanimes* of societal life that Jules Romains once described, as in the gathering of a small crowd around an accident before the body is finally removed and the crowd dispelled.[2]

But when we consider a goodly selection of "canonical" paintings—paintings more often than sculptures—we are bound to admit that the usual global questions tend to be tiresome, where their answers need not be: for instance, "What is a painting?," meaning by that to specify something of its peculiar ontological features and what and why we are interested in the distinctive way a painting "works" as a painting; or "What is it to see a painting as a painting?," meaning by that to specify something of the conditions peculiar to the perceptual achievement of viewing paintings as paintings and what such viewing yields in the way of understanding paintings and the unique skills by which they are thus discerned. Of course, I am already coaxing these blunderbuss questions into complying with what I take to be a productive inquiry.

No sooner do we admit the laxity and prejudice of our usage than we concede that, as distinct from the modern tradition of Western painting and sculpture, much that we now include as art or fine art—the "art" of the medieval church for instance—could not have been easily included, except for a deformation or transformation of what was more likely to be prized in such visual work before the visual image (in the modern sense) displaced the visual presence of the sacred.[3] So the classificatory effort carries in its wake a changeable notion of what is of focal importance in addressing visual art itself. James Elkins, for example, has formulated a strong brief against the privileging of what in the West we think of as the visual arts, reminding us of the very different practices and traditions of non-Western "visual art"; the "popular arts"; "primitive art"; and particularly today, the "non-art" images of science, technology, and new ways of communicating "information," which now provide the bulk of visual images.[4]

That they tend to be discounted as non-art (that is, excluded from the canons of the West) does not justify denying the fact, as Elkins argues persuasively, that "visual expressiveness, eloquence, and complexity are not the proprietary traits of 'high' or 'low' art, and . . . that we have reason to consider the history of art as a branch of the history of images, whether

those images are nominally in science, art, writing, archaeology, or other disciplines."[5] I can report that as a boy I was completely captivated by the great Olmec head in the foyer of the New York Museum of Natural History: it was only later that I learned that it was placed *there* because it was once thought that Mesoamerican art belonged outside the pale of the "fine arts," outside the essential core of the arts of "Western civilization." You begin to glimpse here the possibilities of the politics of classifying the very forms of art.

The principal thing about my dull questions is that they are conceptually inseparable from one another; for, in general, there is no way to specify the perceivable features of the world without implicating our perceiving them; and what we take the objective world to be like must be adequated to our ability to discern its features. That is the supreme lesson developed by Kant and deepened by Hegel, if we may allow for perception's being historicized, which sets a *conditio* sine qua non for all genuinely modern theories of knowledge and reality. Put this way, our questions begin to attract a certain sustainable interest.

Furthermore, if we agree that the paradigm of perception collects what humans can report they perceive—or what, by their own lights, other creatures may be said to perceive though those creatures cannot report the fact—if perception is itself theory laden and subject to historical variation (different saliencies and different forms of habituation), and if (more pointedly) artworks are deliberately contrived artifacts and *their* perception conformably disciplined (being also artifactual), then it is doubtful that either artworks or their perception can be counted on to yield universal regularities or necessities ranging over the whole of the visual arts—no matter how those arts are defined. Unlikely contingencies—Duchamp's *Fountain*, notoriously—subvert our best-held universalisms like cut butter: philosophers alert to the lesson go gently to their arch claims. It's worth a small pause to ponder the truth that Kant never considered, either in the first or third *Critique*, that perception and feeling might change historically. You see how such a worry might have knocked Kant's transcendentalism out of the ballpark at a stroke.

The lesson's clear: we cannot escape the regularities we've learned to discern. But if so, we may as well feature whatever we take to be the strategic or important distinctions regarding whatever things are preeminently included in the West's collection of the great arts of the world.

Others will press in other directions, certainly in accord with new

technologies of perceptual experience. But we ourselves can hardly be expected to make provision for what we have not thought about. Nevertheless, we have already made a few worthwhile gains: for one, that generalizations among the visual arts are likely to be more local than universal, skewed by the interests of diverse aficionados; and for another, that the kinds of perception that are relevant to our discourse about the visual arts are bound to be phenomenological rather than empiricist or physiological. Perhaps, in saying this much, we've already moved too far too fast. But nothing need be lost: we've actually made a strategic start. Have patience, please.

Consider, for example, that Brunelleschi and Alberti are said to have been the first to have discovered the vanishing point in linear-perspective drawing: that is, a certain visual illusion constant to eyes trained to view two-dimensional representations of space as having three-dimensional import. In this sense, Brunelleschi began to formulate the elements of so-called natural or universal perspective; if so, then Masaccio and Masolino were the first to apply Brunelleschi's rules in the form of what has been called "horizon line isocephaly" in the frescoes of the Brancacci Chapel (the Santa Maria della Carmine, in Florence): that is, lining up the heads of figures in the same perceived depth to signify a receding distance. The important point to notice, however, in Masaccio's *Tribute Money, The Healing of the Lame Man*, and *The Resurrection of Tabitha* (attributed to Masolino), is that the linear alignment tolerates a distinct measure of perceptible deviation controlled by an interpreted grasp of what may be said to be the pictorial and perceptual "intent" of the entire array; so we see that what is perceived is itself informed by (does not risk too great a deviation from—but might) the supposed perspectival rules of the *artifactual* (the perceived) space of the paintings in question.[6] In any event, to say this much is already to concede that the spontaneous perception of the three-dimensional perspectived space of pre-Renaissance or early Renaissance painting is culturally "penetrated" by the conceptual discoveries of the day: hence, that the "given" in the perception of painting must be phenomenological before it can be restricted (if we wish) to what, on one theory or another, is thought to be "phenomenal" in a "strictly" sensory sense. The idea will haunt our discussion.

I am hinting here at the immensely complex and much-disputed matter of what it is we actually see, and I'm prepared to offer two heuristic caveats against any hasty claims: first, that we must always distinguish what we suppose is "given" to our sensory apparatus and what is "given"

phenomenologically as what we are prepared to report we see; and second, that an objective account of that distinction is never more than a construction (one among many possible constructions) that fits the holist life of human agents and, inferentially, the life of creatures that cannot report what it is they see. So there is no single privileged model (neurophysiological, ecological, behavioral, actional, reportorial, realist, representational, presentational) that we can count on a priori to provide the best theoretical framework to be favored; and the contrast between the two senses of "given" privileges nothing: for what is given to our sense organs is always inferentially derived from what is given in the second sense, and what is given in phenomenological reporting is never privileged in any evidentiary or metaphysical sense but cannot segregate the subjective aspects of what we are prepared to report about the seeming objects of our perception. As long as we keep these reservations in mind, it makes very good sense to proceed phenomenologically (in what I take to be Hegel's way rather than Husserl's), which is to say, we must begin with what we cannot resist reporting but are unwilling to take on face value alone in any respect that we find we are bound to favor in speaking of what is "objective." Nevertheless, proceeding thus, we cannot fail to see that the arguments of figures like Richard Wollheim and Arthur Danto depend on a privileged entry into the matter of what we really see.[7] (Think, for instance, of Danto's indiscernibility puzzle.)

The point to bear in mind is that the visual structures of paintings *cannot be perceived* at all if we disallow the corollary that the perception of such structures is itself an *artifact of our own cultural formation, noted as such in our theory of perceiving paintings.* It's part of the world of public culture! *Anyone* who falls back deliberately or innocently (David Marr, for instance) to the physiology of perception has missed the right perceptual boat altogether.[8]

Jan van Eyck's intriguing painting *Portrait of Giovanni Arnolfini and His Wife Giovanna Cenami* poses, according to Hubert Damisch, the problem of two vanishing points fixed by the ambiguous function of the mirror: the point at which the artist apparently witnesses the marriage (from where he actually stands viewing it) and the point reflected in the mirror (signifying his assigned position in the painting), both points falling within the pictured space of the mirror's circle.[9] This is said to be not unusual in Flemish work of the period; and indeed, Erwin Panofsky counts several other vanishing points in the *Arnolfini*, which are pictorially acceptable in

the composition as a whole. Is there a difference between being "pictori-ally" and "visually" acceptable here? I think not. Both terms signify percep-tion *in* the phenomenological sense appropriate to *viewing paintings.*

Actually, Panofsky counts "four central vanishing points instead of one" in the *Arnolfini* study (1434) as opposed to the "nearly contemporary and relatively comparable Italian work," Masolino's *Death of Saint Ambrose* (c. 1430), which is said to be "fairly 'correctly' constructed," that is, con-structed in accord with Brunelleschi's rules. Van Eyck, it seems, was not familiar with Brunelleschi's findings.[10] But both Panofsky and Damisch think of perspective in paintings as *perspectiva artificialis* (rather than merely *naturalis*—the perspective of natural optics, presumably Brunelleschi's and Alberti's primary concern). Hence, Damisch views perspective as "a model for thought,"[11] and Panofsky thinks of perspective as a "symbolic form," more or less a matter of cultural convention (though not merely).[12] Da-misch views perspective in his structuralist way, and Panofsky does so as a supporter of Ernst Cassirer's Hegelianized Kantian vision. But both are speaking of the perception of paintings, not of nature. Surely, the "artifi-cial" perspective of a Giotto is spontaneously perceived by someone suit-ably trained to *see* paintings; but there is no obvious way (for instance, in accord with anything like Marr's methods) to disjoin sensory perception and thought (involving a theory of Giotto's perspective) by which to defeat the idea that visual perception is "penetrated" by our conceptual under-standing of Giotto's space.

. . .

Seen this way, the "rules" of pictorial perspective can hardly fail to be constructed and intentionally adjusted for purposes internal to the artist's interests in rendering pictorial space itself—hence, usually not as "natural" perspective in any obvious sense of the term. Damisch's rambling story of the "Urbino perspectives"—regarding the rendering of the Urbino panel (the "*città ideale*"): there is no single perspective in the panel—certainly confirms how the development of "scientific" perspective (Brunelleschi's objective) must yield to the construction of "artificial" perspectives rang-ing from architecture to theater to decoration (as Damisch's summary puts it), as in the pictorial intention of a distinctive perspectival mode, possibly a choice that yields to the artist's own need to invent ever more compli-cated compositional devices. Damisch notes the perceptual tolerance of "incompatible," even "incommensurable," perspective schemes known to

obtain within the pictorial space of the same painting. Certainly, similar complications inform Michel Foucault's perceptive analysis of the baffling perspective of Velázquez's *Las Meninas*, that is, *if* pictorial perspective must be viewed in terms of something like Brunelleschi's famous peep-hole machine—an option Foucault nowhere endorses.[13] There has always been a tendency to yield to Alberti's advice to favor a "sensate wisdom" over the "strict" geometry of natural perspective.

But if all this holds, then Rudolf Arnheim's gestalt conception of the "universality of perceptual patterns" is more than a little off the mark. Arnheim has always favored Wolfgang Köhler's notion of a "causal foundation" of perceived visual patterns in the physical structures of the nervous system. But his heuristic schema—I can only call it that—of "centricity and eccentricity" (that is, the centrifugal centering of vectorial forces emanating from an individual physiological center, say, a person, and the admission of other such centers among which the first counts as no more than one) is not really a distinction that *could* be construed in purely gestalt terms grounded in physical processes, or as segregated somehow (within visual perception) from any influences of an intentional or narrative or historical or interpretive or otherwise culturally informed sort. The gestalt account founders utterly if *perspectiva artificialis* cannot be effectively governed (pictorially) by or reduced to *perspectiva naturalis*, or eliminated.[14] Of course, it cannot.

Arnheim never rightly concedes the full import of his own admission that his visual schema is itself directed by the two "principles" he espouses, which apply in a benign way ("universally") to human life and action but *not* to perception as such:

I began to see that the interaction of centricity and eccentricity directly reflected the twofold task of human beings, namely, the spread of action from the generating core of the self and the interaction with other such centers in the social field. The task in life of trying to find the proper ratio between the demands of the self and the power and needs of other entities was also the task of composition. This psychological relevance justified the concern with the formalities of composition.[15]

Fair enough. But surely Arnheim has a metaphorical ratio in mind, not a physiological measure of any sort. He himself supplies a telltale (unintended) counterinstance to his own gestaltist views in his much-admired *Art and Visual Perception*: there, he mentions a fifteenth-century painting in which St. Michael weighs "one frail little nude [man]" who "outweighs

four big devils plus two millstones" in a pair of scales.[16] The colors and forms and even certain tricks of visual emphasis are insufficient in any plausible gestalt sense to tip the balance in the virtuous soul's favor. The only satisfactory explanation for the visual balance requires the executive contribution of the *narrative* interpretation of the scene, which penetrates and informs what we admit we see! Nothing that Arnheim offers offsets the fatal implication. (The issue bears, by the way, in an important sense on the difference between phenomenalist and phenomenological accounts of the perception of paintings.) For phenomenalism is defeated out of hand wherever perception can be said to be culturally penetrated (as it invariably *is*) in the perception of paintings. Arnheim unintentionally confirms the point.[17]

Even more compelling cases may be mentioned: for instance, James Ensor's canvases of grotesque figures deliberately crowded into a smallish corner of a picture space that reminds us "visually" (by its absence) of the "normal" spacing and balance of such spaces. Despite the crowding, Ensor's paintings, complete with garish colors, are hardly "out of balance": their representational import justifies the visual order and makes it entirely unproblematic. Karsten Harries mentions (for another purpose) the example of Brueghel's *Conversion of Saul*, where two very different landscapes (signifying the two phases of Saul's career) are "reconciled on narrative grounds."[18] Of course, as with the picturing of sacred themes, it's quite impossible to separate the perception of *paintings* from literary and traditional elements of a common culture that have rightly penetrated the visual field. There's the weakness of phenomenalist strategies in the analysis of paintings: they are literally not addressed to what we can report we see, unless "subtractively."

The most developed version of the thesis diametrically opposed to Arnheim's is advanced by Marx Wartofsky. Wartofsky treats the perception of artworks (and more) as "a cultural and historical product of the creative activity of making pictures." He draws two radical conclusions: first, "that all theoretical attempts to construct a theory of vision, which presuppose that seeing is an essential, unchanging structure of [*sic*: 'or'?] process; or that the human eye is describable in some generic physiological way, are, if not fundamentally mistaken, then essentially incomplete"; and, second, "that there is no intrinsically veridical, or 'correct,' mode of representation, that is, there is no criterion of veridicality that is not itself a product of the social and historical choices of norms and visual

representation."[19] This line of reasoning is very different from Nelson Goodman's rationale for discounting pictorial realism, though it arrives at a similar verdict.[20] (But Goodman's inference is a non sequitur and has almost nothing to do with the analysis of perception as such.)

Ultimately, there is no way to assign disjunctive contributions to biological nature and cultural history that join hands in perception's characteristic functioning: we must think of vision (in the phenomenological sense) as an indissolubly "hybrid" competence, paradigmatically identified in cultural space by dint of human reporting; this is in fact the decisive point of Hegel's contribution to the theory of knowledge and perception—in effect, opposing the perception of any *Ding-an-sich*. Whatever is assigned as the stable underlying ingredient of the neurophysiology of perception is entirely inferential at the explanatory level; it cannot be perceptually compared in terms of what is perceptually given in experience.[21]

I take this to be a philosophical discovery about perception that affects in a decisive way any reasonable account of the empirical standing of the physical sciences, or at least of the legitimation of their objective claims based on observational grounds. But if it is, there cannot be a principled disjunction between the physical and the human sciences. (Think of Goethe's reflections on the perceived color of cigar smoke, in opposing Newton's account of color.) The philosophy of art will prove a constant ally of the philosophy of science itself. This is a finding that a grasp of the contribution of Kant and Hegel to "modern" modern philosophy would already have predicted.

The weighting of these two seeming sources of perception—the phenomenal and the phenomenological—is confused again (on both sides of the argument) in the well-known debate between E. H. Gombrich and Nelson Goodman.[22] "Visual" balance, perspectival "correctness," and the like—in two-dimensional representations—cannot in principle be freed from the narrative or interpreted coherence of their intentional order; but of course they cannot violate the bare physical conditions of sensory perception either. We can hardly deny that phenomenological perception is a fact of encultured life. There is no direct inference from the physiological conditions of perceiving anything to any rulelike conditions for perceiving two-dimensional representations of any "intended" visual "world." What, for instance, are the perspectival constraints on the peculiar space (which possesses *some* three-dimensional import) in Picasso's *Three Musicians*? Or indeed, in Picasso's variations on *Las Meninas*? Or in Giotto's Arena panels?

Gombrich rather graciously concedes that "Nelson Goodman has persuasively argued against J. J. Gibson and me that 'the behavior of light sanctions neither our usual nor any other way of rendering space; and perspective provides no absolute or independent standard of fidelity.'" But Gombrich is a great admirer of Constable's "scientific" solution of representing landscapes; hence, he rightly asks, "Fidelity to what?"[23] Goodman is certainly right in what he is reported to have said here.[24] (Gombrich concedes that he himself muddled his own thesis.) But Goodman draws too extreme a conclusion from the dispute (and from Gombrich's concession)—indeed, Gombrich *never* claimed that there *was* any uniquely or independently "natural" way to represent nature—and in giving up a view he (Gombrich) never espoused, Gombrich would never have drawn the conclusion he's assigned, namely, that the bare term "'resemblance' or 'likeness' is useless for any definition of pictorial standards." The claim is false in any case; and the argument is a non sequitur.[25] (It all depends on whether you think resemblance is to be managed phenomenally or phenomenologically: resemblance need not be treated symmetrically in phenomenological terms; and in Goodman's account, to treat resemblance phenomenally is, effectively, little more than a way of insisting that it is formally, that is, necessarily, symmetrical.) But beyond that the logic of Goodman's argument begins to undermine the idea that pictorial representation can actually *be seen*!

The essential point is this: "natural resemblance" *holds within the terms of representational convention* (or better, *cultural construction*). That is, it's an artifact of phenomenological perception. Hence, *realism*, in Gombrich's sense, need hardly confuse the validity of Brunelleschi's experiments with the artifactuality of "natural resemblance" within *perspectiva artificialis*. Gombrich says that "iconicity is the basis of the visual image."[26] But this, too, is not entirely perspicuous, though it goes completely against Goodman (and possibly, also against Wartofsky). What Gombrich should have said is that iconicity is the basis of visual realism, in the sense of "realism" that fits Gombrich's reading of Constable's landscapes as well as the meaning of the difference between, say, the realism of Picasso's *Woman with Chignon* (a gouache from 1904, which compares with the realism of Picasso's blue period and related periods) and a 1927 oil-and-plaster *Head* (Gombrich offers both pieces as specimens, both from the Chicago Art Institute). The latter, apparently the head of a woman, is executed in Picasso's familiar way of deforming the shapes and arrangement of the detached parts of a familiar representation of a head so that we begin to make out

with a little effort what must be the eyes, a mouth full of teeth, probably a length of hair, a nose with nostrils, and the like, the ensemble of which is *not*, in the sense intended, realistic at all. (Obviously, iconicity takes a phenomenological form—is, therefore, theory laden.)

You must bear in mind that "realism" is itself a conceptual construction fitted to the evolving practices of the world of the arts. Goodman's attack has a much weaker target—one that is tied to an empiricist conception of resemblance. In fact, resemblance in the phenomenological sense, unlike the empiricist's, is characteristically directional (since it is "intentional") so that among Romance languages, for instance, taken in pairs, certain resemblances may be readily perceived in one direction while not in the other. I think this is true in pictorial representation as well, for obvious reasons, which Goodman for one would not concede.

In any case, admitting all this is enough to recover the intended sense of Gombrich's phrase "visual image," a pictorial image caught phenomenologically within its established representational style. That there is a "realistic" way of *decoding* the second of Picasso's images is not the point at all; the point is that once we are trained in a run of possible ways of representing perceivable objects in nature, the spontaneous recognition of strong and detailed resemblances confirms what Constable achieved and what Gombrich views as realism—relative to cultural penetration. *If* Goodman meant to deny that there is *any such* responsiveness (which is not a matter of expertise or quickness in decoding any mode of representation—and certainly not the point of contention between nominalism and predicative realism) or a consideration strictly bound by the formal logic of "*A* resembles *B*; therefore *B* resembles *A*"—he was surely wrong.

Resemblance here *is* theory laden, even "prejudiced"; but the *theory* of perception explains the sense in which it meets a brute biological limit (a disposition, not otherwise specified, that we may guess at by the comparison of perceptual tolerances and behavioral responses, themselves burdened in the same way). It is worth mentioning that Goodman standardly avoids the phenomenology of perception and Gombrich rests his entire argument on it.

Goodman (also, Wartofsky) does indeed make extreme claims against Gombrich's sort of "natural" realism—which, remember, is entirely compatible with the so-called conventional (or arbitrary) nature of pictorial representation. Goodman's mistakes—they are palpable and worth remarking—depend ultimately on a confusion between would-be formal

or semiotic fixities and the testimony of perceptual fluency. Here—among Goodman's own pronouncements—we find these two obvious mistakes at least:

[U]nlike representation, resemblance is symmetric: *B* is as much like *A* as *A* is like *B*, but while a painting may represent the Duke of Wellington, the Duke doesn't represent the painting.

A Constable painting of Marlborough Castle is more like any other picture than it is like the Castle, yet it represents the Castle and not another picture—not even the closest copy.[27]

Goodman's remarks are, of course, hostage to his nominalism; but nominalism is utterly untenable in perceptual terms (for independent reasons) and irrelevant to the phenomenological issue. *If* (qua nominalist) you concede that *resemblance* can be made determinate to any degree desired, by introducing an arbitrary convention, as Goodman suggests, you will have lost the argument! Any such convention—say, that of Constable's realism—will easily penetrate phenomenological perception. The *semantic* extension of a perceptual predicate to new cases on the basis of supposed resemblances requires a clear sense of phenomenological practice; if you need a fresh convention at every step, you will already (before you ever start) defeat the point of the original claim. In cases of normal perceptual fluency, you simply *see* the resemblance between a realist portrait of Wellington and Wellington as obviously closer than the portrait of Wellington and a representation of Marlborough Castle! Goodman cannot be speaking about the familiar patterns of human perception—which, of course, manifest intentional (or Intentional) features that Goodman would not willingly admit. Also, the "direction" of the (intended) resemblance may always be invoked phenomenologically. It is not merely a semantic or semiotic factor.

Alternatively put: although there is a point to disjoining (in some respects) perception and intentional portraiture, there is no separation in the reporting of phenomenological perception. Goodman impoverishes our perceptual resources for no good reason. But if so, we begin to suspect that Goodman probably never speaks directly of what we can report we see—when he seems to be speaking about sensory perception. Think, for example, of Goodman's confusion between the "acoustic" and "perceptual densities" of the discrimination of sound (or music), which confirms his easy disjunction between the semiotic and the phenomenological.[28] In this sense, though he's something of an innocent in a further exploration of

the perception of paintings (involving the views of figures like Richard Wollheim, Kendall Walton, and Arthur Danto), his semiotic analysis may be thought (mistakenly) to converge with a certain fashionable analysis of pictorial representation. It need not, as we may infer from Meyer Schapiro's practice, though his preferences in philosophical theorizing seem to converge (nominalistically) with those of the figures just mentioned.

On Goodman's story, we *should* be baffled by the claim that a picture of Marlborough Castle is "more like any other painting than it is like the Castle," for saying only that (which is clearly intended in a perceptual way) ignores the phenomenological salience of the intended representations of the specimen paintings in question.[29] (It obviously plays fast and loose with nominalism.)

This goes some distance toward explaining why J. J. Gibson was so terribly baffled by the failure of all his "ecologically" sensible attempts to decode and retrieve the "information" about the natural world *from paintings*—that is, information Gibson thought must necessarily be embedded in two-dimensional representations: he willingly abandoned the interpretive role of the cognizing subject in natural perception and therefore could not plausibly recover such a function *in the perception of paintings*, where it was needed. There's the reason for Gibson's failure and Gombrich's tentative success: Gibson confuses the distinct resources of phenomenological perception with what he calls "ecological" perception, which is phenomenally tethered to the physiology of perception. The recovery of perceptual information can hardly be the same in the two settings: the one is culturally penetrated; the other is not. The perception of paintings is simply *not* the recovery of any preestablished harmony ("affordances," in Gibson's idiom) of the perceptual powers of animals (including human animals) vis-à-vis their ecological niches. There's simply no room for phenomenological perception in Gibson's ecological model: there couldn't be, since Gibson eliminates the reporting role of cognizing subjects. But then, he effectively eliminates the very point of considering paintings! To see this is to grasp the import of distinguishing carefully between the "ontology" of biological nature and the "ontology" of human culture. (Recall the Prologue.)

In painting, the emphasis is and must be *artificialis*; in ecology, it's meant to be *naturalis*. There's the *reductio* of Gibson's very clever—but obviously misguided—speculation:

All along I have maintained that a picture is a surface so treated that it makes available a limited optic array of some sort at a point of observation. But an array of what? That was the difficulty. My first answer was, *an array of pencils of light rays*. My second was,

an array of visual solid angles, which become *nested solid angles* after a little thought. My third answer was, *an array considered as a structure.* And the final answer was, *an arrangement of invariants of structure.*[30]

Of course, Gibson could never find such invariances in any depictions that departed from whatever he took to be the informational constants of *natural* perception and perspective—a theory Gombrich was frank enough to admit he favored (in his realism), that is, combining a respect for the "conventional" styles of representational perspective and the persistence of realism under such variations (the Egyptian, for instance, as well as the Renaissance).

It's quite possible that Gombrich inaccurately characterizes his own doctrine. Gibson somehow misled himself into thinking that the analysis of the perception of painting was basically ecological (attentive to the physiologically enabling machinery of perception or the retrieval of realist information embedded in two-dimensional representations) rather than phenomenological in the sense addressed to perceiving pictures. You must bear in mind that pictorial representation may be realist (in various conventional ways), fictional, *and* even imaginative (in a sense that is neither realist nor fictional in any clearly defined way—against Kendall Walton, for instance). How then could Gibson possibly have succeeded? (Imagine construing all pictorial representation as variants of something like an iconic map! Think of Giotto.)

Gombrich should not have sided with Gibson any more than he should have yielded to Goodman. But he seems to have done both. In fact, Gibson's remarks suggest very clearly that what *we* regard as a two-dimensional representation of three-dimensional space is better (that is, may be "reductively") construed (as he sees matters) as a "treated" surface (a surface perceptually accessible in phenomenal or empiricist terms) in which information regarding ecological space is somehow straightforwardly embedded. Gibson admits in effect what is phenomenologically given in a painting, but he speaks of it in strictly empiricist terms. (That is Gibson's peculiar mistake.) If Gombrich really meant to endorse such a view, he cannot have understood Gibson's argument at all—or indeed, the import of his own account. The matter becomes even more baffling when we learn that Richard Wollheim is caught in a similar conceptual bramble regarding the phenomenology of pictorial perception, in his analysis of "twofoldness."

All this touches as well on the master thesis of Panofsky's famous essay. Perspective in the modern sense—associated, say, with Brunelleschi and

Dürer (influenced by Piero della Francesca)—"translat[es] psychophysiological space into mathematical space; in other words, an objectification of the subjective."[31]

The phrasing goes a bit awry—perhaps it's too compressed—but Panofsky is speaking *of* a confusion regarding a thoroughly *artifactual* "objectification" of the "subjective" (or visual) in terms of sensory (or phenomenological) experience; he does *not* mean the *replacement*—in the pictorial representation—of the visually experienced *by* the "true [mathematized] objectivity" of natural space itself, whatever that may be thought to be. Panofsky means that even a mathematical objectification must be made to serve the needs of "subjective" or phenomenological perception (artificial perspective, for instance) in regard to the perception of paintings. It must yield along the lines of Alberti's sensible advice:

Perspective creates distance between human beings and things ["the first in the eye that sees, the second in the object seen, the third in the distance between them," says Dürer after Piero della Francesca]; but then in turn it abolishes this distance by, in a sense, drawing this world of things, an autonomous world confronting the individual, into the eye. . . . Thus the history of perspective may be understood with equal justice as a triumph of the distancing and objectifying sense of the real, and as a triumph of the distance-denying human struggle for control. It is as much a consolidation of the external world, as an extension of the domain of the self.[32]

Once again, Panofsky favors a rather oblique, even confusing way of speaking. Nevertheless, it's quite clear that he means to explain what the skilled artist draws on in the phenomenological or "subjective" capacities of his percipient audience, with special attention to the distinctive unifying power of the very idea of perspective (that is, of an active point of view). All of this makes particularly good sense if you agree (for instance, in accord with the philosophical achievement spanning Kant and Hegel) that reality (that is, our picture or conception of reality) answering to our *Erscheinungen* is itself a construction relative to which what passes for realism is deemed to be true![33]

· · ·

If you accept the gathering argument, you surely see why the analysis of the perception of paintings cannot be separated from the analysis of their very curious nature. This is *not* to say that all paintings are representations or representations of things found in nature (or posited by fictive

extension beyond nature). But paintings are artifacts possessing intentional structures—"Intentional" structures (as I prefer to say, writing the term with a capital *I*), meaning that their significative, semiotic, symbolic, expressive, and representational properties are culturally formed and culturally legible and not in any usual sense merely psychological or mentalistic; or more pointedly, only externally related to what we see. Although, of course, whatever is culturally determinate must correspond (must be "adequated") to what *is* distinctive in the emergence of selves, adequated to their culturally formed powers and the cultural world they inhabit and claim to know.[34] In effect, then, I introduce the "Intentional" as a term of art: in a sense, let us say, more Hegelian than Husserlian or Brentanoesque; for neither Husserl nor Brentano features the culturally informed sense of reportable (culturally penetrable) perception that the analysis of paintings requires. The reason for distancing Husserl is very much the same (though it may not seem so) as for distancing Goodman and Gibson and for reminding Gombrich of what he's actually on to.

The fault of all these theorists is essentially the same: namely, their decision (in pertinent settings) to separate "perception" proper from belief and other intentional ("mental") states in the analysis of what we see in paintings—which is to ignore the indissolubly holist nature of the phenomenological reporting of the details of pictorial or Intentional space. Thus, for instance, Dominic Lopes, in an account that yields somewhat in Gibson's direction, centered on "understanding pictures," explicitly says:

[H]aving a visual experience with a content as of [a given] length obviously does not depend on having a concept of any such technical property [being measurable in so many feet, for instance]. The content is non-conceptual. Similar points can be made about other properties represented in experience. For example, the capacity to see a full, continuous spectrum of colors is one which does not require the concepts of every color seen or of wavelengths of light.

Humans are able to discriminate and respond differentially to properties of their environment for which they need not have concepts. The non-conceptuality of the contents of experience is a consequence of the fact that experience depends on perceptual capacities whose operation is independent of our beliefs and whose structure is displayed not through patterns of belief but through differential responses.

The content of a picture's design properties is [also] obviously non-conceptual. Neither artist nor viewer need have concepts of every or any design property in order to experience a picture's design.

It's for this reason, *not* for phenomenological reasons, that Lopes concludes (elsewhere) that "it is a mistake to use visual field similarity to explain depiction, Albertian or otherwise."[35] I see the attraction (and the use) of admitting nonconceptual phenomenal sensing (or perceiving): it's ultimately a Kantian theme. But the issue at stake is *not* whether to admit such processes at all but to decide what a painting is and what, regarding paintings, may be reportably perceived in whatever sense whatever belongs to a painting as such *is* reportably perceived or perceivable. What Lopes *says* entails that Giotto's *perspectiva artificialis is never reportably perceived*! ("It is a mistake," he says, "to use visual field similarity to explain depiction, Albertian or otherwise.") He's confused the nonconceptual "sensory" and the culturally "penetrated" perception of both art and nature.

Lopes's general account of perception seems to hold that we probably have "internalized picturing as part of our visual *conception* of the world, and so we routinely *perceive* the world as if it were pictured. If so, then [in explaining an 'Albertian' depiction of animals in a landscape, for instance, unfamiliar to 'unsophisticated African subjects'], it is not the visual field but our mastery of the Albertian canons of depiction which explains why we are willing [in the example given] to say that trees at variable distances are different in size or that a rectangular object has different shapes from different viewpoints."[36]

But this puts the cart before the conceptual horse. What Lopes calls the "visual field" is itself theoretically *dependent* in a strong sense; at best, it is an idealized abstraction (or "subtraction") projected *from* prior (phenomenologically reportable) perceptions, not itself likely to be as such a proper part *of* anything that might be phenomenologically "given." Phenomenology in the Hegelian sense is effectively presuppositionless: culturally conditioned and contingent, revisable, not privileged in any way, spontaneously reported "in the middle of things."

Lopes theorizes that what is perceptually "basic" is "non-conceptual" qua given; but that is precisely what we are never able to *report* as encultured percipients. He's confounded the order of reportable perceptual experience and its conjectured explanatory ground.

In fact, if you read his account with care, you may well be led to suppose that Lopes confuses two very different senses of the "nonconceptual" content of perception: on one usage, he clearly means that (as in Hume's famous case of an unnamed shade of blue) our perception has a nonconceptual content in that we have no name for what we discern (though of

course, we could name it); but on a second usage, he clearly means that there is, must be, a residual phenomenal content that is inherently non-conceptual, even if we could name it. But first, it is not at all clear that the concept of a "concept" is essentially, or best construed, linguistically (though conceptual distinctions are normally linguistically reported); second, one could easily coopt Hume's distinction to support the idea that a concept need not always (or primarily or essentially) be linguistic; and third, "concept," like "fact," "proposition," "meaning," and the like, is a distinction of art that cannot be counted on to disallow "concepts" in animals that lack language or the assured identification of nonconceptual content in human perception, which depends paradigmatically on our reporting abilities. The nonconceptual sensory is never more than a reasonably abstracted artifact of conceptually informed phenomenological perception.

I cannot see much reason to trust the use of any such distinction very far: it always seems to be advanced in order to favor some sense of basic or privileged perception that can be coopted for argumentative advantages not otherwise earned. There is evidence, for instance, that elephants, dolphins, and chimpanzees are capable of visual self-reference (in a mirror). Is that "concept-less" sensing, or does it entail "nonlinguistic concepts"? Why would anyone discount the robust reporting of phenomenological perception (regarding paintings) on the basis of such an extremely attenuated conjecture like that of nonconceptual sensory perception—even if we admit the selective pertinence of conceding such perception?[37]

The peculiarity of artworks then lies in this: in spite of their lacking psychological standing, their Intentional properties remain phenomenologically real—that is, objectively reportable in a way that is spontaneously fluent in the perceptual sense and not contrived. This is precisely what the splendid history of perspective makes so clear, what, for instance, Panofsky's account of the "ambivalent method" of perspective confirms.[38] For there is no way to admit the existence of art except as inhabiting a distinctive sector of reality created in some sui generis way by human hands and human minds—emergently, Intentionally—by an extension of the very powers by which every human society first transforms its own offspring (its members, as the transformed members of *Homo sapiens*, so to say) into a second generation of linguistically and culturally apt selves: a remarkably dense world easily as close to us as anything that is merely physical. My formula for capturing all this is to say that art, like speech, is *uttered* by apt selves,

who are themselves not dissimilarly uttered (more or less as a by-product of the fluent activities of an ongoing society). The two sorts of artifacts are, therefore, "made for one another."

The reason for caution here is that a crucial conceptual difficulty may be too easily overlooked. (Let me venture an explanatory aside and then return to the primary issues.) Quite recently a popular aesthetician, Jerrold Levinson, examining the nature of visual art somewhat along the lines of Richard Wollheim's well-known conception of paintings as physical objects, neglects to explain just how, precisely, *he* means to account for expressiveness or representationality (or other Intentional structures—those, say, implicating *perspectiva artificialis* or genre or stylistic considerations) in terms of the actual *nature* of a painting, its ontological standing so to say. Levinson's treatment is of interest primarily because it is so up-to-date, so obviously informed by a thorough familiarity with the best-known views in current analytic philosophies of art. Nevertheless, his account is noticeably defective at the point of maximal interest. It is in fact impossible to say (on the textual evidence) exactly what Levinson's theory finally comes to. It seems to lack the precise ingredients required in speaking of the perception *of paintings*! Levinson says:

Particular physical artworks, such as paintings, typically have subtle aesthetic properties that natural physical objects (e.g., rocks or trees) and nonartwork artifacts (e.g., chairs or pencils) do not, and that is due to both their generally more specific essential patterning and their complicated intentional-historical governing, which brings them into an appreciatively relevant relation to the history of art and art-making. But an intentioned-and-specifically-configured physical object is still, in the important sense, a physical object: it is composed of matter, is at one place at one time, and is subject to a familiar range of causal interactions with other physical objects.[39]

This is an exceedingly contorted formulation, but it helps to orient us quickly to the principal questions. Notice that Levinson speaks of "an intention*ed*-and-specifically-configur*ed* physical object"; he does not speak of a physical object actually *possessing* or manifesting "intention*al*" (or as I prefer, "Intentional") properties; paintings, he says, are "configured"— formed, shaped, contrived in the usual craft ways—but it is not clear that *their* being configured results in *their* actually possessing, *as* artworks, say, *any perceivable* "stylistic," "genre," or expressively qualified perspectival structures (that is, Intentional structures). Rocks and trees, just as chairs and pencils, pertinently lack Intentional properties (unless of course one

means to speak, as Levinson does not, of a certain Esherick chair—the one, say, in the Philadelphia Museum of Art!—which indeed *may be* viewed in terms of *perspectiva artificialis*); certainly, ordinary chairs *lack* perspectival properties as an intrinsic Intentional feature of *their* own phenomenologically accessible structure. You must bear in mind the familiar idea that physical objects cannot really possess in any literal or intrinsic sense Intentional properties. (Esherick's chair is a diabolically clever object.) This is the ultimate, the insurmountable *pons* of theories like those of Wollheim and Levinson. At a first pass, it seems to clear the air for a theory of perception that never exceeds what might be close to a phenomenalist account of the perception of mere physical objects—but it does not.

On Levinson's thesis then, a painter "configures" a painted surface (that is, applies paint to a canvas) in an "intentioned" (an Intentionally freighted, as I prefer to say) way, for expressive or representational purposes; but because his "work"—what he produces—remains a physical object, the painting itself still *lacks* the attributes we are expected to appreciate. Hence, on the argument offered, it is possible (if it is possible at all) to regard such "properties" as "objective" only if they may be ascribed (or imputed) *by way of* projecting their "intended import" onto the appropriate "configured" physical object—as by consulting the artist's craft intentions and allied inner mental states (and other such adjustments). Extraordinary contortion: altogether unnecessary, never convincingly adequate, and very possibly incoherent. It is plainly belied by the sheer fluency with which unfamiliar paintings can be correctly described. (Imagine walking into an unfamiliar art museum and finding your way among its collections at once.) You cannot fail to see, of course, that Levinson's "intentionalism" *requires* that a painting be a physical object: hence, that its perceivable properties be (essentially) non-Intentional and its Intentional import assigned to whatever our adopting Levinson's intentionalism is thought to make possible. I regard the maneuver as a knockdown *reductio*.

The "intention*ed*" properties of paintings are only "relationally" assigned, it seems, *to physical things*, as a result of what Levinson curiously labels "their complicated intentional-historical *governing*," which signifies either *causal* effects produced *in physical things* or intentional (Intentional) attributions *projected* (nonperceptually) or *imputed* from the artist's mental life and craft activity (or perhaps from art-critical discourse alone). The attributions are apparently justifiably cast in perceptual terms (interpretively) as a result of a *physical object's* having been pertinently "involved" in

a certain kind of "external" causal craftsmanship and external "mentalistic" art history. (You cannot fail to see how much this borrows from Arthur Danto's theory.) Hence, the Intentional masquerades as directly perceptual; but it's really meant to "reduce" as far as possible the cultural world to the psychological and behavioral aspects of artists' and audiences' lives (including, selectively, their linguistic practices).

What is completely missing in Levinson's account is any mention of the actual perception *of* the properties that are *in* the painting (and on that score, benignly imputed to it). There's no acknowledgment of the phenomenology of our perception *of the painting itself.* The reason has to be that, in fact, there really *is* no painting (that is, nothing other than the painted physical object), no distinct object that *can* be perceptually examined in the relevant way paintings are said to be perceived.

The altered *physical* object never *has* any Intentional structures of its own that we could see—unless we conceded that "phenomenological perception" *is* itself no more than a "relationally" justified (aesthetic or art-historical) interpretation (or paraphrase) of the reported perception of a physical object somehow confined to what has realist standing in the very perception of mere physical things. The pertinent properties, then, are only imputed to a "painting" in the same sense in which, in principle, such properties could never be first discovered (perceptually) *in* a mere physical object. For of course, if they could be so discovered, Levinson's theory would be completely pointless. (It would be either redundant or arbitrarily impoverished beyond recovery—or indeed, incoherent or simply false.)

There is no sign in Levinson's account that he could actually examine Van Eyck's *Arnolfini* and *find in it* the Flemish treatment of perspective Panofsky finds. On his own account, it looks as if he could only look at the canvas and paint and, because he *remembers* something of Van Eyck's personal history (what he calls "intentional-historical governing"), *could validate imputing to the physical object Van Eyck's perspectival intentions regarding it*! Of course, Levinson would never deny that we can directly read and hear one another's words, but he is unwilling to say (in the relevant sense) that we can also look at one another's paintings and see *them*! How can that be made out? (Think of photographs and films.)

Some may not recognize in these maneuvers a definite adherence to what, following Donald Davidson's lead, is now often called "naturalizing," that is, adherence to a philosophical policy regarding the scope of realism: the discursive policy that results from restricting the primary use of the term

to no more than the physical, extensional, nonintentional characterizations of things, explained (under adequate conditions) entirely in causal terms modeled on what is normally offered in the physical sciences.[40] Roughly, to speak in this way is to prefer the idiom (and deliberate limitations) of a lean form of the unity of science program. Something similarly spare plainly attracts Monroe Beardsley, Arthur Danto, Nelson Goodman, and Richard Wollheim. If Levinson's idiom could be shown to be inadequate to our investigative needs (regarding paintings), then so, too, would the idioms of those just mentioned. That would be a very large windfall.

In any case, Levinson adds that "a painting or sculpture is not a brute object, on the order of a hunk, mass, or conglomeration, but rather a specifically articulated one; if, for example, a painting is a piece of canvas and an amount of paint, it is only that canvas and that paint *conditioned and configured* in a specific way, and preserving a certain appearance, and not those things *simpliciter*, in any state or arrangement."[41] He means that paintings are interesting hunks; but they *are*, finally, hunks, and they have only physical properties! (Would he characterize persons conformably?)

He means his language (applied to artworks) to harbor no Intentional qualifications intrinsically. That is the point, in fact, of the busy machinery of Levinson's notion of "hypothetical intentionalism," which is hardly an improvement on "actual intentionalism"; it's a dismissal of the latter along the reductive lines just sketched. Hence, also, the idea of combining "actual" and "hypothetical" intentionalism (which some have been drawn to) is a confusion of opposed philosophical motives. (The issue will occupy us again in Chapters 3 and 4.)

For the moment, consider only that Levinson qualifies his account this way: "if, for example, a painting is a piece of canvas and an amount of paint, it is only that canvas and that paint *conditioned and configured* in a specific way, and preserving a certain appearance, and not those things *simpliciter*." If the "conditioning" and "configuring" were described in Intentionally freighted ways *so that* the resultant "appearance" was also directly perceived in an Intentionally pertinent way, then Levinson's argument would be no more than a *façon de parler*; and if the two parts of the description failed to match, Levinson's argument would be entirely superfluous and irrelevant. *Tertium non datur.*

I return to the earlier argument. As soon as you consider a connoisseur's appreciation of the very different spirit of perspective in Italian and Flemish painting shortly after Brunelleschi's discoveries, you see how im-

possible it is *not* to attribute directly to *them* "intentioned-and-specifically-configured" properties that are already Intentional in the fullest *perceptual* sense. Surely we can supplement, correct, even check our memory (or research) about the artist's expressed intentions by examining the *Arnolfini* itself. Here, for instance, is Panofsky's comparison of the *Arnolfini* portrait and the *Death of St. Ambrose* (mentioned earlier), the first by a Flemish painter, the second by an Italian—to which is added a brief comparison of Van Eyck and Piero della Francesca. (You must bear in mind what has already been said about the dual uses of the new perspective.) "What matters," Panofsky says,

is that the Italian master conceives of light as a quantitative and isolating rather than a qualitative and connective principle, and that he places us before rather than within the picture space. . . . [W]here the death chamber of St. Ambrose is a complete and closed unit, entirely contained within the limits of the frame and not communicating with the outside world, the nuptial chamber of the Arnolfini is, in spite of its cozy narrowness, a slice of infinity.

Continuing, he says:

Millard Meiss has recently pointed out the close connection that exists between Jan van Eyck's *Madonna van der Paele* of 1436 and Piero della Francesca's Brera altarpiece produced for Frederico of Urbino in the early seventies. . . . Yet no two pictures so closely related in iconography and composition could be more different in spirit. Piero's soaring basilica with its unbroken, windowless surfaces is majestic and well-contained, where Jan's small, low, circular church, seen as a "close-up" and communicating with the out-doors by a fenestrated ambulatory, is, like the Arnolfini portrait, both intimate and suggestive of infinity.[42]

I put it to you that this kind of comment could hardly have been made without invoking an art-historically informed *perceptual* experience of the paintings themselves. Assuming that much, *some* sufficiently ramified Intentional idiom applied directly to the perception of paintings can hardly be avoided. There is no conceivable argument for admitting the encultured "second nature" of human selves and denying (at the same time) the propriety of applying *their* own perceptual distinctions *to what selves (themselves) "utter" and create and perceive or understand* in the way of words and pictures. In fact, *if* the naturalizing idiom had any use at all, it would of course provide reductive paraphrases of phenomenological analyses like Panofsky's. But it can't, as far as anyone can see. Furthermore, whether or

not its reductive intent could ever be sustained, the fact remains that none of the philosophers we've been considering has ever made a plausible case for it—nor indeed has anyone else. It may be no more than a pious wish.

You must realize that the argument depends on joining philosophical analysis and the philosophical achievements registered in the history of philosophy. The preference of a phenomenological approach (à la Hegel) is the result of admitting the paradoxes of pre-Kantian philosophy that the constructivism Kant and Hegel share (minimally: the indissoluble holism of the subjective and the objective in the analysis of cognition and cognized reality) helps us to escape and thereby undermines (at least conditionally) any reductive account of *perception* (for instance, Lopes's) that pretends, without pertinent argument, to restore some sort of pre-Kantian privilege in our post-Kantian, post-Hegelian world.

No one has ever shown that there are linguistic or explanatory resources in the "naturalizing" mode that could convincingly compare with the rigor and subtlety and fluency of the Intentional (art-historical) idiom. But if that is so, then it is completely unconvincing to suppose that the objectivity of the latter could ever be bested by an idiom that *offered no independent way to examine the actual properties of actual paintings*. What possible bearing could a merely general review of the cultural aptitudes of human selves provide that could never validate any objective, fine-grained analysis *of particular paintings*—say, of Panofsky's gauge? It seems a hopeless claim, if it is not merely a dependent simulation of what it refuses to acknowledge. For of course, it's very hard to see how the original "imputation" of "intentioned" force *could* be rightly ascribed to selected physical objects "objectively" *if* the study of artists' intentions (or their cultural adjustment, under whatever considerations may be put forward) was not itself already dependent on the coordinate examination of the *public* manifestations (the actual paintings viewed as analogues of public speech) artists are said to "utter" in the craft way!

I see no way to escape the correction: to deny its pertinence is tantamount to adopting an impossible solipsism. To feature an artist's intentions when addressing *physical objects* is either off the mark regarding whatever may be discerned as the Intentional structures of the paintings before us or dualistic; normal intentionalism addresses *paintings* (or other artworks) directly in Intentional terms. A "behavioral" treatment of the artist's craft leads directly to admitting (the presupposition of) pictorial perception. There's a very large difficulty there.

So the strategy confuses or conflates two very different notions of the intentional (or Intentional): one addresses the classic problem of Cartesian dualism—the difference between the mental and the physical; the other addresses what is culturally emergent and distinctive of human selves—the difference between the phenomenological features of encultured perception and a physiologically reductive (or at best, an empiricist, or perhaps a pre-encultured) account of perception itself. There is no sense at all in which, say, what Panofsky attributes to the *Arnolfini* or the *St. Ambrose* is *psychological* (subjective or mentalistic) in any interesting regard—any more than it would be to say that the perceived smoothness of a stone was a psychological projection of some inner mental "idea." (Imagine!)

It's surprising to learn how widespread a habit it is to avoid addressing the work of art *as an actual object*. The obvious reason is that it is genuinely difficult to say what it *is* and what its conditions of identity and individuating boundaries are. That must be admitted. Of course, it leads us into heterodoxy—which many will wish to resist. But if so, then whatever we affirm about the discipline of *perceiving* a painting will be hostage to these same uncertainties. You realize that to admit the working *craft* of painters is to "Intentionalize" their crafted materials, as well as admit *their* (*and our*) phenomenological perception of what they actually produce at every stage of their work. Artists *see* the significative feature emerge as they work!

You cannot play the reductionist or dualist game even to this extent if you don't intend to play by the rules your own examples implicate.[43] You cannot treat craft and artwork disjunctively if you treat the craft of producing paintings as the encultured "uttering" of such paintings: you would lose the realist standing of such objects, *and* you would find it impossible to match, referentially, physical marks or attributes and encultured utterances—whether deeds or public objects. Notice that in understanding speech, we often don't really know what physical sounds have actually been produced in uttering what we and others say! When we see Rembrandt's eye in a late self-portrait, we usually don't discern (or discern first or at the same time) the clever mixture of colors by which the eye is detected: in the second, we recover the connection easily enough; in the first, we often cannot. (Bear in mind that the Intentional is first defined in a public space culturally, not mentalistically, though it applies as well to the cultural formation of the inner life of second-natured selves. To deny this, or to reverse the order of analysis, is to court solipsism.)

You see how inexorably the argument proceeds. Once we treat paintings as deliberately contrived artifacts, we are bound to distinguish between *perspectiva artificialis* and *perspectiva naturalis* (and invoke similar distinctions in the history of painting): there will always be an Intentional purpose in pictorial representation that, for one thing, changes with the changing interests of one historical society or another and, for a second, can never (except like the broken clock that tells time correctly twice a day) converge with "natural perspective" (Brunelleschi's trick). But if so, then it is more than reasonable to treat the Intentional features of pictorial perspective in terms of the objective perception of paintings themselves. That, of course, requires a theory of *paintings* (an ontology if you please) that distinguishes between natural (or merely physical) and cultural things. All this makes a tidy basket, but it goes against the current philosophical fashion.

. . .

I turn here abruptly to a topic I've kept more of less in the wings. I've touched on it thus far only in a passing way, but it must be brought to center stage. It may be the linchpin of the entire effort to reach an adequate theory of the perception of paintings. I'll leave it to your judgment, but I think it is decisive—it's certainly largely neglected though not actually ignored. It presumes to bring the metaphysics and epistemology of painting together in the analysis of what distinguishes the cultural world. Its resolution helps us to see the true force of Hegel's and Wittgenstein's distinctive contributions to the theory of culture—a fortiori, to the theory of painting. At the same time, it confronts and challenges a somewhat unemphasized feature of Arthur Danto's well-known account of perceiving paintings. Danto lays down a marker against Wittgenstein's theory so that Wittgenstein and (at least by implication) Hegel appear as irreconcilable opponents of his theory of perception. He confirms by this that to allow Wittgenstein's claim to stand would effectively be to defeat his own thesis.

The confrontation comes to this: broadly speaking, both Hegel and Wittgenstein favor a phenomenological account that features the cultural "penetration" of perception, the indissoluble unity of thinking and perceiving at the level at which we normally report what we take to be perceptually "given"; whereas Danto explicitly rejects the very idea of any such penetration at any genuine level of perceptual reporting. There seems to be no room for compromise between the two positions: the contest is absolutely disjunctive.

Now the point of Danto's frontal challenge to Wittgenstein is perfectly clear. Danto must hold his ground if the thesis of the "Artworld" paper is to survive: for example, his indiscernibility thesis would make no sense if the rejection of the penetration doctrine were defeated; he would then be forced to subordinate his phenomenal account of indiscernibility to the ampler resources and lesser mercies of a phenomenological reading that would outflank the other in the blink of an eye. Whereas, if Wittgenstein's advocacy of the penetration thesis were sustained (which, effectively though hardly intentionally, is itself an oblique reading of Hegel's notion of the *geistlich* applied to sensory perception), then the Intentional distinctions of the cultural world would have to count as public, therefore as directly perceivable, and then the realist contrast between physical nature and human culture would prove undeniable. Furthermore, if that were true, then all the theories of the perception of paintings I've been collecting—Wollheim's, Danto's, Walton's, Levinson's, Lopes's (and others I've touched on too briefly for my present purpose)—would be shown at once to be irretrievably mistaken, and the reconciliation between the physical and human sciences (under the banner of "philosophical anthropology") would be able to displace altogether the scientism of the views I've been considering.

I mean to air a very particular piece of analysis from Danto's hand that offers the single most explicit account (that I know of) of what Danto himself calls the "phenomenology of perception"—published in the early 1990s. We are in Danto's debt here, as will soon be clear. No other advocate of the views I've been assembling (some admittedly more marginal than others), no theorists like Monroe Beardsley, Nelson Goodman, George Dickie, Noël Carroll, Gregory Currie at the very least, have ventured (as far as I know) to state and defend a thesis opposing penetration as unflinchingly as Danto.

Danto begins his account by actually invoking Wittgenstein's objection to any principled disjunction between thought and language (or between perception and language) in the context of "enlanguaged" thought (or theory-laden perception), and then adopts a philosophical position explicitly opposed to Wittgenstein's. He opts then for the *necessity* of *separating* bare sensory perception from the verbal description (or theory-laden interpretation) of what is said to be perceived. He risks thereby—well, more than risks—a "dualism" between perception and language, despite his Hegelian proclivities. (You may find a similar thesis in Lopes.) Danto

cannot be a "Hegelian" if he is not a "phenomenologist" in the Hegelian way; he cannot be a Hegelian phenomenologist if he separates perception from linguistic penetration; and he cannot justify any talk of directly perceiving *paintings* if he disjoins perception and "description" (Danto's terms) in the way he does.

Danto's reading of Wittgenstein is quite perceptive—so perceptive in fact that (in my opinion) it does his own theory in. He interprets Wittgenstein as having broached a *philosophical* doctrine that he (Danto) finds, in an extreme form, in Schopenhauer and Nietzsche and contemporaneously in T. S. Kuhn and N. R. Hanson—and (of special interest to philosophers of art) in Nelson Goodman. (I think he's mistaken about Goodman: I've touched on this earlier.) "Wittgenstein did not draw [the] extreme consequence that, in an important respect, observers with different theories do not perceive the same thing."[44] (This, of course, separates Wittgenstein from figures like Kuhn and Hanson.) Danto then summarizes Wittgenstein's view this way:

Wittgenstein's chief thesis [in *Philosophical Investigations*] was that we cannot as easily separate perception and description as had been taken for granted by philosophers, including himself in his great metaphysical work, the *Tractatus Logico-Philosophicus*. . . . By the time he wrote the *Investigations*, Wittgenstein was of the view that we do not have, as it were, the world on the one side and language on the other, but rather that language in some way shapes reality, or at least our experience of the world.[45]

It is hard to see how if Danto realized why Wittgenstein would draw attention to the grounds on which he viewed the *Investigations* as rejecting the central thesis of the *Tractatus*—that is, to avoid its intolerable paradox—he (Danto) could fail to see that the same consideration would render his own rejection of the penetration thesis vulnerable as well. He would see the sense in which Wittgenstein (as a constructivist of a vaguely Kantian or Hegelian sort) would be bound to make the adjustment he embraces, and he would recognize the obligation on himself, apart from his Hegelian pretensions, to explain his own reasons for rejecting Wittgenstein's solution. The fact is, he fails to follow through. If he had thought of matters this way, he would have realized that he could not rely on a mere obiter dictum to clinch his argument regarding what, in the same paper, he terms "artistic perception." Nevertheless, we may ask ourselves: How would a "Wittgensteinian" counter Danto's counterclaim, knowing full well that Danto grasps the point of the original claim? There would be a stalemate

there that could not, rationally or responsibly, be allowed to occur! Danto would find himself in the same box Wittgenstein found himself in.

Danto seems to think there's room for a third option between admitting the penetration of perception by language or theory (with metaphysical, even relativistic, consequences—as in Kuhn's account, possibly also in Wittgenstein's in the *Investigations*)—and denying any such penetration. Perhaps Danto thinks that the pertinent forms of perception *are*, if penetrated at all, penetrated only "to a degree" so that some *parts* of reportable perception are actually *not* (cannot be) penetrated. Something of the sort does seem to be Danto's thesis all right; in fact, it's essential to the premise of Danto's theory of the (occasional) perceptual indiscernibility of different artworks, or of matched artwork and non-artwork (as in featuring Warhol's *Brillo Box*, Danto's own imagined series of painted red squares, Duchamp's readymades, appropriation art, and similar trickery). But there's no supporting argument offered in the paper before us: it's all obiter dictum, though it is at least explicit dictum. The upshot is that Danto's position *is* indeed a form of metaphysical dualism when seen in a Wittgensteinian light; though I'm bound to say it looks like an undefended dualism from any standard point of view: it mentions, but nowhere engages, the vexed matter of the encultured nature of human perception. It's a question that haunts the analysis of pictorial representation: it cannot go untested.

In any event, Danto sorts the opposing champions as "internalists" and "externalists":

The internalists want to say we see different things, the externalists that we see the same things but against the background of different sorts of beliefs, so that we may have different expectations, but the phenomenology of perception is otherwise neutral to the beliefs.[46]

Here, we begin to see that the question of "degree" is quite misleading: the externalists deny that, in the relevant cases, it's perception that's penetrated—they concede that only belief is penetrated; the internalists insist that perception's penetrated as well. (I take Danto to be an externalist—finally.) I don't see how the difference between the two positions can fail to be exclusionary, an issue very different from whether, *within* the internalists' space, the *perceptual* differences that result from penetration are likely to be phenomenologically diverse or not. The very difference between the internalists and the externalists cannot be put phenomenologically at all; or if it can, it cannot be rendered in Hegelian terms. It

would have to be "Cartesian" in some quasi-transcendental sense. It marks an important *pons* in analytic aesthetics. I should also add, to avoid confusion, that the terms "externalist" and "internalist" are sometimes used in the pertinent literature—in that part of the philosophy of mind, for instance, that considers sensory or perceptual experience as confined to the activity of the brain or not—in a way that reverses Danto's usage; so what I am calling "penetration" would usually be called "externalist," and what is confined neurophysiologically to the brain is called, correspondingly, "internalist" or "individualistic."[47]

Danto speaks of the "degree" to which theoretical beliefs or "physical knowledge" may penetrate perception when, for instance, a physicist looks at an X-ray tube.[48] He raises what he takes to be the same question in the context of offering a clever reading of Guercino's *Saint Luke Displaying a Painting of the Virgin*. He concedes (for the sake of the argument) a significant degree of penetration in both cases. In the first, it is certainly possible to construe what's going on as involving the penetration of belief, but not perception; whereas, as I see matters, it must be perception that's penetrated in the second example, not merely belief. The two cases are not at all the same: the difference rests with the fact that, in the first instance, perception is not really at stake in the explanatory context; whereas, in invoking a perceptual description that undoubtedly has an explanatory (or elucidative) function, appeal to the comparative power of the alternative phenomenal and phenomenological readings are themselves burdened by the need to provide an antecedent account of what we understand to be entailed in perceiving paintings. Danto fails us here. He says:

My sense is that the experience of art description really does penetrate perception, but that is because perception itself is given the structure of thought. What the painting says is really different from what the scene itself contains. . . . It therefore, as a painting, has [acquires, as a result of the analysis and description offered] a set of meanings its subject is incapable of expressing [but yields as a result of our "standing outside the painting" rather than being a witness "in the painting"]. Pictorial perception activates the same mechanisms that perception itself does. Artistic perception is of another order altogether. With artistic perception, we enter the domain of the Spirit, as Hegel said, and the visible is transformed into something of another order, as the Word is when made flesh.[49]

A pretty simile, but a baffling one. Can you tell the difference between "pictorial perception" and "artistic perception" or between either

and the phenomenology of trained perception among paintings? I confess I can't. Here Danto seems to be conflating constraints on the *physiology of sensory perception* ("the same mechanisms") with constraints on the *phenomenology of perceiving paintings* ("perception . . . given the structure of thought"). They're hardly the same. (I think it more than likely that Danto favors a nonconceptual run of phenomenal perception.) Remember this: if the perception of paintings were strictly constrained by the physiology of perception, we would never be justified in claiming to *see meaningful structures* of any kind! That discrepancy has not yet been explained. You see the fatal dilemma Danto has imposed on his own theory of perceiving artworks. It's part of his conceptual machinery for validating genuinely indiscernible artworks. But it needs a thorough airing, which Danto nowhere supplies. In any case, I acknowledge the possibility Danto supplies (the penetration of belief), but I cannot see that all, or even the preponderant part of, the instances that may be drawn from the history of painting would lend themselves perspicuously to Danto's option. The maneuver couldn't be more than a *petitio*. There must be stronger grounds for Danto's counterclaim, or it must surely fail. I say it fails.

On any reading, the constraints imposed by the first condition Danto advances (the X-ray case) are entirely theoretical, applied at some explanatory level that depends (inductively) *on* what we actually do perceive—since we cannot first report phenomenologically *whatever* we introduce as perceivable on the basis of any merely explanatory theory of how our sense organs function. By contrast, *on* the internalist's reading, the phenomenology of perceiving *anything* admits the penetration of perception by language, thought, theory, belief, knowledge, and the like, because what *we* report *we* perceive (without obvious privilege), we *perceive* as characteristically so qualified: that is precisely what we say is perceptually given, in Hegel's sense. The phenomenology of perceiving *paintings* cannot in principle be significantly different. Danto's disjunction between perception and description (or perception and thought, or perception and belief) cannot escape being profoundly equivocal.

Either way, what Danto says is not philosophically responsive—is in fact quite arbitrary. For one thing, he completely fails to address the internalist's challenge. Surely, the history of early modern philosophy culminating in the work of Kant and Hegel shows how much is made paradoxical if we fail to admit the penetration of sensory perception (by language and

thought) regarding anything we take to be perceptually objective or phenomenologically given.[50] For a second, the question of degree of penetration is, conceptually, internal to the internalist's doctrine; it cannot be a mere first-order induction applied to perceptual episodes. For a third, as already remarked, Danto's maneuver would, in principle, either eliminate the perception of paintings altogether or make a mystery of their being perceptually accessible or objectively describable at all.[51] Effectively, Danto is a pre-Kantian here as far as the theory of sensory perception is concerned.

Beyond that, we must bear in mind that the very paradigm of cultural life—the fluency of speech—would make no sense unless Intentional penetration were entirely ordinary: once we admit this much, the obvious analogies of visual perception—pictorial representation in particular—will seem much more than merely plausible. What could possibly serve as a valid basis for resisting the concession, if empiricism and phenomenalism proved incapable of providing (as they do) an autonomous, systematic, entirely adequate account of the full range of reportable perception? The least realism accorded the cultural world would be proof against it.

On Danto's theory, we cannot actually *see* a painting; we can only *think* of what it must be like! To be entirely candid, I cannot see how Danto could reconcile his opposition to the penetration thesis in any sense that accorded with Hegel's phenomenological emphasis: *no* merely non-Intentionally qualified perception of physical nature could fail to yield, on Hegel's terms, to the ampler resources of the penetration thesis; the argument for culturally freighted perception must be at least as compelling. Danto has made a debater's mistake here. You see, of course, that the concession wanted completely undermines the "Artworld" theory (and with it, the indiscernibility thesis). If the penetration thesis holds, the indiscernibility thesis would have no application except trivially. Whatever may penetrate the perception of artworks supports a phenomenologically pertinent difference between the physical and the Intentional, even if we also postulated a (further) phenomenal (non-Intentional) indiscernibility between any two artworks or between an artwork and a non-artwork: the "indiscernibility" would then be abstracted from *within* the discernible differences admitted—which would render the latter entirely benign. Again, it is always in principle possible that two denumerably different things be admitted to be indistinguishable in *some* restricted predicative space, no matter what intrinsic properties were admitted: two blades of grass, two copies of the same book; but then, indiscernibility would pose no con-

ceptual difficulties for any serious theory of art. I see no other possibilities worth considering.

You may also see here something of the oblique importance of Wittgenstein's argumentative "practice" for the philosophy of art. Our "Hegelian" Danto has adopted a pre-Kantian view of perceptual realism, and Wittgenstein's long reach has found him out. Cognate difficulties are easily located in the views of Richard Wollheim and Kendall Walton.

The general trouble with Danto's line of reasoning is this: he treats the choice between the internalist and externalist options as if they concerned nothing but a first-order inductive choice between theories of perception that are physiologically or non-Intentionally characterized (a range of "empiricist" options, let us say). But there is obviously more than an induction at stake, and the options are the wrong ones to consider. It makes no sense to think that the internalist thesis (Wittgenstein's) could possibly be a matter of *degree*.

Garry Hagberg, a perceptive commentator on Wittgenstein as well as on Danto, appositely remarks that Danto's thesis, applied to action, "underwrite[s] Danto's aesthetic methodology of juxtaposed indiscernibles and preserve[s] (as well as conceal[s]) those elements of the old [dualistic] ways of thinking that Wittgenstein opposed in his work."[52] Precisely. Internalism and externalism are second-order philosophical options, where, effectively, externalism counts as a turn toward Cartesian metaphysics—on Danto's usage. (So Wittgenstein *is* "doing" metaphysics after all. His argument depends on it.)

If we read Danto literally, the admission of the question of degree of penetration (by theory or language) amounts to a confusion between a specific induction advanced *within the internalist stand* and internalism itself. Internalism *is* (what I would call) a constructive (or constructivist) realism; hence, no difficulty need arise in admitting that the penetration that obtains in perception and science is probably *not* "total." But that's not a neutral induction; it's an inference made possible *within* the philosophical posit that holds that perceptual objectivity is itself a conceptual construction. (All that's needed is a distinction between *noumena* and objectively independent things.) I take this, in fact, to force a *reductio* of Danto's entire position: certainly it signifies that his theory cannot be reconciled with Hegel's on phenomenological grounds.

The least comparison between Danto's and Wittgenstein's treatments of the "penetration" question inescapably betrays the contrived nature of

Danto's opposition to Wittgenstein's line of reasoning: to *his* (Wittgenstein's) philosophical intuition—let us say, his contribution to the philosophy of art. We might never have guessed it unless someone (Danto in this instance) actually chose to confront Wittgenstein's "metaphysics" directly. But if the argument counts against Danto, it counts against Wollheim as well.

· · ·

Let me add a final reference and reflection on that reference. Richard Wollheim opens his Mellon Lectures (1984) with the following challenge:

What . . . is the special feature of the visual arts, something which must be over and above the general way in which all the arts are connected with a tradition, and which has, allegedly, the consequence that if we are to understand painting, or sculpture, or graphic art, we must reach an historical understanding of them? I do not know, and, given the small progress that art-history has made in explaining the visual arts, I am inclined to think that the belief that there is such a feature is itself something that needs historical explanation: it is an historical accident.[53]

Perhaps; but Wollheim does not venture any supporting arguments in his lectures, and the history of connoisseurship hardly bears him out.

The easy reply, which Wollheim must surely have anticipated, is this: it's the same "tradition," the same matter of fact of being "connected with a tradition" (Wollheim's phrase)—in effect, Kendall Walton's thought as well, for a related purpose—that matches and explains the intrinsically Intentional properties of artworks and the perceptual and reflective aptitudes of an informed audience engaged in discerning whatever may be objectively seen in paintings. The perception of paintings is as artifactual as the Intentional properties we discern in them: to be sure, in mastering the one, we are trained to discern the other! There seems to be no point or advantage in opposing this concession, unless, tendentiously, for the sake of promoting a favorable approach to some form of reductionism—which is not in the least uncharacteristic of Wollheim's analysis of style and pictorial representation. In fact, the "concession" I am endorsing has never been so subtly and persistently disputed as it is in our own time.

Wollheim's abrupt dismissal of historically qualified (historicized) properties (perceptual properties, mind you) that we might claim to discern in paintings—as opposed to admitting the changing history of pictorial style without conceding that perception may itself change under evolving pictorial practices—fits very neatly with Wollheim's general ten-

dency to dampen every attraction to strong and explicit Intentional properties or, per contra, to encourage the "reduction" or replacement of such characterizations by non-Intentional formulas. The issue cannot even arise in the context of empiricism (since intentional or Intentional properties are phenomenally disallowed in Danto's account); but the option is both reasonable and manageable if cast in phenomenological terms.

You may tease out Wollheim's philosophical motivation in his otherwise puzzling remarks about style—in particular, his distinction between "general style" and "individual style." He seems to take a forthright stand, but his distinctions are sometimes less fortunate than he might wish. Here are some telltale pronouncements:

In the first place, the characteristics associated with individual styles [the styles of individual artists] do not alter.[54]

The style itself is distinct from the characteristics associated with it, and it is it that causes them to be as they are. Individual style is in the artist who has it, and though, in the present state of knowledge, it must be a matter of speculation precisely how it is stored in the mind style has psychological reality. These two distinctive marks of individual style are linked. It is just because the characteristics associated with individual style are characteristically caused by something that is different from them and is in the artist that it is not up to us to decide what they are, settling now for this set or that set.[55]

Wollheim resists the attractive analogy between "pictorial style" and "language"; he offers in its place a more instructive analogy between "having a style" and "knowing a language"; the latter, he says, emphasizes "competences."[56] But the maneuver actually draws him away from a close analysis of pictorial *perception* itself and favors (problematically) a causal rather than a phenomenological account. (Causal theories of perception are never perspicuous in descriptive ways, except dependently.)

Effectively, this means that where, as with style, Intentionally explicit attributes are indicated, Wollheim drives hard to show that they are rightly ascribed to the artist's "psychological" gifts rather than to what (independently) belong to actual (perceived) paintings: there's the point of his strong contrast between what's in the mind (style) and what's in the painting (the "effects" of exercising a personal style). The idea is never fully worked out: it insinuates its adequacy; and it is easily seen to lead in the same general direction—being a kind of benign reductionism promoted by way of a dualistic idiom—that one also finds in the very different accounts advanced

by Goodman, Danto, Walton, Levinson, and others who resist admitting historicized and Intentional properties.

The trouble with Wollheim's argument is that if the "competence" he has in mind is akin to the dormative powers of opium (according to Molière's joke), then it doesn't affect our analysis of perceptual qualities at all; and if it is meant to be a substantive claim, then it may actually help to account *for* the discernibility of the Intentionally qualified properties we normally report we "see." It could only begin to claim its reductive prize if it denied that there *were* any Intentional properties "outside the mind" (which, I would say, is precisely what Danto champions in the "Artworld" paper and *The Transfiguration of the Commonplace*).

The closest Wollheim comes to Danto's formula is this: "Individual style has not only psychological reality, it has psycho-motor reality."[57] Fine. But thus far at least, reductionism is surely a non sequitur; *and* on independent grounds, all efforts to confine the intentional (or the Intentional) to the "private" work of the mind is incoherent on its face. As Wittgenstein shows, the psychological requires a form of external expression accessible to public analysis: paintings serve us in that capacity. Yet Wollheim nowhere provides an account of the public standing of style in the perception of paintings.

The thrust of the argument against Wollheim is, of course, of considerable strategic interest: if you agree that when rightly instructed, we do see the Intentional properties of paintings, then you will also agree that an empiricist or "phenomenalist" account of perceiving must be subsumed under, abstracted from, never conceded to be independent of, a culturally informed "phenomenological" account; and if you subscribe to a philosophical theory of perception close to Hegel's critique of Kant's first *Critique* (along the lines of the *Phenomenology*)—which I would say is very close to the "true" beginnings of the strongest forms of "modern" modern philosophy—then you will readily acknowledge that the argument holds in an even more commanding form: one that requires us to admit that the perception of the physical world is itself inseparable from the encultured perception of the world of historical events and deeds. For what we identify as physical objects are characterized *as* independent things only by way of certain theorizing "constructions" that incorporate and endlessly reinterpret the *Erscheinungen* with which we suppose we begin to understand the world we claim to see.

Very probably the fault rests with Wollheim's notion of history. It's difficult to understand how Wollheim could admit that "the arts are

connected with a tradition" and then pretend that the evolving forms of creativity do not affect or alter the very structure of thought and perception—in particular, changes in thinking that appear to penetrate the details of pictorial perception. Think, for instance, of the change in perceptual sensibility that evolved from Pissarro to Cézanne to Braque's and Picasso's cubism, which surely implicates a deeper sense of history than Wollheim could possibly challenge. In any event, we have only Wollheim's say-so to rely on in resisting the seeming solution. Wollheim regularly draws back from perceptual distinctions even where he seems to be addressing them. The formula, in both Danto and Wollheim—seemingly clever at first but self-defeating and ultimately incoherent—is to withdraw from the perception of the Intentional (or intentional) in paintings and replace perception by Intentional description or imputation applied to what is phenomenally perceived, derived entirely from the inner mental life (the "thought") of artists (or audiences), which, of course, cannot escape the solipsistic premise.

There is no way to explain the perception *of* a painting without bothering to explain what kind of "thing" a painting is; and there is no way to explain *that* without bothering to explain whether and why paintings *and* the perception of them are (or are not) inherently subject to historical (or historicized) change (see Chapter 3 and Epilogue). That, I believe, is the dread question nearly all analytic philosophies of art wish to avoid, since it directly challenges the tendency to favor reductive accounts of the nature and perception of paintings. But it cannot be evaded. It is already captive in the argument about perspective and the phenomenology of perceptual experience. Think of seeing Giotto's Arena panels as depicting—well before the invention of Renaissance perspective—a phenomenologically tolerable perspective that on close inspection proves to be quite surprising, possibly even counterintuitive. The right answer seems to be, Yes: the perception of paintings (and more) *is* historicized and "penetrated" by our evolving theories and conceptions—but not in a way that is impossible to learn and not in a way that ignores the essential fact that encultured human agents "utter" the artworks they perceive.

Short of tackling the larger issue that looms here, we cannot fail to notice the tendency to avoid any full-blooded account that admits perception's hybrid nature at the human level—that is, that acknowledges the inseparability of the biological and the cultural aspects of sensorily grounded perception—and then moves on to consider the cultural penetration of

visual perception itself in diverse and historically evolving ways that bear directly on the analysis of paintings, their perception, our sense of realism and naturalism, and our perception of representations as such (see Chapter 3). Wollheim, who pursues the important question of what may reasonably be thought to be the perceptual conditions that yield a sense of naturalistic representation ranging over many different styles of painting, seems to shy away from pursuing any consideration that would weaken a broadly biological model or encourage us to examine the possible advantages of admitting diversely realized, historically "encultured" forms of perception.

Wollheim's elaboration of the phenomenon of "seeing-in" (which is explicitly associated with Leonardo da Vinci's well-known recommendation to search for visual images in surfaces of all kinds) and of "twofoldness" (which involves the familiar but incompletely explained duality and reciprocity of seeing the surface of a painting and "seeing-in"—*in* seeing the surface—what is representationally disclosed in it as a causal effect of seeing how the surface is physically configured) *never* risks offering examples that might call into question the adequacy of any merely biologized account of realism or naturalism (terms Wollheim views as "interchangeable" but not synonymous).

Let me now introduce a passage from Wollheim's own account of pictorial perception in order to ensure some closure in these sprawling reflections. There's a well-known thesis advanced very briefly in Wollheim's Mellon Lectures that captures the essential nerve of his entire theory of pictorial representation: it concerns what Wollheim calls "twofoldness," which he characterizes as involving "two aspects of a single experience." I agree with this formulation ("a single experience"); though I warn you that "a single experience" does not mean (or entail) "a single perception." Wollheim tends to muddle the two elements of twofoldness (*in* pictorial representation); he tries to draw (what we might otherwise treat as) the phenomenology of pictorial perception *from* phenomenal sources approaching the empiricist limit: that is, he does not concede as part of the admissible range of *perception* the perception of Intentional structures. As a consequence, he means quite literally that the "single experience" of twofoldness (which accounts for the perception of pictorial representation) is not, as such, "a single perception"—though it includes a perceptual ingredient! In this unguarded way, Wollheim supplies a paradigm of the conceptual error I find to be rampant in contemporary accounts of pictorial perception.

The passage runs as follows—it's worth having Wollheim's precise phrasing:

Seeing-in is a distinct kind of perception, and it is triggered off by the presence within the field of vision of a differentiated surface. Not all differentiated surfaces will have this effect, but I doubt that anything significant can be said about exactly what a surface must be like for it to have this effect. [I must warn you that, on Wollheim's account, style in the craft sense is never discerned in seeing-in.] When the surface is right, then an experience with a certain phenomenology will occur, and it is this phenomenology that is distinctive about seeing-in. [Phenomenology—the phenomenology of Intentional structures—is strictly mentalistic, in Wollheim's idiom.] Theorists of representation consistently overlook or reduce this phenomenology with twofoldness because, when seeing-in occurs, two things happen: I am visually aware of the surface I look at, and I discern something standing out in front of, or (in certain cases) receding behind, something else. [Here, Wollheim mentions, favorably, Leonardo's advice.] The two things that happen when I look at, for instance, the stained wall are, it must be stressed, two aspects of a single experience that I have, and the two aspects are distinguishable but also inseparable. They are two aspects of a single experience, they are not two experiences.[58]

"Seeing-in," I take it, answers to Leonardo's famous trick about finding images in all sorts of surfaces. Wollheim says that "it precedes representation . . . is prior to it logically and historically": he means images that *are not yet* pictorial representations at all and probably precede deliberate pictorial representation itself.[59] He seems to mean, however, that *it still precedes* pictorial representation even among (what we might ordinarily call) "actual" pictorial representations!

If I understand him correctly, Wollheim wishes us to believe that pictorial representation depends on *preparing a surface so that representations will "emerge" as a result of "seeing-in"*—of tricking the eye in a "subjective" manner akin to Leonardo's advice. He therefore means that the *phenomenology* of "seeing" a pictorial representation (seeing-in) is a learned skill that supplies or projects representations *entirely from* the side of the psychological powers of the would-be percipient (whether artist or appreciative viewer). *There is no objectively perceivable representation (no Intentional structure or property) in the painting, or on its surface*, because of course the painted physical surface has no Intentional, no perceivable Intentional properties at all! But would Wollheim—or anyone—say that spoken language is not directly heard and understood

as heard? Or photographs or cinematic images, not directly seen? Does the parallel count for nothing?

What Wollheim says strikes me as altogether wrongheaded and arbitrary. What he means is that the *surface* is discerned in an empiricist or phenomenal way and that *we* can discipline ourselves *to* "see-in" *that* surface—"phenomenologically," as Wollheim says—the *representation* the artist intended (psychologically). Per contra, I would say: (1) seeing the surface in Wollheim's sense is never more than an abstraction drawn from within phenomenological perception itself; and (2) the *surface* that we see when we see a pictorial representation phenomenologically is itself "continuous" with the representation we see; it is just as much in need of explanation as is the representation we see. (You must bear in mind the equivocation on "surface.")

The *phenomenal surface*, which Wollheim thinks of in ocular or biological terms, is always an abstraction (or subtraction) from the other. It is not, as such, an "aspect" of the "single experience" that is the perception *of the painting*; it is never more than a theoretically posited potential ingredient in the phenomenological perception of the painted surface *and* the pictorial representation that together form "a single experience" (twofoldness, which includes seeing-in). The details of the empiricist or ocular or neurophysiological account are never, as such, actual ingredients of perceptual experience in the phenomenological sense, just as we cannot report perceptually what happens along the optic nerve or on the retina.

The relation between perceiving the surface and perceiving the representation is much more complicated, because not all that enters into the phenomenology of the surface need enter into the phenomenology of the representation. The relation is not straightforwardly compositional at any point of perceiving the painting. I think here of Cézanne's watercolors (particularly the unfinished ones): we see in Cézanne how pictorial representation is *built up* (phenomenologically) by layered brushstrokes (rather than by *our seeing-in, in* seeing layers of paint, the representations we project). We see the brushstrokes directly as gradually composing the represented scene. Wollheim does indeed return to the twofoldness of *pictorial representation* in a way that appears to do more justice to the complexity of the painted surface, which "yields" (somehow) the representation in question; but, against Wollheim, the latter is not a "causal effect" of the former and is not a causal effect of viewing a mere painted surface.[60]

Thus, when he speaks of the "marked surface" of a painting, Wollheim distinguishes between *its* "configurational aspect" and its "recognitional aspect." I'm prepared to endorse this distinction as a useful one—in fact, a distinction that fits the Cézanne case very well. But Wollheim also says (quite bafflingly) that these two features *are* "the two aspects of seeing-in" (presumably in the sense required by Leonardo's case).[61] That can't possibly be right: it falsifies our perception of Cézanne. It is very difficult, therefore, to get clear about the distinction itself: for if it belongs to seeing-in generically (according to Leonardo's advice), then the terms "recognitional" and "configurational" are fatally equivocal; and if they take a distinctive form in speaking of *paintings* as opposed to Leonardo's case, Wollheim has yet to explain the contrast he intends. He never quite tells us how these two considerations cofunction in their very different ways of functioning.

The essential puzzle remains unanswered: paintings remain Intentionally complex artifacts, so both the configurational and the recognitional play a sui generis role with respect to pictorial representation, a role that cannot be the same as whatever may be eked out in Wollheim's treatment of the Leonardo case.[62] In the one, we speak directly of seeing the public structures of paintings; in the other, we trick the eye into "seeing" Intentional images (our own inventions) "in" physical surfaces. We gradually realize what's missing in Wollheim's account. It points to a gap in a wide swath of recent analytic philosophies of art: it has to do with the denial of the realist standing of the entire world of human culture—or alternatively, with the restriction (as far as possible) of that world to the psychologically realist standing of the lives of artists and selves and the intentional (or Intentional) acts they perform—cast so as *not* to include (or to include only derivatively) what they actually produce or utter thereby! But of course, that's precisely what the admission of speech and the film knocks into a cocked hat.

2

"One and Only One Correct Interpretation"

ONCE YOU CONCEDE the heterodox puzzles of the perception and understanding of the arts, the heterodox nature of artworks themselves, you cannot assume, a priori, that the description and interpretation of paintings and literature must, if entitled to claim objective standing, ultimately conform in a principled way to the familiar orthodoxies of bivalence and excluded middle. Indeed, to regard the sciences as cultural practices subject to the winds of historicity, constructivist interests, discontinuous and local progress, opportunistic intuitions, ad hoc methodologies, and the like suggests the plausibility (consistent with realism) of entertaining relativistic and incommensurabilist options (if coherent on independent grounds) among the sciences themselves. I myself believe the nerve of Hegel's critique of Kant's first *Critique* actually sanctions such a tolerance: I also believe that Thomas Kuhn was driven to a related concession, though he was shocked to find it true.[1] If you grasp the sense then in which Hegel's dialectical vision (more than his explicit doctrine) may now be the single most promising conceptual vision of our Eurocentric world, you begin to see the strategic importance of testing our most daring metaphysical and methodological options in the space of the philosophy of art. That is indeed an important part of the motivation of these studies. I hasten, therefore, to press the advantage.

I claim there are no principled grounds on which to demonstrate that the interpretation of artworks and histories and related cultural phenomena could never be coherent or objective if it were not committed to the regulative constraint that, for every suitably individuated referent,

there was (there must be) a unique interpretation; or that partial or incomplete interpretations could never be validated if they were not demonstrably compatible with the single, ideally complete interpretation that fitted (must fit) the artwork or referent in question.

The intuition behind the contested claim is kin to the dream of the uniformity of nature—the a priori vision that what counts as physical nature sets severe logical constraints on inquiries that rightly govern what we may regard as real in the cultural world. This sort of thinking, however, puts the cart before the horse; for if we admit the realist standing of the improbable things we call artworks, language, histories, actions, we will find it quite unlikely, perhaps impossible, that the logic of our cultural inquiries is assuredly committed to the canonical constraints fitted to our accounts of physical nature—which, of course, may also prove unruly at times. There are very good reasons to suppose the human world requires a more tolerant logic regarding truth claims: and let it be noted, even the claims of the physical sciences fall within the human world.

The operative term in the preceding paragraph is "committed," since the proposed condition is undoubtedly too strenuous to be shown to be unconditionally apt in any literal sense. Perhaps the champions of the doctrine may be permitted to show no more than that our "regulative" loyalties conform in a strong sense even where circumstances conspire to force us to accept logically weaker compromises: for instance, in adhering to a strict bivalence and excluded middle, though we find that continual ambiguity, vagueness, imprecision, equivocation, and related uncertainties force us to accept the validity of slimmer claims. I believe that even such concessions cannot be enough and that an interpretive practice that, for ontic and epistemic reasons, permitted the use of truthlike values not bound exceptionlessly to the strictures mentioned need not lead inexorably to incoherent or self-contradictory claims—"somewhere" (as Aristotle says, in *Metaphysics* Gamma)—by merely adhering to what otherwise would surely be an evidentiary practice at least as careful as that relied on in the "objectivist" alternative. Almost without exception, contemporary opponents of relativism ignore this sort of challenge. The discussion is surprisingly primitive—even careless—and has hardly moved beyond the notably weak objections collected in Plato and Aristotle.

A striking version of the claim I oppose has been advanced by P. D. Juhl. It is in fact a version of the Romantic hermeneutic doctrine pressed as hard as possible. Juhl says straight out: "[T]here is in principle one and

only one correct interpretation of a work. . . . [I]f a work has several correct interpretations, they must (if I am right) be logically compatible. . . . [That is, they] can be combined into one (comprehensive) interpretation of the work."[2] Juhl's is a logically stronger version of a view earlier espoused by E. D. Hirsch, also a Romantic hermeneut. Neither Juhl nor Hirsch speaks directly about the ontology of literary or other artworks: I am myself persuaded that their claim ultimately implicates something close to Kant's conception of genius, which effectively invokes a *natural* gift that (as with mimesis) makes art appear as if it were nature. That is the most plausible model on which the single-interpretation thesis makes any sense at all. But first, neither of these two theorists spells out any such account or attempts to defend it; second, it is impossible to defend effectively, if artworks are Intentional "in nature"; and third, contrary to their own hermeneutic concerns, it would completely deflate the contrast between nature and culture. Certainly, if Hans-Georg Gadamer is right, for example against R. G. Collingwood, in holding that original intent cannot be simply "recovered" in historical time but only defensibly "replaced" or reconstructed through some authentic "fusion of horizons," then the intentionalisms of contemporary theorists like Danto, Levinson, Noël Carroll, Hirsch, and Juhl are dead in the water and the claims of the classical Romantics will have to be suitably adjusted.[3] More problematically still, the single-interpretation thesis has been advanced by Monroe Beardsley, who happens to be an avowed opponent of hermeneutics and all reliance on authorial intent.[4] The essential issue needs to be pursued with care.

All three theorists (Beardsley, Hirsch, and Juhl) insist on the necessary compatibility and convergence of all valid interpretations of a given work, no matter how "partial" or incomplete would-be interpretations may actually be. But if the very *nature* of interpretable properties cannot, for formal or ontic reasons, be shown to preclude incompatible interpretations, the unique-interpretation thesis will simply turn out to be arbitrary or false. (I mean, of course, incompatible interpretations that are not rendered "compatible" by the formal tricks of disjunctive logic. Think, for instance, of the enormously difficult problem of "locating" the "meaning" of a poem.) I claim that there is no convincing argument for the "single-" or "one-interpretation" thesis. As far as I know, no one has ever offered a knockdown argument to show that its denial is contradictory or paradoxical—or arbitrary or anarchical or unworkable or implausible or not in accord with critical practice or simply chaotic.

There's no convincing argument at all. None of the theorists mentioned says enough about the *nature* of an artwork to begin to make a compelling case. Certainly, as far as the hermeneutic version of the claim is concerned, insistence on the unlikelihood that an artist's intention may accommodate incompatible or incommensurable interpretations of a given work probably places too heavy a burden on the use of intentions, even if conceded to be relevant: artists' intentions treated independently of the properties of artworks tend to afford an implausible tribunal. Intention in the psychological or biographical or mentalistic sense may well prove criterially irrelevant or trivially redundant, and an appeal to an exclusionary use of psychological intentions applied criterially to interpretations may simply be no more than question begging, possibly incoherent.

The counterthesis rests on a faute de mieux strategy, but it has no trouble mustering positive considerations. Fully developed, it demonstrates the coherence and viability—possibly the preferability—of one or another subset of the following claims: (1) a given work of art (viewed as an exemplar of suitably interpretable *denotata*) can consistently support plural interpretations that are valid and objective, even if not mutually compatible; (2) if we agree that pertinent *de re* and *de cogitatione* modal necessities cannot be confirmed, then no evidentiary resources offered by the partisans of the unique-interpretation thesis will be adequate to defeat thesis 1; (3) intrinsically interpretable properties lack the kind of determinacy the unique-interpretation thesis requires; (4) claims 1–3 are compatible with any reasonable view of referential and predicative objectivity; (5) the defense of objectivity in interpretive and noninterpretive matters need not (indeed, does not) proceed in the same way; (6) the defense of thesis 1 need not depend on any equivocation regarding attributing incompatible interpretations to the same referent;[5] (7) there is no compelling reason to restrict evidentiary or interpretive sources in such a way that thesis 1 could never be reasonably defended;[6] (8) interpretations defensible at time *t* may well alter the objective interpretability of a work at *t'* later than *t*, consistent with items 3–7; (9) thesis 1 accords with actual critical practice; (10) thesis 1 is, or may be construed to be, a realist claim; (11) thesis 1 is compatible with grading and ranking better and poorer interpretations; and (12) thesis 1 does indeed allow for our detecting the falsity, indefensibility, or defect of particular interpretations. These are very strong counterclaims.

The validity of thesis 1 is overdetermined. But its best defense favors what may be called an argument from "adequation": that is, (1) that the ad-

missible range of interpretive claims must accord with the assigned nature of the interpretable things to which they answer, and (2) that the conceptual connection between the ontic and epistemic features of that adequation precludes any privilege or priority favoring either over the other. This is too compressed an argument to be helpful as it stands. I begin again, therefore, in a more discursive way.

. . .

I do not find it at all odd to concede that, say, Louis Leakey was drawn to *interpret* the stratification of the Olduvai Gorge in northern Tanzania when he and his wife attempted to date the australopithecine fossils they first found there. I've seen the site: the layered sedimentations are perfectly visible, and on the strength of what I imagine are reasonable geological theories, Leakey was justified in claiming to have found the earliest remains (up to that date) of primeval man. In admitting all this, however, we must take care to explain how it is that a natural formation— the Gorge—can be open to interpretation when plainly it lacks the kind of property that inherently invites interpretation: that is, any of the usual expressive, representational, symbolic, semiotic, stylistic, traditional, historical, genre-bound, linguistic, purposive, or normative attributes "adequationally" ascribed to artworks or historical events.

The obvious answer is that expressive and representational properties in paintings and sculptures are "intrinsically" interpretable and the Gorge is interpretable "by courtesy" only, by being subsumed under an explanatory theory—which is itself, of course, a cultural artifact. Intrinsically interpretable properties I term "Intentional," meaning that they are properties of cultural origin, publicly attributed to things that are the products of, or entail the labor of, human artists or agents, and that they are intrinsically interpretable for that precise reason. Aristotle, I note, nowhere addresses the possibility of a principled distinction between the natural and the cultural, which I view as decisive for the theory of interpretation, pretty well in accord with distinctions that have become unavoidable ever since the converging influence of the French and Industrial Revolutions. The modern distinction between the natural and the cultural was not available to the Greeks (as I have argued in the Prologue).

I put the point this way because many recent theories of art, of interpretation, of history, of the human condition itself, confine themselves voluntarily to conceptual resources that hardly exceed the resources of the

entire historical interval spanning ancient and early eighteenth-century philosophies. They call a halt to pertinent theory well before the advent of any distinctly modern conception of history! Theories of interpretation that fail to come to terms with the ontic difference between the natural and the cultural, or with the historicity of the human world, or the intrinsically interpretable nature of the Intentional, are, I assume, simply defective. Admittedly, this is a harsh judgment (though a fair one), which exposes uncompromisingly the inherent conceptual limitation of more than the first two thousand years of Western philosophy.

Wherever, beyond the human or the encultured, we *interpret* what is before us—the behavior of animals or prelinguistic children, for instance, the causal processes and effects of the inanimate world—we speak by way of an obvious courtesy: in the first, we anthropomorphize animal and infant behavior in terms of human exemplars; in the second, we subsume what is merely "natural" under a theory that links a description of the phenomena in question to some scientific explanation we are trying to support or test. (Explanations are, of course, Intentional and assessed in intensional terms.) Here we must acknowledge a benign equivocation on the term "interpret."

All this is familiar. But the reminder confirms that there is little point in theorizing about the logic of interpretation without attending to *the nature of interpretable things.* The warning is resisted by those who assume the uniformity of the world—for instance, under the dubious belief that whatever is real is simply physical or must be modeled on the canonical description of physical phenomena.[7] Others profess to be able to choose a reasonable model of the logic of interpretation—under the uncertain scruple of remaining agnostic (or ignorant) about the nature of the interpretable things they invoke.[8] But how can we proceed if we neglect to test the conceptual "adequation" between *denotatum* and predicable? I reject both policies as deficient on their face.

By "adequation," I mean no more than the conceptual congruity between the supposed "nature" of given *denotata* and whatever further attributes we ascribe to them as "objectively" theirs. Michelangelo's *Pietà*, we say, really represents the *pietà*: whatever counts as an objective interpretation of its actual representational features must surely be qualified by whatever may be rightly said of them. This seems beyond dispute, though it is plainly disputed—and neglected—on its ontic side.

You will have noticed that in speaking of interpretation, I have cast

my net as widely as possible, that is, to range over "all things cultural," so I see no reason to privilege the determination of verbal meaning over, say, the interpretation of the Intentional structures of paintings and historical events. I believe our spontaneous ability to hear and understand speech provides the strongest paradigm of what we mean by understanding cultural things. But that is another matter. I mean to treat "interpretation" in a very wide sense—in the sense of understanding what is culturally significant or culturally significative, which undercuts the single-interpretation thesis at the same time it corrects mistakes in theorizing about the interpretation of poetry, the role of authors' intentions, the difference between the "intentional" conceived psychologically and the "Intentional" in the culturally robust (or realist) sense, which, in interpreting artworks (as distinct from conversation, say) is not centered on the "psychological" at all.[9]

. . .

The pivot of the argument rests with the analysis of Intentional properties. If I had unlimited space, I would bring that analysis into full accord with the conditions of the existence of cultural entities, with the sui generis emergence of the cultural from the physical, with the "second-natured" nature of human selves, with the fit between the cognizing competence of human selves and the cognizable things of the cultural world in which selves are first formed, with the historicity of the human world and the cognition of that world, with the very different ontologies of natural and cultural entities and the hybrid nature of the latter, with objective differences in reference and predication affecting entities of the two sorts, with the dependence of the cognition of natural entities on our reflexive understanding of the cultural world, with the constructive or constructivist nature of knowledge itself, with logical and technological constraints on interpretive relevance, with the analysis of linguistic meaning and its relation to meaningful structures that are not themselves linguistic. None of these issues is aired in a convincing and sustained way by your run-of-the-mill advocate of the single-interpretation thesis. Even Hirsch, a notably scrupulous discussant, concedes, however obliquely, the inadequacy of his own brief: for instance, regarding the fixity of genres, which is essential to the success of the Romantic argument but cannot in principle be changelessly assured.

It would be a splendid economy that would set all of this aside, confident that the direct analysis of Intentional properties could rightly

decide the single-right-interpretation issue.[10] I'm convinced the economy is worth pursuing. Consider then some of the strongest specimen theories of interpretive work. Juhl, a most energetic "singularist," has certainly badgered the well-known disagreement between F. W. Bateson's and Cleanth Brooks's interpretations of Wordsworth's "A slumber did my spirit seal"— but without providing compelling evidence for his own thesis. Many have worried these particular readings, which, roughly, are said to mingle personal grief upon the loss of a loved one and either a kind of "pantheistic" affirmation of cosmic order or resignation in the face of a meaningless and ultimately dead world.[11] The critical stanza, following the speaker's realization of his beloved's death and the dawning of the thoughtful reflection it now occasions, is this:

> No motion has she now, no force;
> She neither hears nor sees:
> Rolled round in earth's diurnal course,
> With rocks, and stones, and trees.

I venture to say that one might reasonably find "in" the poem a distant echo, adjusted to Wordsworth's contemporary world, of John Donne's well-known divided reflections on the meaning of the then-contemporary eclipse of Ptolemaic astronomy, which is not actually mentioned in the Wordsworth poem. (Think of the example in methodological terms!)

The meaning of the poem's words is not ambiguous in the usual sense of that term: Wordsworth is not often ambiguous in a verbal way, and he is certainly not ambiguous here. Yet within a reasonable fit the lines lend themselves to the two interpretations mentioned, which are indeed incompatible though each is textually complete: it is unlikely the poet "intended" both. Juhl confines himself (far too much) to whether the phrase *Rolled round* signifies "gentle" or "violent" motion, in a sense suited to the rest of the line on either reading—hence, to affirming or denying a meaningful universe.[12] To my mind, Juhl's strategy obscures the option of reading the phrase *Rolled round* in a way that is *not* primarily occupied at all with its verbal congruity with specifically "gentle" or "violent" motion. (It seems plainly noncommittal.) The stanza does, however, pose the additional question whether the daily rotation of the earth favors the one or the other cosmic conviction.

There is no satisfactory resolution of this matter on authorial, textual, or on any other grounds: the two readings are palpably incompatible, and

neither is demonstrably arbitrary or dependent on any obvious verbal ambiguity. Other commentators—Torsten Pettersson, for instance, with regard to Gray's *Elegy*, Morris Weitz with regard to Shakespeare's *Hamlet*—have similarly collected diverging interpretations that yield at least a number of reasonably strong competing readings (by various hands) that cannot be dismissed or easily reconciled along the lines of a single valid interpretation or made to rest (where divergent) on enabling verbal ambiguities.[13]

Consider also some very well-known interpretive specimens involving paintings, which require literary reference or historical context to establish their validity. I'm certain Leo Steinberg's celebrated lecture on the sexuality of Christ will be familiar to a large audience. What is particularly interesting about Steinberg's wide-ranging analysis is that it is theologically well informed, even inventive in its detailed conjectures; that it is guided by a fresh, authoritative disclosure of early fifteenth-century papal sermons that identify the general "Incarnationist" theology of the time, which Steinberg learned from a certain J. W. O'Malley, S.J., on whom he draws;[14] and that O'Malley himself (who attended Steinberg's original lecture, on invitation) confirms the accuracy of Steinberg's grasp of the Incarnationist doctrine as well as the plausibility of his innovative conjectures about the significance of certain themes (for instance, the Infant's circumcision and erections).[15] Steinberg's work depends convincingly on the conceptual fashions of the period to which his specimens belong. But notice: they do not rest on confirming artists' intentions in narrowly psychological or biographical terms.

I have two comments to offer, which are not meant to demean Steinberg's argument or his evidence. If I'm not mistaken, O'Malley was surprised by the fluency of Steinberg's account, drawn as it was from a detailed study of particular paintings and sculptures rather than imposed on them on the supposed authority of hitherto unknown or relatively unnoticed sermons; although, as I say, Steinberg relies on O'Malley's text in grasping the novelty of the Incarnationist doctrine. His interpretation would have been laughed out of court—even angrily contested—if we did not have something like O'Malley's new information about the actual texts of contemporaneous papal sermons (which Steinberg samples). The Incarnationist theology was in the air, but we cannot say with certainty that the artists of the period were pointedly occupied with its doctrinal distinctions at every turn. Accordingly, conformable interpretations cannot be more than plausible.

Thus it is that Steinberg contests interpretations of pertinent scenes—the "nursing Madonna" for instance—which was tactfully judged by Millard Meiss to signify "the Madonna's humility," but which Steinberg construes as attesting to "the truth of the Incarnation";[16] similarly, Steinberg reinterprets a woodcut by Hans Baldung Grien, in which St. Anne fondles the Infant's penis, against the judgment of "the foremost Baldung scholar Carl Koch" to the effect that St. Anne's gesture should be interpreted in accord with "the artist's known interest in folk superstition."[17]

What is important for the theory of interpretation here is, first, that the relevant readings *cannot* be reliably recovered from the paintings alone; they depend on textual and historical information judged perceptually plausible, which, as far as one can see, overrides "authorial intent" in the narrow sense; and second, that the interpretation of the perceptual features of particular paintings is brought into line with the ethos of the age, where we do not have sufficient grounds for singling out one painting or sculpture or woodcut or another from a *general* pattern of fifteenth- and sixteenth-century work. Please bear in mind that the line between the visual perception of a painting and the interpretation of what we perceive is not a sharp one (in any principled way), except on the adoption of a theory of visual perception that is both too impoverished to accommodate the actual fluencies of viewing paintings (empiricist phenomenalism) or contested in a fair way by alternative theories that construe the would-be disjunction in more labile ways (visual phenomenology yielding in Hegel's direction for instance).

You will find a similar interpretive strategy in Meyer Schapiro's well-known rejection of Freud's interpretation of Leonardo's treatment of Mary and St. Anne as being more or less of the same age, "therefore" (according to Freud) reflecting Leonardo's bastardy (that is, his having two mothers, his natural and his adoptive mother, which Freud draws inferentially from Leonardo's notebooks). Schapiro "defeats" the thesis by drawing attention to the then-current cult of St. Anne, which favored depicting Anne in her prime—"hence" the parity of the represented ages of the two women.[18]

In Schapiro's and Steinberg's cases, what we appreciate is the force of the *prior* question of the proper gauge within which we might hope to confirm one interpretation over another, among the works in question. Both Steinberg and Schapiro signify that *under the circumstances* it would be pointless to test their interpretations biographically or psychologically rather than in terms of the theological currents and the turn in the period

toward naturalistic representation. There are very large alternative inter-
pretive options here, large enough, I would say, to favor item 1 of my
original tally. What is particularly telling about Steinberg's and Schapiro's
argumentative strategies is simply that they consult the actual cultural
structures of the world they examine—not merely psychologistically or
biographically—but as a palpably Intentional (societal) ambience. These
structures are presented phenomenologically, possibly realistically as well.
But that's precisely what is usually missing in "scientistically" minded theo-
ries of art and criticism that tend to construe paintings as mere physical
objects (see Chapter 1).

Nevertheless, when we reach Michelangelo's *Risen Christ* in the early
sixteenth century, the older argument seems inadequate. Steinberg reports
that "every 16th-century copy [of the sculpture] represents the figure as
aproned." Michelangelo gives us a naturalistic nude Christ "complete [as
the Incarnationist idiom has it] in all the parts of a man." But, says Stein-
berg: "If Michelangelo denuded his *Risen Christ*, he must have sensed a
rightness in his decision more compelling than inhibitions of modesty;
must have seen that a loincloth would convict these genitalia of being 'pu-
denda,' thereby denying the very work of redemption which promised to
free human nature from its Adamic contagion of shame."[19]

Pretty enough, but not compelling and certainly not decisive in the
way of a unique right interpretation. Perhaps one cannot simply disconfirm
Steinberg's conjecture. (I wouldn't dream of it.) But by parity of reasoning
(keeping Steinberg's larger argument in mind), it seems more reasonable
to avoid psychologizing; it also seems much too specific to proffer a the-
ologized conjecture in Michelangelo's behalf even when joined to the other
slim evidence Steinberg adduces: he cites, for instance, a remotely sugges-
tive text from St. Thomas. It seems better to refer the full naturalism of the
sculptural figure to Michelangelo's general practice: perhaps the boldness
of the nudity reflects stylistic consistency if we invoke a wider ethos.

There may be no doctrinal import of Steinberg's sort beyond the
obvious convergence of the ancient and Renaissance preference for natu-
ralism and the period's acceptance of the Incarnationist teaching. Here we
begin to see the limitations of moving toward a determinate or exclusion-
ary interpretation: there seem to be no sufficient grounds for going beyond
sheer plausibility—but not because of a "lack of evidence" centered in the
paintings and sculptures themselves. The fact is—it makes an interesting
irony—insistence on the executive role of intention (in the biographical

sense) is likely to favor some form of relativism over the doctrine of a single right interpretation.

There is an instructive comparison that can be made out between Steinberg's treatment of the Michelangelo and Meyer Schapiro's treatment of Giotto's Arena fresco featuring the betrayal of Christ. Schapiro had also explored the connection between texts and pictorial images and had, by that device, developed an incipient semiotics of frontal and profile faces in religious paintings. But when he comes to Giotto's arresting treatment of Jesus and Judas, both of whose faces are in profile, Schapiro features "Giotto's originality of conception," which he could indeed confirm by way of Giotto's oeuvre and an earlier tradition of painting religious events, viewed against the import of the biblical text.

Schapiro contrasts the treatment of Giotto's paired faces with a painting of the same event that hangs in Assisi, produced a generation before (in which Christ's face and posture are frontal and the face of Judas is in profile). As Schapiro says, "[T]he pair [in the Assisi painting] lack entirely the inwardness of Giotto's image of the fateful encounter of two men who look into each other's eyes and in that instant reveal their souls. The uncanny power of the glance in a strictly frontal head is transferred to the profile as an objective natural expression, fully motivated in the situation. It is perhaps the first example of a painting in which the reciprocal subjective relations of an I and a You have been made visible through the confrontation of two profiles."[20] (The frontal treatment of the face of Jesus was canonical in earlier renditions.)

This is a bold conjecture, but it is not psychologized or even, really, theologized. It is notably in accord with Giotto's transitional role and originality in the history of painting *and* almost entirely supported by visual and pictorial considerations. It is in fact an excellent example of Schapiro's well-known strategy of "objective phenomenology," more empirical than psychologistic, impossible to account for except in terms of a cultural realism appropriate to the perception of paintings. I must ask you to keep Schapiro's interpretation in mind as suggesting how we might treat the logical distinction of descriptions of specifically Intentional materials. What is important here is Schapiro's attempt to demarcate a visual clue regarding Giotto's decisive innovation. His interpretation becomes an unavoidable option in the gathering history of connoisseurship, but it cannot possibly preclude being contested by another strong interpretation, if there is one to be had, drawn from another selection of earlier paintings suggesting an

alternative reading of Giotto's image. I find Schapiro's argument compelling, but it does not pretend to confirm any unique interpretation. None could be vouchsafed by Schapiro's methods.[21]

Notice also that the biblical import of the two faces may (in a very strong sense) be admitted to have "penetrated" the perceptual responsiveness of informed viewers of Giotto's fresco, so it would not be improper to speak of *seeing* (phenomenologically) what Schapiro claims to see: his remarks belong to a reasonably spare conception of the seamless continuity of perception and interpretation. Whereas, for me at least, the shortened crossbeam of the Cross in Michelangelo's sculpture permits us to impute some further interpretive significance to its relative length rather than any straightforwardly perceptual discovery: perhaps it leads us beyond the trauma of the Crucifixion in the presence of the Cross. The fact that Christ looks away from the Cross and his body is draped in a casual and decidedly unaccented pose may be conjecturally *interpreted* in an interesting way— not actually seen—as a comment of some sort on the meaning of His having risen. But I judge the perceptual and interpretive elements to be rather differently weighted in the two cases.

· · ·

I take these examples to confirm that there is no obvious way in which relying on authorial or artistic intent, textual meaning, historical ethos, genre, syntax, biography, context, rules or practices of interpretation, canons, or anything of the kind could possibly force us to accept the unique-interpretation thesis. It's quite possible that in particular cases the idea of exploring plural, nonconverging, or incompatible interpretations would prove pointless. But on empirical grounds alone, it is surely the better part of good sense to leave the matter open ended. It's the theoretical issue that's troublesome, and it's the pretense of having discovered a certain modal necessity binding on interpretation that poses the most insistent questions. When, for instance, we read in Beardsley, "I hold that there are a great many interpretations that obey what might be called the principle of 'the Intolerability of Incompatibles,' i.e., if two of them are logically incompatible, they cannot both be true. Indeed, I hold that *all* of the literary interpretations that deserve the name obey this principle. But of course I do not wish to deny that there are cases of ambiguity where no interpretation can be established over its rivals, nor do I wish to deny that there are many cases where we cannot be sure that we have the correct interpretation,"[22] we

must admit that Beardsley himself offers no more than an obiter dictum—in effect, a Fregean dictum. For instance, he never explains the bearing of the difference *in nature* between a poem and a stone.

It's easy to see how, against Beardsley's view, we *could* still admit, provisionally, incompatible interpretations—on the expectation (Beardsley's perhaps) that such conflicts cannot fail to be overcome as we approach the uniquely valid option. But why should Beardsley's dictum be honored at all? Well, you may argue—I agree Beardsley had something of this sort in mind—the interpretation of artworks (literature, paradigmatically) is very much like the description of physical objects. Physical objects have (are said to have) determinate properties independently of any inquiry; hence, their description accords with a strict bivalence, and interpretation should accord with the same bivalence. But you may also argue *this* way: artworks possess Intentional properties, whereas physical objects do not. Interpretation, therefore, addresses "meanings" and "meaningful" structures, and such structures do not, or cannot be shown to, behave in the same way (logically) that physical properties do; hence, Beardsley's argument fails.

How does the counterargument go? More or less as follows: first, by affirming that Intentional properties are not determinate in the same way physical properties are; and second, by conceding that they nevertheless remain sufficiently determinable to be open to their own kind of objective confirmation. The enabling notion holds that objectivity is itself a reasoned or critical construction fitted, reflexively, to different kinds of inquiries, that is, fitted to inquiries about different kinds of things, very probably involving different kinds of cognitive competence. The idea is simply that intrinsically interpretable properties—expressive, representational, symbolic properties: all Intentional, as I say—are sui generis, determinable enough to be confirmed but not determinate in the way physical exemplars are said to be. If so, contrary to Beardsley's view, they cannot be made to conform to a strict bivalence.

If this single concession could be won, it would prove impossible to vindicate the interpretive analogue of objectivism in the sciences: *some* reasonably strong form of relativism would have to be acknowledged,[23] for the determinacy/determinability problem would effectively preclude any principled victory for the unique-interpretation thesis. I don't suppose this can be fully demonstrated without bringing item 1 of my original tally into convincing alignment with the rest of the tally given; but any practitioner

of criticism or art history sympathetic with this line of challenge against the unique-interpretation thesis will find it easy to supply what's needed.

The argument affords a faute de mieux strategy in the face of the peculiarities of Intentional structures and properties. It looks as if we may not be able to do better. To my knowledge, no advocate of the single-interpretation thesis has ever bothered to lay down a reasonable sketch of linguistic meaning or of nonlinguistic structures of the Intentional kind as a proper evidentiary basis for preferring his thesis over its denial. No one denies that the bare idea is formally consistent and coherent. It's just that there's no good reason to prefer it! Think of this: where are the meanings of words to be found; and is the meaning of a poem simply the meaning of its words?

Let me mention another specimen view opposed to mine (and aired earlier) that converges somewhat with Beardsley's, though by way of artists' intentions—that is, just the reverse of Beardsley's strategy. Arthur Danto straightforwardly declares:

I believe we cannot be deeply wrong if we suppose that the correct interpretation of object-as-artwork is the one which coincides most closely with the artist's own inter-pretation. . . . My theory of interpretation is constitutive, for an object is an artwork *at all* only in relation to an interpretation. . . . If interpretations are what constitute works, there are no works without them and works are misconstituted when interpre-tation is wrong. And knowing the artist's interpretation is in effect identifying what he or she has made. The interpretation is not something outside the work: work and interpretation arise together in aesthetic consciousness. As interpretation is inseparable from work, it is inseparable from the artist if it is the artist's work.[24]

Now I find this remarkably unguarded. It seems to mean, strictly speaking, that we don't have (or cannot discern) a *work* at all if we cannot know the artist's intention by way of something like the artist's say-so! Hence, too, if a would-be work is ambiguous (though that may not have been the artist's *intention*—Danto considers the possibility of ambiguity), then once again we will be unable to recover the work at all or recover any one work. And if the hermeneuts are right—even Romantic theorists like Hirsch, who introduce genre studies in order to override any narrowly bio-graphical or psychological reading of intention[25]—then once again Danto will have put us at risk with regard to individuating and identifying par-ticular works.[26] But what, finally, *is* Danto's philosophical argument or evi-dence? It looks very much as if Danto means that "work and interpretation

arise together" because an artwork "is" an interpretation (or what is posited by an interpretation) of something more fundamental—a mere physical object! But is a word an interpretation of a mark or sound? Not usually.

What could possibly show that exploring an artist's intention *through* the enabling practices of the society in which the artist works (what Danto condemns as "deep interpretation") "always look[s] past the work to something else"?[27] I don't find the supporting argument in Danto's text. It looks like special pleading, and it leaps beyond the entire practice of hermeneutics without a by-your-leave. I agree it would be nonsense to disregard the artist's intention altogether, though it may need to be reconsidered. In fact, *if* it is ever critically relevant, an artist's psychological intention may have to be recovered from the meaningful (or Intentional) structures of the artist's actual work. In that sense, psychological intention is "external" to the work in question; otherwise, Intentional structure, being "internal" to the work (and therefore nonpsychological), suggests the vacuity of Danto's alternative strategy. If that's true, as I believe it is, then Danto's intentionalism will be completely undermined (see Chapter 1). And if that's true, we would be on our way to demonstrating, faute de mieux, that neither an intentionalist account (Juhl's, Hirsch's, Danto's) nor an anti-intentionalist account (Beardsley's) could be counted on to ensure the single-interpretation thesis. As it happens, there are no stronger champions to be found.

I don't see the force of any claim to the effect that (1) interpretations must accord with an artist's original intention vis-à-vis his or her own work; (2) all departures from original intentions are "wrong" or, worse, are about nothing at all or at least not about any one or the same thing; (3) wherever there is an "actual" work, there must be a determinate "constituting" interpretation in accord with the artist's intention; (4) artists' intentions provide the only way artworks can actually be understood to be Intentionally constituted—or actually exist as Intentionally structured "things"; or most important, (5) Intentional attributions drawn from examining the tradition (remember Steinberg and Schapiro) are (must be) "outside" the work (must "always look past the work to something else"). *Where is the evidence that any of this is so?*[28] Where, indeed, is the explanation of the power or plausibility of any such intentionalism?

Consider also Danto's recommendation that "we suppose that the correct interpretation of object-as-artwork is the one which coincides most closely with the artist's own interpretation." But there are difficulties. For

one thing, it cannot be read in any but a strongly psychologizing way. Second, it gives a seemingly insurmountable authority to the artist's original intention (or to his interpretation of his intention) in establishing the very existence of a particular artwork. Third, if that is so, then the very existence of an "object-as-artwork" is placed at considerable risk if we question the artist's view of his own work (now, a distinctly problematic locution). Fourth, the same phrasing seems to affirm that there is no principled difference between the artist's psychological intention regarding his work and the so-called Intentional features of the work itself. But that would yield a *reductio* of intentionalism. As far as I know, Danto has never ventured beyond the formula I've cited.

. . .

It's unlikely that one could find a stronger set of opposing claims than those advanced by Juhl, Hirsch, Beardsley, and Danto. They all deny item 1 of my original tally and favor the unique-interpretation thesis to boot. But none of them—and no one else, to my knowledge—has ever demonstrated the falsity of item 1 or the persuasiveness of its denial over its affirmation. Beardsley's account risks losing the distinctive nature of artworks as such; Juhl's founders on the supposed determinacy of artists' intentions; Hirsch's demonstrates the untenability of a purely psychologized view of authorial intent but fails to see that introducing the corrective work of objective genres cannot protect his own theory from any of the vagaries of relativistic or historicized interpretation; and Danto's account confirms the insuperable paradox of treating artists' original intentions as "constituting" artworks.

I have suggested another resource—item 3 of my first tally—drawn from the inherent nature of significative properties (that is, from the analysis of Intentional properties). This new line of reasoning has the virtue of advancing well beyond polemics. In any event, item 3 puts the burden of proof squarely on those who, like Beardsley, believe we *can* finally arrive at the unique-interpretation thesis without bothering to address the matter of the inseparability of the epistemic and ontic aspects of interpretation.[29] But we cannot! The inseparability issue is really nothing but the adequation issue complicated by the distinctive features of cultural life and inquiry. We cannot say what is real in the world (including artworks) if we have no right to claim to know such matters for a fact; and we cannot know what we claim is true about the world if the world is not as we claim it is.

The deciding issue comes to this: non-Intentional properties (physical properties preeminently) can almost always be made intensionally more determinate in a "linear" way by adding further distinctions of meaning within the admitted scope of the sense of a given predicate while holding its extension constant—as if by making selections from an antecedently regularized vocabulary. But that is normally not possible with Intentional properties in interpretive contexts. Among the latter, each interpretive ascription must (it seems) be separately tailored and separately judged valid when applied to a particular referent. Here we lack the sense of any antecedently prepared vocabulary from which we may make an apt selection, inversely matching extensional and intensional increases in determinacy. Consider, for example, increasing the intensional determinacy of the predicate "red," that is, making more and more precise determinations *of a particular red*, without altering its extension (or without altering it by much) and without increasing it. These determinations can normally be arrayed in such a way that when extension decreases, it decreases inversely and linearly with increasing intension. But Intentional properties ("baroque," for instance) or interpretive descriptions (Schapiro's account of Giotto's treatment of the faces of Jesus and Judas) do not behave in the same way as "red"; each description or epithet must be judged apt or just—*un mot juste*—in the form of a singular attribution, *not*, as with "red," as a standard, linearly determinable predicate. Intentional predicates rarely behave like "red"; and when, marginally, they do, they are usually modeled on the non-Intentional itself, as in restricting stylistic attributes (extensionally) to a certain historical in terval or when they function as little more than mere physical distinctions ("early" or "high" baroque, gradations of piano and lento).

There's a grand puzzle here: it may be the single most important distinction affecting the "logic" of interpretation. Let me be as clear as I can. I hold that among "natural" (or better, physical) *denotata*, attributes are normally said to be *determinate*, though they must of course remain general—which is to say, already *determinable* (to a further degree) in intensional respects, with relatively constant extension; whereas Intentional attributes are characteristically not determinate *in that way*, hence, also *not* conformably determinable in the sense that applies among physical things ("linearly," let us say). If so, then what count as the objective interpretations of artworks and other cultural phenomena cannot be reliably restricted to the strong bivalent logic said to be adequate to the valid use of physical and non-Intentional predicates. Objectivity must accord with

what we take the real world to include. Opponents of the "adequation" thesis miss the importance of this constraint.

Physical properties are said to be determinate and linearly determinable in principle, without our ever reaching an "infimate" or last predicable (applied, say, to a specific red). In this sense, Intentional properties are determinate and determinable in a very different way. They remain determinate of course, but only in the way of their relatively discrete fit to a single *denotatum* for which they are expressly selected or fashioned. Where an interpretation is admittedly apt, we normally are not able to make it more determinate by adding further linearly linked intensional distinctions meant to pick out *the same feature* the first interpretation had identified. Intentional predicates are custom-made, heterogeneous, idiosyncratic, holist, "punctal" (to use an obsolete term), designed to fit individual *denotata* in such a way that they cannot be reliably disjoined from their referents— so as to form an all-purpose extensional vocabulary similar to a system of physical predicates. Some marginal yielding is possible but not much: even period styles tend to be holistic rather than extensional and require holistic adjustments when applied to strong new specimens beyond their first exemplars.

It is notably difficult, for instance, to treat Rubens as an exemplar of the early baroque and then fit the category to El Greco, or indeed difficult not to fail, in bringing El Greco into line (by linear additions) with the phases of the Italian baroque and its variant forms in Spain and the Low Countries. Pertinently compared properties in Rubens and El Greco do not form part of an independent array of linearly ordered general predicables. This seems to be the rule rather than the exception. Among Intentional properties, we lack (almost always lack) extensional criteria of application; hence we treat them attributively, *in* the context of applying them to particular *denotata*—often, undoubted exemplars. Whereas among physical properties, precisely because we apply them extensionally, we can easily invent (and often find) relatively independent gradations of application that can be made of freshly identified *denotata*. In the first case, we speak of what is apt and in the second, of what is true or adequate.

If you think about this carefully, you realize that in applying physical predicates along the lines indicated, it should be a straightforward matter to distinguish between the descriptive and further "interpretive" ascriptions to given *denotata*; but the prioritizing of the descriptive over the interpretive will not normally obtain in a parallel way with regard to

Intentional properties. For example, the Olduvai Gorge may be described physically in ways that, in principle, can be made increasingly determinate linearly; also, the physical properties of the Gorge (pertinently selected from valid descriptions) may then be interpreted in accord with some explanatory theory, say, confirming Louis Leakey's dating of the australopithecine fossils embedded in the Gorge. Even though physical properties may be ascribed descriptively to a painting (its size, for instance, its being an oil or watercolor), either the ascription is never solely construed as a mere physical property, or when it is, it is rightly ascribed only under the authority of some prior Intentional identification of the painting to which it is attributed—where the painting cannot rightly be identified as a painting by physical means alone. Thus, whatever is rightly confirmed as "descriptive" of the painting qua painting will be rightly ascribed (say, holistically or hermeneutically or in some similar way) only when it accords with a valid "interpretation" of the work itself (as with *un mot juste*, its characterization as a "baroque" piece, or in some such way). In the second instance, but not the first, the use of the terms "descriptive" and "interpretive" probably signifies no more than the provisional ordering of what, relatively speaking, is uncontested as an Intentional ascription (say, a particular piece identified as a cubist painting by Braque) as distinct from a closely contested analysis of the significance of the compositional complexities of that same painting (for instance, involving some innovative, therefore "interpretive" feature in the evolution of the cubist style). The seeming fussiness of these distinctions is, of course, often closely linked to deciding the appropriate "logic" of particular truth claims regarding physical and cultural phenomena: the latter are, as a matter of course, bound to be more hospitable to relativistic claims than the former, but not disjunctively.

. . .

I favor a strong distinction between the *linear* and *punctal* natures of non-Intentional and Intentional properties, respectively. But the significance of that difference gains its full force only when it is set in the larger context of a theory of physical and cultural phenomena. Let me add, without ceremony therefore, a series of ordered distinctions to strengthen its intended lesson.

First of all, there is no algorithmic way (and no approximation to same) for confirming referential or denotative success with regard to either physical or cultural things. Cultural phenomena are not poorer in this

regard than physical phenomena. The best-known theories regarding re-identifying numerically distinct referents—from Frege to Kripke—utterly fail to solve the epistemic question; it cannot be done in any predicative way, and every strategy (including the causal theory of reference) finally depends on the predicative. Most discussants hardly make the effort.[30]

There is also no algorithmic way to confirm predicative similarity (through whatever variant manifestations may arise—as in the ancient puzzle of the One and the Many). Only if some form of Platonism could be made operative in cognitive terms (which no one believes) could the predication of non-Intentional attributes provide a possible basis for an extensional treatment of Intentional attributes. The result is that we usu-ally subordinate all confidence in an exceptionless bivalent treatment of predication to the consensual tolerance of one or another viable society. This is close to Wittgenstein's master theme in *Philosophical Investigations*, except that Wittgenstein pretty well ignores the question of the histori-cized process of *lebensformlich* practices and the related problems of inter- and intrasocietal divergences that could never preclude the relevance of relativistic and incommensurabilist options.[31] But to admit any of these considerations would already defeat the unique-interpretation thesis—and obviously more.

Second, by distinguishing between "physical" and "cultural" entities, in the sense that the first lack and the second possess Intentional proper-ties, we cannot fail to admit that artworks and histories are not "natural-kind" phenomena (though they remain "natural," of course). But if that is so, and if cultural *denotata* can be individuated and reidentified with as much success as natural-kind entities, then apart from preserving co-herence and discursive control, there is no reason to deny the distinction of intrinsically interpretable things—hence, no reason to deny that such things *may be validly (alternatively) interpreted in incompatible ways that may be regarded as objective.*

The cultural world honors its sui generis forms of diversity by con-structing its own form of objective discourse. There's an innovation no form of reductive materialism could possibly countenance. The analytic cham-pions of the single-right-interpretation thesis (Beardsley and Danto, say) tend to oppose any theory that subverts the viability of reductive material-ism, even if they themselves would never subscribe to the entire doctrine.

We may say that cultural entities lack "natures" (natural-kind natures), have "histories" instead, or have natures that are no more than histories (on

their Intentional side). But we must also bear in mind that, qua real, cultural entities are, despite being artifactual, indissolubly embodied in material entities: hybrid second-natured selves, in the members of *Homo sapiens*; Michelangelo's *Moses*, in a block of cut marble. In saying that Intentionally qualified entities are "embodied," I mean that, (1) qua real, they are emergent in a cultural or sui generis way with respect to the merely physical or biological world; (2) they are inseparable from their particular *materiae*; and (3) their real (Intentional) properties are also hybrid properties, indissolubly "incarnate" in material properties.[32] They are also, of course, (4) normally discernible as such in phenomenologically pertinent ways; and (5) discerned by suitably encultured selves, similarly embodied, whose own powers of perception and experience are adequately matched to the discernibility of the objects and events in question.

Relative to a constructivist metaphysics—dependent, say, on the decisive work of Kant and Hegel, but yielding more in the direction of Hegel's lectures on the fine arts than on Kant's first *Critique* (however qualified by the third *Critique*)—the cultural world and the Intentionally qualified things of the cultural world are "there" or "exist" in a robustly realist sense so as to be open to being objectively perceived or understood. But the sense in which this is so is sui generis to that world. The determinate/determinable distinction does not preclude this possibility.

I see no other way to capture what we mean by objectivity here: it's for this reason that a phenomenological rather than an empiricist account of the perception of cultural things is needed. (The phenomenalism of the empiricist sort is, in any case, always theoretically dependent on *some* prior conception of what is phenomenologically "given," without privilege, in a humanly reportable way.)

Michelangelo's creative work is incarnate in his physical labor: he gives form to the *Pietà in* applying his hammer and chisel to a block of marble. The "two" are not separable elements (though they may be considered in abstraction from one another): the application of his tools is a culturally emergent ability in the same sense in which Michelangelo's conception (of the *Pietà*) emerges in "his mind." Here, "mind" is a functional nominalization that however localized in the brain and nervous system, collects, holistically, all the cofunctioning functions of that single living career that we call a self or person, which, of course, is also hybrid and culturally emergent within the space of an encompassing society.

Aristotle achieved an excellent approximation to an adequate account

of persons and artworks, except for the fatal limitation that he had no systematic understanding of the difference between physical nature and human culture: he could not anticipate the enormous conceptual advance produced by Hegel's notion of a historical and historicized *Geist*—which should itself be construed as a nominalization ranging over the inclusive run of Intentional predicables (appropriate to the collective life of an entire society as well as to the lives of individual selves) incarnate in the non-Intentional properties of the human world—apt for both creator and creation. The paradigm, of course, is language, or speech, which cannot be described or explained in physical or biological terms alone; so Aristotle's *poiesis* and *techne* must be "geistified" to bring the idiom of the ancients into accord with that of the moderns.

The full significance of these distinctions may still elude you. What needs to be emphasized is that contrary to what holds true for physical entities, it *is* possible that the numerical identity of artworks can be fixed as effectively as the identity of physical objects; all the while we admit their labile "nature."

Number and nature need not move in tandem conceptually, despite what Aristotle says. It is generally assumed that a change in the "essential" nature of natural-kind entities logically precludes the possibility that a designated particular *of some kind* ("of that nature") could, consistently, remain one and the same thing through such a change. *That is not an operative constraint binding on cultural entities.* (Cultural entities are simply not natural-kind entities.) *Hamlet*, for instance, can be identified as one and the same play though its "nature" actually changes and evolves through the normal process of interpretation over the ages! Its properties remain determinable, without being determinate in the manner already sketched; and its properties may be subject to change in a perfectly legible and manageable way that accords with the characteristic practice of historicized interpretations of the Intentional. Nothing of this kind obtains in any strict way in physical nature as such, although the growth and change of a single organism's life helps to fix its numerical identity. (Think of the phases of the life of a moth.)

Taken together, the distinctive strands of the ontology of cultural things make it impossible to preclude the interpretive options afforded by relativism and allied policies. At any rate, the option is a coherent one and cannot be ruled out of bounds by objectivist tastes. It is in this precise sense that the ontology of cultural entities affords a basis for defeating

the unique-interpretation thesis. It simply acknowledges a world of larger possibilities.

Finally, if we take the historicity of thought seriously, we must accommodate the "constructed" nature of the cultural world itself, the constructed nature of Intentional properties within that world, *and* the constructed nature of the cognitive competence of interpreting selves. By "constructed" or "constructive" or "constructivist," I mean *here* what is real in substantive or predicative respects, or both, that result from distinctly cultural processes such that what rightly counts as objective in that world is imputed to be such by inquiring selves who are themselves constructed within the same world and that may, as a result, be *phenomenologically* confirmed. The "constructed" is not meant to entail any pernicious form of idealism, though the cultural world, unlike the physical world, *is* actually produced by human efforts. Nor does the constructed entail the arbitrary or the skeptical: questions of truth and objectivity remain in play; it's only that those same notions are rendered constructivist themselves and therefore can be made to accommodate alternatives to bivalence and excluded middle.

I should add that I use the term "constructive" or "constructivist" in an allied but quite different sense as well: namely, the sense in which the subjective and objective aspects of cognitive states are indissolubly joined so that it is impossible, by perceptual or experiential or rational means, to identify the compositional contribution of the one and the other within any cognitive state. I take this use to mark, among other things, the force and validity of Hegel's masterful critique of Kant's first *Critique*; and I take the other use to mark the most effective objection to the metaphysics of reduction and dualism. Their different senses join hands as well in theorizing about the interpretation of artworks and the logic of interpretation.

To admit the constructed and historicized nature of the Intentional world makes it impossible to view objectivity in cultural matters as anything but a constructed norm subject to indefinitely extended, historicized revisions. Cultural understanding is essentially a society's self-understanding (*Geist*, in Hegel's ingenious idiom) formed under the conditions of radical history by creatures who are themselves precipitates of that same process. It is impossible to draw from these conditions grounds for championing anything like the unique-interpretation thesis.

I have now identified four interlocking features of the cultural world on which interpretive objectivity depends: the constructed nature of referential and predicative success in general, the difference in the logical con-

nection between "number" and "nature" as applied to natural and cultural *denotata*, the historicized conditions of a society's reflexive understanding of its own utterances, and the very different senses in which Intentional and non-Intentional properties may be said to be determinate and determinable. Two strong conclusions follow: one, that it is philosophically hopeless to venture an opinion on the logic of interpretive work without a reasonable sense of the ontology of the cultural world itself; the other, that all evidence bearing on the first conclusion confirms that there can be no convincing grounds for believing that the unique-interpretation thesis could possibly be true. I rest my case.

3

Toward a Phenomenology of Painting and Literature

IN ONE OF HIS STUNNING classroom lectures, Meyer Schapiro, I re-call as if it were yesterday, allowed his prepared text to wander a little, to dwell on an aside rather longer than the occasion seemed to warrant. The thought that took his fancy has haunted me agreeably from time to time for more than fifty years. It seems to have been gathering strength in a completely unforced way. For instance, it has helped me to see a very natural connection between the analysis of the puzzles of pictorial perception and the sometimes awkward matter of what has been called the "moral function" of literature, which I might not have tumbled to otherwise and which simplifies our command of both issues.

On a quick scan, they seem to be quite independent of one another, but perhaps they're not. I see them as neatly joined through the analysis of the role of imagination in pictorial perception and literary understanding—a chance conjunction set in motion by Schapiro's little aside. In any case, the linkage seems to make short work of certain nagging paradoxes regarding pictorial representation and the moral function of fiction: the first, because we need to know what it means to say we see a pictorial world in seeing a painting; the other, because we need to know what it means to say our appreciation of the fictive world of a novel enriches our moral sensibilities. Both questions are met by recovering a neglected feature of imagination's role in perception and in what may be called *Bildung* in the cultural sense.[1]

Quite recently, Schapiro's observation came to mind again while I sat through a small but thoughtful film about, of all things, young women

from Colombia driven by poverty to serve as heroin mules traveling between New York and Bogotá. What struck me was that the film, I mean cinema in general, permits us, enables us actually, to examine human faces carefully in a way that is almost never possible "in life"; although, of course, skilled moviegoers like ourselves (all of us) know exactly how to bridge the barrier between life and art without actually erasing the difference. We live here in imagination's limbo, without penalty.[2]

That, simply put, is the nerve of moral life, the moral nerve of life itself, *not* primarily the appraisal of moral propositions or moral truths, though even these, approached with care, may claim their small place. If art is play, as an influential line of speculation has it, it's the play of imagination in the sense intended here, not (in any more technical sense) the play of fiction or make-believe.[3] We cull, within imagined worlds, the possibilities of the actual world (and more), for imagination need make no "ontic commitment" in our play. Some "worlds" may indeed, as in science fiction, be purely fictive, and some may even be impossible; but in its most spacious play imagination tends to be compatible with both fiction and reality, as well as with worlds that neutralize the bite of the question of mingling fiction and reality in order to address a composite of their former elements that frees them from such sources. I think here of Tolstoy's *War and Peace.*

It became clear to me then, quite suddenly, that the "moral function" of the film—the educative lesson of all the arts, I may as well say—affords an almost limitless device by which we may consider, more thoughtfully than otherwise, the infinitely varied aspects of "the human condition"; and learning from that, we learn to do the same effectively "in life." We fashion an informal archive of remembered scenarios spanning real life, imagination, and fiction in rather an easy way (bits and pieces, really) that lend some charm and force to ordinary reflections about whatever absorbs us in the world—and more. In reflecting on a performance of *Death of a Salesman*, for instance, I allow myself to imagine (not necessarily fictively or as a rehearsal of any actual demands) a *passage* of possible scenarios that bind the meaning of my own life and Willy Loman's in a way that is formally detached from ontic commitment but captures the pathos of forcing some analogy between our lives. There's the pivot of the moral *paideia* of the arts: it takes up its proper function in imagination first, rather than in the circumstances of actual decisions, and it disciplines our readiness in practical affairs more than in assessing the subtleties of moral propositions.

What struck me was that the mature film actually "prepares" us for the close perception of life (as well as art) and "prepares" the "worlds" of life and art for the kind of episodic discovery I've just mentioned. The association with Schapiro, let me say, goes this way: Schapiro took a bit of time away from his planned discussion—of what I imagine was a choice phase of French painting after Manet—in order to make an oblique but perfectly relevant observation about the paintings in the Lascaux caves. (It must have been the Lascaux caves.) He stopped to share with his class a piece of wonderment focused on the fact that some of the figures in the caves were apparently produced by painting over previously painted figures! He remarked that what *we* call painting always involves our perception of a "prepared" surface (a piece of canvas, say, a ceiling, a sheet of paper—but "prepared," not simply a physical surface), linking in that perception a distinctly restricted and an ampler phenomenological datum, where the first (I suggest) may be empirically abstracted from within the space of the second. Certainly, the second could never be inferred (or abstracted) from the data of a mere physical surface, a surface that had no Intentional perceptual features at all: *that* would return us with a vengeance to the paradoxes of the pre-Kantian, the "Cartesian" world—or, say, to the rhetoric of figures like Danto or Levinson or Gregory Currie.

The same problem arises in a different way in the analysis of our ability to understand speech (I'll come back to that shortly). But the function of a "prepared surface" in painting is more a matter of signaling (in a culturally reliable way) the propriety of a certain trained practice of perceiving paintings—in which, for instance, the perception of a *visually represented world* need not be judged to be the perception of either a fictive or an actual world![4] It requires no more than the (phenomenological) perception of a visually imaginable world, the practice of which is regularized as perceptual by our trained interest in painting—a practice continuous in experience with our perception of the actual world we take ourselves to inhabit. We are aware of all this when, for example, we discern the dignity of Arnolfini's marriage recorded in Van Eyck's representation. The referential commitment to the actual marriage is a logically distinct (and normally independent) posit imposed on what can be pictorially perceived.

To return to Schapiro's example: the thought centered on the second datum (pictorial representation) signifies the distinctive "intentionality" (that is, the Intentionality) of paintings, which is, of course, matched in various local ways in all the arts. Schapiro himself kept to the bare facts of

the matter. I have no reason to believe he would approve what I've added, though I think it could and would bear up very nicely under challenge. The point remains: after Hegel's critique of Kant, empirical or empiricist constraints on what to count as sensory perception in a strict evidentiary sense—in accord, for instance, with a physiological theory of how the sense organs actually work—must themselves be dependent on some prior (but not privileged) phenomenologically generous perceptual reporting if we are not to fall back to pre-Kantian difficulties.[5]

We needn't choose this option, however, merely to accommodate Schapiro's very pretty point—or for that matter, the use to which I've put it—but it is true that the distinctive features of *perceiving* art as art would be more than difficult to explain if we did not take advantage of the conceptual resources made possible by the decisive revolution in modern philosophy effected in the innovations introduced by Kant and (in my opinion) adjusted ingeniously and more plausibly by Hegel.[6] (What I say here is colored, of course, by my sense of Hegel's contribution, but it's cast entirely in my own terms.)

I realized while viewing the film that a literary text also "prepares" us and the world it discloses in a matched but very different way. Drawing a line between fiction and reality is normally of no great importance *perceptually* in viewing pictorial representations by way of our grasp of the "prepared surface" of a painting; and a painting is itself a "metaphysical" (a critically significant) transform of a mere painted canvas or physical surface that matches our own transformation from *Homo sapiens* to encultured selves—as a result of which we spontaneously follow the implied directive of the prepared surface. The "prepared surface" is, therefore, already a perceptually regularized transform of its physical surface. Such a perception must be characterized phenomenologically; it is *penetrated* through and through by culturally informed sensibilities, addressed to Intentional structures and enriched most particularly by a trained power of visual imagination—the ability to see spontaneously and pertinently the three-dimensional features, say, of pictorial representations. It is impossible that such perception be "concept-free" or suitably explained by bringing *external* intentional factors (beliefs, for instance) to bear on what may then be posited as a more "basic" form of nonconceptual perception.[7]

This is an entirely perceptual matter that avoids any and all confusion between the merely imaginative dimension of such perception and the pretense of perceiving what is imaginary, or indeed the mistaken insis-

tence that perception is occupied only with what (in the Intentional sense) belongs to the real world. Pictorial representations are straightforwardly found in our cultural world, just as stories are. Though perceiving the one and understanding the other *require* imagination, neither entails a commitment to anything imaginary *or* real (regarding what is represented).

The right phenomenological stance is normally invited and induced, and known to be. Similarly, in being understood, a stretch of words or language, as in a poem or novel, makes accessible to imagination its imaginable world. Language, of course, is already a cultural transform of mere sounds (or marks)—though it is never obliged, in being that, to mark its represented world as determinately fictive *or* real: it may be no more than *imagined*, that is, without assigning ontic import to its "intended" world. We prepare ourselves (or are automatically inducted into the use of the skills in question) by clues of a sort close to what Schapiro has identified.

You must keep in mind the marvel of spontaneously hearing intelligible speech whenever philosophers insist (as many nowadays implicitly do) that we hear only sounds to which we somehow attach meanings or meaningful structures—drawn, it seems, from inner mental resources linked to some artist's creative intentions or some audience's recovery of plausible such intentions. Of course, part of Schapiro's instruction has to do with the remarkable way the flood of new kinds of painting released by Manet's example focuses on the endlessly varied significance of the prepared surface itself. But the prepared surface remains, for Schapiro, a public datum. So also are paintings and their pictorial representations.

Here it would not be unreasonable to appeal to something like Wittgenstein's insistence that inner mental states stand in need of outward criteria. Fashionable aestheticians who treat artworks as physical objects of some suitable kind (Wollheim, Danto, Levinson, among others) regularly fail to come to terms with Wittgenstein's complaint: in effect, they remove with one hand what they colloquially restore with the other—for instance, regarding style, expressiveness, and representationality.

The lesson could never have been presented, in *perceptual* terms, in the "empiricist" way—built bottom up by way of ingredients answering to a theory of how the eye functions (or for that matter, how information functions in perception). It requires instead a phenomenologically pertinent transformation of our ocular gifts that would make it possible to report, say, the manner in which we actually *see* how French painting develops after Manet. A merely "empirical" account that refused to admit the

direct perception of intentional (or Intentional) structures, hobbled in the manner suggested, would require some extraordinarily complex *inferential* or relational connection between what we "really" see (physical surfaces and physical things) and what we say we see in *seeing* paintings (pictorial representations, for instance). There is no way to escape the dangling implausibility (and conceptual inadequacy) of such a maneuver.[8] It's quite impossible, for instance, to adopt a Hegelian sense of historical life and reject a Hegelian sense of the phenomenology of perception. They go hand in hand in defining the indissoluble public space of theoretical knowledge and practical understanding.

I should perhaps add here, briefly, for the sake of philosophical candor (and philosophical provocation) that I very much prefer Hegel's phenomenological intuitions to Husserl's: first, because Hegel's model (in the *Phenomenology*) is essentially naturalistic rather than aprioristic; second, because it is meant to feature, freely and presuppositionlessly, the reporting of whatever falls within the range of our *Erscheinungen*; third, because it is meant therefore to capture what is "given" in reportable experience rather than to apply any antecedently self-validating methodology regarding what is alleged to be (foundationally) "given" in and recovered from what is said to be hidden by the "natural attitude"—*by* the privileged work of (Husserl's) *epoché* (as in *Ideas* I); and fourth, because analyses like the one I'm pursuing here help us to see just how resourceful a naturalistic phenomenology can be (Schapiro's, for example), without invoking transcendental privilege and without disallowing the critical advantage of any naturalistic successor to Kant's transcendentalism (Hegel's, preeminently). There's a larger question to be raised here, but this is not the setting for it. It needs to be mentioned, but it must also be postponed.

I now return to another aspect of my initial memory. I could see that what I've called the moral function of literature was itself embedded (as in watching a film or reading a novel) in the phenomenology of experiencing the then-"apparent" world of the story. Here I invoke the distinctive rigor of Hegel's phenomenology in order to range over all the different forms of perception and perceptual imagination "penetrated," conceptually and culturally, in accord with our trained practices of reading, listening, and viewing that belong to the perception and understanding of artworks.

These are difficult but hardly fanciful concessions, though they may seem extravagant to some. For certainly it is an essential skill of human

societies *to be able to hear and understand speech*! That is the phenomeno-
logical example par excellence and the key to the *reductio* of every attempt
to reduce or eliminate the cultural world. We absolutely need a model of
perceptual experience that can acknowledge the direct grasp of the ordinary
complexities of speech. I claim there is no way to describe or explain this
skill in terms derived from any induction from mere sounds or from any
rulelike or lawlike supervenience joining sound and linguistic meaning.[9]
The only option that makes sense requires a sui generis form of evolu-
tion or emergence, and because of that, the transformation of prelinguis-
tic forms of animal communication that have gradually evolved into a
proto-language and a proto-culture, which thereupon are able to produce,
reflexively, further cultural developments that can no longer be traced in
a causally legible way to the bare transition mentioned. This, therefore,
introduces a "metaphysical" change.[10]

Merely to acknowledge that we hear and understand speech directly
already entails a sui generis transformation from precultural forms of exis-
tence to culturally qualified competences that usher in human powers that
appear nowhere else in the world. This holds for the species *Homo sapiens*
and every individual member of that species transformed into a person or
self by acquiring a language in infancy.

As I say, the reason this is so is simply that our cultural powers cannot
be described or explained (that is, reduced) in terms confined to the things
of any subcultural world. No explanatory conjecture seems at all reasonable
if it does not admit an emergent continuum bridging biologically precul-
tural processes and fully cultural ones. Every form of plausible reduction
applied to the cultural must begin with a physicalist reduction of language.
But there is no such achievement in the offing. Furthermore, if that is so,
then we ourselves become "second-natured" by becoming enlanguaged and
encultured—capable, uniquely and only thus, of reflecting on our experi-
ence and reporting and expressing our thoughts in word and deed and
art—which belong to the Intentional forms of *utterance* that mark the
specifically human world. (This is precisely what I had in mind in speak-
ing in the Prologue of "external" *Bildung* in a manner drawn from Hegel's
reflections; though I'm bound to say it's quite surprising to see how little
is actually said about the original transformation among figures like the
post-Kantian idealists, Herder and Gadamer and the like. I have no doubt
that the subversive possibilities of championing historicity have some bear-
ing on this, but I can't imagine that that would account for its not being

reasonably salient. In any case, I regard it as a defining feature of what I've called "philosophical anthropology.")

It's in this elementary sense that Schapiro's remark about the prepared surface of paintings takes hold: the recognition of such a surface makes sense only in an encultured world; it is, we may suppose, a characteristic sign of our being trained, phenomenologically, to *see* paintings as paintings.[11]

This thesis, too, may seem extraneous, but it is surely not if, as I've argued, the acquired ability to hear and understand true speech *is* the very paradigm of the phenomenology of cultural life and art. We learn to see the world, the world we speak about spontaneously, in ways that are penetrated by linguistic distinctions and encultured experience. That is, the "prepared surface" of a particular span of language (*never* a strict covariance between sound and sense) reveals (to apt speakers) "the real world" in very much the same way a run of poetry reveals an imaginable world—a world to be understood and imagined—and for the same reasons. You would be right to favor, once again, the sense in which human perception and understanding are culturally formed, transformed, and penetrated by language and by whatever our acquiring language makes possible—the phenomenological turn, say, beyond that part of the bare incipience of painting that Schapiro dwells on—now, as pictorial representation. (Of course, the Lascaux caves remain the deep mystery that they are.) But the entire argument confirms the grand advantage of treating perceptual experience (and perceptual imagination) primarily in phenomenological terms if we are ever to make sense of "seeing a painting" or "understanding a novel."

You see, of course, that there are many different notions of "perception" vying for a favorable inning here. They come together in my mind in a deeper way through the strategic suggestion that the phenomenological perception and experience of artworks are triggered and made possible by our enculturing practices' having "prepared" the space—and prepared us to discern the space—in which the "worlds" *they* disclose can be perceived to have been thus disclosed. Of course, if *that's* true, then the theories of the perception of painting advanced so commandingly by figures like Arthur Danto and Richard Wollheim are seriously mistaken.[12] For they resist admitting that we ever really *perceive* in a way we can actually report (except by trick or rhetoric) any Intentionally qualified visual properties! A painting, however, is not a painted canvas: it is, like intelligible speech (our paradigm), the spontaneously transformed significative artifact that now

presents (to those among us who have learned to "see") a perceivable and perceptually imaginable world that answers to our normal phenomenological training and skills.

I say "normal" because we all acquire the remarkable skill *to hear speech directly* (not mere sounds) and to understand directly what we hear! We do much the same in viewing a painting and in reading a poem— though there are other differences yet to be fathomed. Nevertheless, the prepared surface of a painting is the prepared surface of an encultured (or metaphysical) transform of what might otherwise be construed as the surface of a mere "painted canvas," something that must intrinsically lack Intentional properties. (The latter is, indeed, Jerrold Levinson's deficient formula.)[13] Nothing, of course, is put at risk by merely introducing the term "metaphysical" here: the metaphysical is nothing but a way of labeling a particularly important distinction regarding what "there is" or "exists" in the world; it implicates no cognitive privilege or necessity or universality of any kind. It counts only against untenable efforts to reduce "one kind of thing" to another.

Everything so far remarked provides a ground for the analysis of what we should mean by speaking of the "objective" interpretation of a painting or poem. I have tried to answer the objectivity question elsewhere.[14] Here, I am interested more in the surprising conditions under which the question arises at all—and under which it can be satisfactorily answered. As I hope will become clear, there are some unexpected difficulties in attempting to fix (for interpretive purposes) the discernible meaning and significative structure of paintings and poems that cannot fail to affect in the deepest way our theory of interpretive objectivity. (This is, in fact, the key to my retelling of Schapiro's insight.) But it means that the question of objective interpretation depends on a larger theory of human nature and on the complex relationship between physical nature and human culture (implicated in the very existence of artworks and selves) in such a way as to affect profoundly our answer to the interpretation question. That may come as a surprise.

. . .

The difference between paintings and poems in the respect I still need to make explicit should help us understand why there are two foci of attention to be considered in drawing up a theory of the nature of artworks apt for answering the interpretation question. One features the

fact, already broached, that what from an empirical point of view might be said—in accord, say, with descriptions favoring the physical and avoiding the Intentional—to be a mere "painted canvas" *is*, from a phenomenological viewpoint addressed to cultural things, already informed by our way of understanding and perceiving the arts: that is, what *must* already be metaphysically transformed into a painting. This is, admittedly, a dense doctrine.

Let it be said, however, that the transformation of a physical *materia* into a cultural artifact that thereby acquires "meanings" or "meaningful structures," or "intentional (Intentional) content" of the kind artworks regularly exhibit, occurs all the time: Michelangelo takes hammer and chisel to a block of marble and, lo, in time the *Pietà* emerges—discernible as such to human selves who have been instructed about how to *see* the resultant *Pietà*. The transformation is not a piece of magic, any more than the uttering of physical sounds "counts" as (*is* transformed into) speech! This way of speaking obliges us to work out an analysis of the relationship between physical objects and artworks analogous (remember!) to that between the members of *Homo sapiens* and encultured selves.

We may be puzzled about how to describe the transformation—how selves "evolve" or "emerge" as (metaphysical) transforms of the members of *Homo sapiens*, or correspondingly, how speech evolves from sound and pictures from surfaces that have paint on them—but we are hardly uncertain *that* we distinguish between the two sorts of things in each pair. They *are* "metaphysically" different simply because certain decisively important properties attributed to the one member of either pair cannot rightly be attributed to the other. The question of the emergence of the cultural is indeed a strategic one—something, I would say, that would bear comparison with the first emergence of living forms. But for my present purpose, its not being entirely clear just how language and culture evolve imposes no strenuous constraint on admitting the differences themselves. It's just that we are uncertain about the critical details of the early history of the human race and, correspondingly, the critical details of early childhood. Similar questions (also metaphysically important) arise regarding the emergence of proto-life-forms from the inanimate world, as well as of consciousness from advanced life-forms.[15]

For my present purpose, it is enough to note that (1) artworks possess properties mere physical objects do not and (literally) cannot possess—for example, expressive and representational properties; (2) such properties

can, though discernible (that is, directly perceived in paintings, directly understood or imagined in poetry), be discerned only through suitably trained skills that account for what is thus perceived and thus imagined; (3) the objectivity of Intentional ascriptions and interpretations requires a critical choice among alternative such attributions (perceived or imagined or understood) that are fitted to those practices, traditions, modes of production and criticism that answer to the trained capacities in question; and (4) the kind of objective judgments possible here are such only as can be adequated to the nature of the objects and properties we acknowledge.

The second focus of attention concerns a decisive difference and similarity between paintings and literary pieces. We ordinarily say we view— and actually see—paintings, in the sense in which we see the perceivable worlds they disclose. Not everyone is prepared to speak this way, I should add, though I myself have never heard of a plausible way of speaking of paintings that did not concede that we *see* paintings in the sense intended. But we *don't see* poems or novels in *that* way, even if we see a written text or even if, as with *The Mayor of Casterbridge*, we see the BBC dramatization of the book. We *read* the story (we may, of course, hear it being read aloud, which is also not pertinently analogous to seeing a painting).

The differences are not entirely easy to spell out. But certainly, the literary arts presuppose the existence and use of an antecedently well-formed natural language possessing a complex, entirely abstract structure of semantic and syntactic elements indissolubly embedded (in use) in some extremely variable array of sounds (or marks), which, only in the phenomenological space in which the first (sound, say) can be discerned (that is, a historical culture, a life-world, acknowledged naively, in a way relatively unencumbered by antecedent theory), can they be at all reliably linked to the other—phonemically and verbally (rather than merely acoustically).[16]

To be sure, there *are* sensory qualities of speech that affect meaning; but determinate, fine-tuned differences in the merely acoustic qualities of words and sentences have remarkably little bearing (unless dependently) on understanding the meaning of the words and sentences of a poem or novel. Even there, we must read with a sense of a speaking voice's uttering whatever we determine *to be* the meaningful words and sentences of a given literary piece—where discerning the act and meaning of so "speaking" must be imagined *and* constrained by what is not primarily sensory at all (that is, linguistic meaning).

Also, of course, the matter of "the meaning of the words" is very different from that of "the meaning of the poem": the second is not known to be directly inferable from the first, though they are obviously bound to one another. They are in fact—they must be—hermeneutically linked. Consequently, "the meaning of the words" must be equivocal: "dictionary meanings" cannot fix the meaning of "the words" *in* any given poem. Think of the simplicity of Kafka's prose in *The Castle* as distinct from the grand puzzles of the novel. Here my suggestion is to acknowledge the equivocal senses of the term "the text." As I see matters, "text" normally signifies the various part/ whole elements and relations within the "meaning" of a literary "work," which, when rightly assembled, holistically or hermeneutically, constitutes the work itself. In that sense, text and work are functionally inseparable.

I disagree, therefore, with Gregory Currie's recent attempt to disjoin "text" and "work," as if to ensure the objective accessibility of the "words of the text." This can never be more than contingently conceded, as in fixing the canonical wording of a text. But even that is a dependent matter: the words of a text are internal to the work; externally adduced words are guesses regarding the (possible) meaning of a text.[17]

You see the delicacy of distinguishing with precision between our understanding painting and our understanding literature: by and large, we *see* paintings and we *understand* literature. We cannot do either in any narrowly "sensory" or "empiricist" way, because what is discerned here involves meanings and meaningful structures that cannot be matched in any way with the bare functioning or our sense organs. We must accommodate, within the phenomenological perception of paintings, our theorizing ability to abstract, *from* such perception, whatever we claim answers to the eye's way of functioning. But that already requires a deformation of what we initially claim to see in the phenomenologically or pertinently prepared sense. The reduction of what is phenomenologically encultured in perception *to* anything empirically restricted to non-Intentional sensory discrimination presupposes the reduction of the encultured powers of percipient selves to the bare biology of the perceptual powers of *Homo sapiens*. Any attempt to hold to the first without gaining the advantage of the second simply ignores the plain fact that the intended reduction is itself the proposal of theorizing selves already aware of the culturally rich perceptual data they are attempting to simulate by reductive means.

In any case, to see a painting entails seeing the world it is said to disclose; *that* cannot be seen in any merely ocular or empiricist way. Think of

seeing Judas's betrayal of Jesus in Giotto's Arena fresco. So the objective in-terpretation of the meaning or significance of what is disclosed in paintings is constrained by some consensual understanding of how the painting may be rightly *seen*, and candidate views are likely to be further constrained by what we concede may be "empirically" abstracted from within the bounds of our phenomenological perception.

Furthermore, the "moral function" imputed to paintings is impos-sible to assign in any way paralleling literature, unless, as in Giotto's Arena panel, the very structures perceived—the two faces in profile, for instance, said to have been introduced for the first time in Christian art—may rightly incorporate without contradiction literary, historical, semiotic, intentional, and similar allusive ingredients *as* fully perceptual. Here we appeal, within a critical practice, to the authority of the biblical text "implicated" in the painting. We behold the presented world of the betrayal. In all of this, we see how difficult it is to move with assurance toward any uniquely correct interpretation of an artwork, and we learn how difficult it is to disallow, in interpreting what we *see* in representational painting, what are obviously problematic literary elements that cannot be *seen* in any merely empiricist-oriented way—that is, apart from our cultural training.

The literary or canonical references (to Judas and Jesus) are validly perceived to "penetrate," to qualify perceptually, the differentiated elements of the represented world we see. We cannot say with precision, within the phenomenological mode, what exactly, paralleling the use of the empiri-cist model, is perceived and what we merely take to be perceived, as by an inseparably imaginative qualification of the first. But that is just as true of what we treat as veridical perception in the practical world—as in report-ing what we have seen as, say, witnesses giving testimony in a court of law. We do no more in the one setting than we do in the other, apart from imaginatively vivifying the pictured three-dimensional world of a paint-ing: we do indeed *see* a pictured three-dimensional world just as we *hear* speech! If you deny this, you may as well ask whether we ever see move-ment in the actual world or stars in the night sky or a man entering a room when no more than the forward part of his leg is visible. Once you admit the Intentional complexity of our perception of physical nature (as well as our technologized world), you have prioritized the phenomenological over the empiricist—and assigned the second no more than a dependent, theoretically inferred or abstracted role. And once you have done that, you cannot balk at admitting the direct perception of pictorial space.

So, there is bound to be a deep and ineliminable informality in the very idea of the "visual perception" of paintings. This is not to subvert the rigor of art-historical analyses or interpretations of any regularized kind, but rather to get clear about its distinctive way of working. Broadly speaking, the objective standing of the interpretation of particular paintings is normatively keyed to the very practice of phenomenological description and interpretation, regarding which, it is clear, fashions and sensibilities change, diversify, and gradually learn to tolerate departures from contingently entrenched canons.

Even so, a compelling case can be made to the effect that although logically looser than what is preferred in the experimental sciences, objective interpretation in the arts is neither arbitrary nor committed to any wanton inconsistency, even in tolerating incompatible practices and findings. On the contrary, its own rigor is enhanced by just that sort of amplitude.

In the literary arts, matters take a more radical and problematic form. For one thing, on an argument briefly sketched earlier, there simply is no salient sense in which the perception of literature rests on any mode of sensory perception comparable to what obtains in painting and music. Literature has often been viewed, for just this reason, as a dubious sort of fine art. Yet critical interpretations of the adventurous kind not infrequently favored in painting and music are nowhere more widespread, more vigorous, diverse, experimental, aware of their own history, attentive to the demands of their own characteristic rigor, than in literature. In any case, associations with the original meaning of the term "aesthetic" carry very little force these days.[18]

It is true, as already remarked, that to *see* the world a painting discloses is to understand the way our practice of viewing paintings rightly informs their perception. Here, seeing paintings and understanding literature converge to some extent. For we deliberately construe the visual sense of "perceive" generously enough, though responsibly, in order to accommodate what remains closely relevant to our perception of paintings but cannot easily be said to be separately perceived—wherever visual perception plays the executive role in our phenomenological response to a particular artwork (a painting, here).[19] When, for instance, you see something very similar to the "mysterious" Mona Lisa smile in a number of Leonardo's paintings, you may wonder whether the smile is no more than a vestige of Verrocchio's influence—or something else (as Freud suggests).

When Michelangelo presents Christ fully nude in the sculpture *Risen*

Christ (Santa Maria sopra Minerva), we cannot tell, although the Incarnationist doctrine was in full swing, whether Michelangelo's decision to do so, which was entirely congruent with presenting Christ "complete in all the parts of a man" and which raised objections at the time, was actually meant to comply with the Incarnationist doctrine itself. That cannot be *seen* phenomenologically, quite apart from the fact that it cannot be seen in any near-empiricist sense either.[20] Here, speculations about the artist's intentions and practice addressed to what *can* be seen are normally permitted to color our phenomenological perception of the sculpture itself. But there *is* a certain insuperable informality in saying so.

· · ·

In literature, the relationship is entirely reversed. There *is* no sensory basis (phenomenological or otherwise) *on* which the description and interpretation of "the world disclosed" might be said to depend: whatever we venture as a fair account of the imagined world of a poem or novel must be projected *from* our understanding of the piece in question. Our imagined world is inseparable from our understanding the piece's meaning. Understanding a particular novel is nothing but understanding how to read that novel appropriately, how to apply our trained mastery of an inclusive practice of reading to the apt reading of the piece before us—in effect, how to imagine correctly the world it discloses. That is, language is ubiquitous in the human world—for "metaphysical" reasons. (Our own second-natured nature depends on it.) We are not capable of any culturally developed practice at all if we lack the mastery of the natural language in which it is embedded: we are not yet even selves!

Nevertheless, if understanding a newspaper account of the fall of the Berlin Wall is normally and validly enhanced by visual memory and visual imagination, then why should we deny the relevance of such resources in rightly understanding and appreciating the "text" (or "world") of a poem or novel? "Text" and "world" are not exactly the same thing here, but understanding the first normally does not preclude imagining the world of its implicated work. The fullest "moral function" of a poem depends on imagination tethered to an artwork rather than to any set of separate words and sentences *not yet* interpreted (assembled) as rightly constituting that particular literary piece.[21]

It is improbable that the moral function of literature lies primarily with propositional truths.[22] It's the power of literature to originate and vivify

the pertinent possibilities of life that defines its moral function. Nothing could be simpler or more reasonable. It's certainly not plausible to suppose that imagination's moral function requires the continual discovery of new moral truths. (Literature would be hopelessly banal.) Also, of course, the moral can hardly be equated with, or exhausted by, the merely didactic. As far as my own sensibilities are concerned, I cannot imagine anything more persuasive (philosophically) about the moral function of literature and about the way a moral *paideia* instructs an "aesthetically" appreciative audience than in that audience's beholding Lear's dawning realization of his monstrous insensibility to Cordelia. Once you witness something of that quality, you cannot fail to see how the questions academic philosophy poses betray its peculiarly inapt formulations.

The practice of producing and viewing paintings is, in a sense, less essential to our "second-natured" nature (as emergent selves) than our linguistic fluencies. There is nothing that is essentially cultural that does not depend in a fundamental way on our linguistic competence: even the perception of another's character revealed in behavior and facial expression is guided by our linguistic fluency and the related aptitudes that depend on such fluency. For of course, it's our linguistic competence that accounts primarily for our powers of reflexive reference.

Yet, consider this. To be able to see the unbearable grace of Maria Tallchief's dying swan—where words usually fail—is, however specialized, continuous with our seeing the pathos of ordinary life. It's for this reason that, though literature depends directly on our mastery of the paradigmatic fluencies of language, it's the imaginable possibilities of the worlds that literature discloses—which themselves draw on the phenomenology of everyday life and which (in turn) we sometimes view rather like an imagined world (as in assimilating "life" to film or theater or literature)—that makes literature itself seem perceptual in the strong sense in which painting *is* primarily perceptual. (That is also part of the equivocal charm of television news!) Hence, although (as I believe) linguistic aptitude is the seat of the self, our powers of informed imagination more nearly define the channel of literature's moral function. It is by imagination's capacity to link fiction and reality in its ontically "neutral" way that we mark its (and our) capacity to understand and savor the possibilities of the human condition.

Furthermore, the interpretation of literature has its decidedly uncertain side, since poems and novels are normally taken to be independent, relatively self-contained, somewhat detached and free floating, seemingly

legible artifacts not noticeably "prepared" (in anything like Schapiro's sense)—apart from what we infer from interpretive evidence regarding a particular text. *Literary* pieces simply appear, in this respect, to have a certain presence within the "everyday" linguistic fluencies on which they obviously depend. They cannot be entirely detached, of course. But there is absolutely no reason to think their mode of meaning can be fixed primarily as an extension (however complicated) of any "conversational" sort.[23]

The explanation may be due to the fact that we ourselves, second natured as a result of having internalized the language and practices of our home society, regard our language and culture as perfectly "natural"—as, in an obvious sense, they are. There's often nothing to separate literary pieces easily from the play of ordinary linguistic practices (factual reports, for example), except perhaps for their seeming autonomy (which is almost never entirely reliable). Being artifacts ourselves (more accurately, hybrids, but in any case second natured), what is most natural for us, as selves, are the spontaneous fluencies of the enabling conditions of our hybrid existence. So there remains a need, certainly a use, for devices like the prepared surface that we usually find in painting, although it is obviously an alluring part of literary strategy to baffle the very perception of the "literary." Dostoevsky's journalistic touches should not mislead us regarding the complex constructions of his novels: they are not primarily conversational or reportorial forms of communication.

Language, then, is inherently artifactual, even where we cannot be sure of the demarcation between its literary and nonliterary uses. Our linguistic fluencies are natural nevertheless—though also culturally emergent and second natured. So, insofar as the linguistic is, correspondingly, paradigmatic of the entire cultural world, our grasp of language is, correspondingly, paradigmatic of our phenomenological fluency in painting as well as literature.

It is impossible to explain these fluencies in terms of any mere "empirical" correlation or convention involving, and restricted to, any supposedly deeper biological or physical sources. Ordinary linguistic fluency requires an effective and profound immersion in the cultural practices of a living society; it cannot be approximated, *except derivatively*, as a simulation by means of merely external or behavioral (or even mentalistic) cues, all of which must already be interpretively informed by a knowledge of an enabling cultural world. (There simply are no supervenientist correlations of any reliable kind between the physical and the cultural!)

Some South Pacific island languages, for instance, are said to be all but impossible to learn by "externalist" means, in spite of the seeming simplicity of their grammars, since their syntactic features are semantically embedded in an unusually "thick" way in conveying the exotic cultural experience and cultural memory of the people who speak these languages—not otherwise easily accessible from anything like the grammars of Indo-European languages. Chomsky's grammars would be utterly baffled by such complications.[24] We cannot rightly understand the fine-grained contexts of Intentional relevance and meaning by *any* empirically external means alone—cast, say, in non-Intentional terms: physicalist, "mechanical," neurophysiological, or extensionalist. There are no algorithms, no transducers, to be had here. (Think of the effective ways of learning an alien language: learning Chinese would be all but hopeless on behaviorist grounds deprived of cultural immersion.) Unless, that is, the reduction or supervenience of the cultural world (the Intentional world) could be demonstrated once and for all. There are, however, no remotely plausible or promising programs of such sorts for natural languages, though simulation is indeed both useful and impressive (see Chapter 4). Here you begin to grasp the good sense—at once moral, aesthetic, cultural, historical, even scientific—of Herder's insistence on the "concrete" and the "individual" (as opposed to the "abstract" and the "universal") in responding appropriately to works of art.

Faute de mieux, the cultural world may be judged to have emerged from the inanimate and subhuman world in a sui generis way as a result of successfully internalizing the emergent language of one human society or another—which, on the best evidence, must itself have gradually evolved from the incipiently proto-linguistic forms of primate communication. In turn, the primate forms were biologically grounded and must then have evolved very modestly by further societally entrenched discriminations that could easily have been regularized in proto-grammatical and proto-semantic ways—short of the functions of true language.

Two considerations are paramount here: one, that if any such conjecture were valid, it would certainly follow that the entire world of the arts must be an inherent part of any such emergent cultural world—"natural," of course, to the emergent human selves who inhabit such a world; the other, that the Intentional features of artworks and other cultural phenomena would then be directly discernible, as by perception and understanding, among the correspondingly apt (second-natured) selves who produce

and appreciate their Intentional handiwork. Furthermore, if the argument holds, then certain strong philosophies of art (Wollheim's, Danto's, Walton's, Levinson's, for instance), which attempt to treat artworks (chiefly paintings) as "mere" physical things may be shown to have gone astray long before they ever attempt to explain, say, the perception of paintings. They ought first to bring their conjectures into line with something close to the Hegelian corrective; but they cannot do that, for they favor externalist (that is, dualist) strategies of understanding (in the service of a weak reductionism).

My own Darwinian conjecture is meant to provide no more than a hint of the likeliest sort of empirical conception by which the Hegelian "corrective" ought to prove entirely acceptable now. Needless to say, it would outflank reductionism and dualism at a stroke; confirm the advantages of a phenomenological model of perception over any empiricist alternative; account for the encultured nature of human understanding in every sector of inquiry; confirm (accordingly) the inseparability of metaphysics and epistemology; comply with the decisive innovations introduced by Kant and Hegel in (our) overcoming the paradoxes of twentieth- and twenty-first-century Anglo-American philosophy (aesthetics, for the moment) as easily as those of the pre-Kantian Cartesian world (since they are basically the same); demonstrate the thoroughly naturalistic status of the concepts and processes of an emergent cultural world; reject (as a consequence) any disjunction between the work of the physical and human sciences as well as any privileging of non-Intentional inquiry over Intentionally informed inquiry; and (therefore) validate the prospects of objective inquiries of a thoroughly cultural sort (the description and interpretation of artworks for instance, the description and explanation of human life and history) in virtue (at the very least) of the thoroughly Intentional nature of the physical sciences *as* sciences (a philosophical fact suppressed or denied for entirely arbitrary and indefensible reasons).

The result would be what I suggest is a *philosophical anthropology*: otherwise, a thorough reconception of theoretical and practical inquiry that makes entirely legible the best parts of analytic and continental philosophy. But above all, it would problematize all presumptions of easy universality—in deference to historicity and the primacy of the local and concrete.

It needs to be said that apt speakers grasp the principal uses of ordinary language only in ways that are inherently improvisational, informal,

centered in the social forms of consensual tolerance, governed by insistent practical interests. In addition, all of this is context bound, honed by prolonged immersion in the life of a society, skillfully adjusted through palpable historical drift, and endlessly subject to significant divergences of local idiom and idiolect in substantive ways. Given all that, it is indeed a miracle that despite enormous diversity among the acoustic features of everyday speech, the deep uncertainties and inaccuracies of written language in "representing our thoughts and intentions," and the inherent indeterminacies of reference, predication, meaning, context, intention, and the like, we need not despair in our exertions at mutual understanding. Still, nothing yet acknowledged resolves the puzzle of interpretive objectivity and precision, especially regarding the logic of interpretation along relativistic and historicist lines.

All the more surprising, therefore, that the literary arts tend to favor little more than the most elementary counterparts of what I've called the "prepared surface" in painting: say, something like the formula "Once upon a time" or the usual conventions for printing a Shakespearean sonnet or representing terza rima. In painting, the practice is more instructive, precisely because the interpretation of painting depends on what is perceptible in the visual way, both empirically and phenomenologically; whereas, as already remarked, the literary arts depend, finally, on our linguistic *practices*. Syntax and semantics are not primarily perceptual structures, though speech and written texts provide appropriate perceptual cues for understanding discourse—"textual," therefore, in a sense akin to the richer, already encultured sense that answers to the priorities of phenomenological perception. This makes for a considerable difference between painting and literature in the determinacy and precision of meaning and meaningful structure.

. . .

For these and related reasons interpretive theories in the literary arts, as distinct from those in painting and music, are as wildly radical and diverse as they often are; or per contra, as conservative as they sometimes are in insisting on a single right interpretation (for every well-formed work)—in order to offset the imagined chaos produced by admitting the opposed sort of tolerance. In the philosophy of literature, the single-right-interpretation theory has been advanced both in the empiricist spirit by Monroe Beardsley and in a broadly phenomenological or hermeneutic

spirit by E. D. Hirsch.[25] Beardsley offers no argument at all to support his claim; and Hirsch pretty well concedes the impossibility of producing any uniquely compelling criterial account of genres, which he admits he needs (that is, an essentialist doctrine) if his own argument is to succeed at all. It can't possibly be secured, and as it turns out, no chaos follows from the defeat of Hirsch's dogma.

This is not the occasion to sketch a reasonable account of interpretive objectivity. (I've made the effort frequently enough.) For my present purpose, it's enough to note that the theory of literary interpretation is very closely tied to the theory of what a literary work is. I don't deny that, rightly understood, this must be true of every theory of interpretation. Nevertheless, I'm persuaded that literary theory shows much more scatter and divergence on matters that directly affect our sense of what should count as objective (in the way of interpretation) than is true in those arts that are perceptually grounded in the way I've noted in speaking of painting. I could easily mention a number of well-regarded theories of recent vintage that, though very different from one another (and likely to yield very different sorts of critical options in weighing up such theories), actually converge in treating a literary work as effectively open in principle to an almost unlimited variety of distinctly disciplined, robust, evidentiarily responsible, diverse, historically evolving, often incompatible and incommensurable (though still objectively valid) interpretations.[26] (Think here of figures as diverse as Roland Barthes, Harold Bloom, John Crowe Ransom, Stanley Fish, and Stephen Greenblatt.)

Part of the rationale for any such tolerance undoubtedly depends on admitting the historicity of the cultural world itself—the historicity of thinking, with respect, say, to both the creation of artworks and their interpretation. That by itself would hardly strengthen the intended contrast between literature and painting. It might still count, however, but only when applied, differentially, *to* specific literary pieces and paintings. Because, as I've been suggesting, the interpretation of literature depends overwhelmingly on our mastery of linguistic *practices* regarding fixing "meanings"—which are already notably abstract and subject to the vagaries collected earlier; whereas that's not quite true—or true in quite the same way—in interpreting paintings.

The plain fact is that we have here the beginnings of a theory of perception in terms of which we may plausibly speak of seeing pictorial representations *in* a painting; but there is no analogous sense in which we speak

of discerning meanings *in* a run of language or literature. Not only that, but "meanings" (the meanings of relatively isolated words and sentences) and, say, the meanings of poems cannot possibly be related (perceptually) in any way similar to the relationship that holds between "pictorial representations" and paintings. Once we notice the lack of analogy, we are likely to consider whether, for instance, it is entirely correct to speak of the interpretation of novels and poems as interpretations of (the verbal meaning of) words and sentences: we soon realize that it's not a perspicuous way of speaking, even if we continue to speak of interpreting literary pieces in order to fathom their meaning. The sense of the term will have shifted away from any analogue of what is usually central in painting.

It is never really verbal meaning that we finally seek, though what we find in literature may well require (usually does require) a great deal of care about verbal meanings. It is much more difficult to say what we *should* say we mean to unearth in poetry and novels when compared with what we grasp in the analysis and interpretation of paintings. But the literal-minded models of linguistic meaning—speech-act theory, the model of conversational implicatures, authors' intentions—are clearly mistaken and impoverishing. (That may surprise you.)

One thing we might say is that we mean to identify and interpret the world that a poem or novel discloses. Normally we imagine such a world as we read; but it is not an imaginary world simply because it is imagined.[27] An imagined world is simply *that*, possibly neither fictive nor real—fleshed out imaginatively, that is, by imagination, without ontic bias or commitment in either direction. A literary world is imagined in a sense that approaches, though never reaches, full equality with a pictorial world. I can add only the briefest thought here to mark the fact that translation follows the line of words and sentences, whereas interpretation seeks to capture the sense of an entire work. But translation makes no sense except hermeneutically, that is, on the assumption of an adequate interpretation by which it may be guided. Interpretation does not ordinarily generate a translation, though it must follow the verbal lines of a text. It's only that text and work are themselves hermeneutically connected in part/whole relations. Furthermore, if, as I say, artworks are only determinable in meaning, not normally determinate, then of course, plural, divergent, relativistic translations are well nigh ineluctable. The moral function of literature then is connected more with the work of interpretation than with translational accuracy—which, of course, makes perfect sense.

If you insist, however, that something similar to understanding literature is also true of the Intentional or significative structures of painting and music (grounded in what may be seen and heard), I would not oppose your claim—it would strengthen my thesis from a more oblique direction (though it remains a conceptual extravagance nevertheless).

It's just that a literary world cannot be *seen* in any sensorily qualified way; it can only be perceptually imagined—even if we suppose it to be grounded in our memory of the actual world. But the world of a pictorial representation *can* be seen, even if we suppose that that world is, finally, fictive, because of course, a pictorially represented world is not, qua representation, fictive at all. (So much for "make-believe.") Also, please notice, *the* world pictorially or linguistically represented is, as I say, determinable only, not determinate in the way in which we regard the physical world as determinate (whether with complete justification or not); so in our seeing (phenomenologically) what is represented in a painting, perception is made more determinate (though variably, for different percipients) by interpretive considerations that penetrate perception itself. Here, visual perception and visual imagination tend to be continuous and not always easily disjoined. We cannot, therefore, fail to mark an important difference in understanding and appreciating literature and painting.

I do in fact favor historicism, relativism, and incommensurabilism in the interpretation of all the arts. Still, the argument is more interesting when applied to the literary arts; it has a different lesson to offer than whatever may be drawn from the arts more closely bound to the sensory modalities. Perhaps the reason is this: visual imagination, constrained by verbal meanings, which are themselves already more labile than visual structures, is more labile than visual imagination constrained by visual perception.

Part of the argument rests on the difference between the relationship between verbal meaning and visual imagination (in literature) and between what is visible and what is visually imagined (in painting). If you think about the contrast in phenomenological terms, then the following findings seem quite clear: first, that what we imagine as the disclosed world of a literary work is open to considerable diversity—in a way that accords with a fair sense of validity—in something like the respect in which the different ways of mounting *Hamlet* may be thought to be imaginatively congruent with the "meaning" of the play. Second, whereas what we imagine as the disclosed world of a late Rembrandt self-portrait is, in large part, what we already claim to see (*phenomenologically*) *in* viewing the portrait

(within the terms of a larger practice). Music is problematic in a further respect, since much music is normally performed in terms of what can be heard phenomenologically and, at the same time, heard in accord with a relatively determinate and legible score. (Though that cannot be more than an oversimplification.)

The perception of a painting is then already prepared, phenomenologically, for discerning the visual world that it "discloses" to the trained observer: there is no clear demarcation line between such perception and visual imagination—though there are surely clear extremes. You must bear in mind that even in "the real world," in perceiving a mountain, say, we perceive a three-dimensional mass in spite of the fact that the mountain's volume extending behind its front surface cannot be "seen" in any restricted empiricist sense, though our own movements in the mountain's vicinity contribute data that confirm its three-dimensionality. Here, "theory" penetrates perceptual reports in a way that is not unlike the way in which, in speaking of paintings, visual imagination, "Intentionally" directed to what is perceptually disclosed, penetrates phenomenological perception. (The matter of judging the validity and objectivity of such reports cannot be settled in advance.)

In any case, if you consider literary theorists as diverse as Hans-Georg Gadamer, Roland Barthes, and Mikhail Bakhtin—or if you add others like Stanley Fish and Wolfgang Iser—you will be struck by the immensely diverse, freewheeling nature of literary theory—obviously centered on the troublesome question of how to discern the objective meaning of literary works under conditions of pertinent historical change, dialectic and local diversity, varieties of indeterminacy peculiar to verbal meaning, and the ease of penetration of verbal meaning by changing fashions of interpretation (and interpretive theory), as in George Thomson's Marxist reading of the *Oresteia* or Harold Bloom's interpretation of *Miss Lonelyhearts*. Anachronism, you see, is also an uncertain charge at times: Aeschylus may have thought of societal processes ancestral to Marx's theories. You cannot concede the admissibility of Barthes's reading of Balzac's *Sarrasine* or Bakhtin's reading of the Dostoevskyan "hero" or Gadamer's reflections on Paul Célan's poetry in the light of his doctrine of *Horizontverschmelzung* or Fish's way of validating his reading of Milton or Lukács's discovery of the unmarked subterranean narratives of Walter Scott's novels, if you have no pertinent theory of how the very nature of literature fits your claim.

I'm not interested in mounting a close argument here about objectivity itself. On the contrary, my thought is that whatever may be persuasive in this regard would have to come to terms with such preliminary reflections as I've been providing. They're not all preliminary, of course. Because the problem of just where we might claim to find "the meaning" of a poem or novel is so extraordinarily difficult—and the conditions of linguistic fluency so forbidding—that when we speculate *further* about how literature produces new forms of linguistic fluency that no one can possibly understand by consulting the entrenched forms of "everyday use" (to speak with Wittgenstein) or in accord with the canonical forms of some well-defined body of literature, we realize that our theories must be daring enough for the task. Imagine following James Joyce or Samuel Beckett or Stéphane Mallarmé. The diversities mentioned, then, are all to the good.

4

"Seeing-in," "Make-Believe," "Transfiguration"
The Perception of Pictorial Representation

LIVING IN PHILADELPHIA, a city that has benefited in a mixed way from rehabilitating its charming eighteenth- and nineteenth-century houses during a period of busy "gentrification," I must admit the melancholy truth that among the many failed attempts to fit new-fangled versions of the classic forms into architecturally significant neighborhoods, one comes rather easily upon innovations by obviously well-informed architects pleased to live in those same neighborhoods in their own creations. Their designs now clash with the lines of quiet grace of the colonial and Federal buildings that still stand among the living. They've made gymnastic reference to the original designs of the older buildings they deform—which can hardly be said to quote or copy them.

There's a lesson there that bears on the conceptual analysis of what we *see*, in seeing paintings. A not insignificant number of very well known recent Anglo-American philosophers of art have, for some inexplicable reason, abandoned the perfectly adequate truth that in viewing the paintings of the Western canon, we really do see pictorial images like the represented interiors of Vermeer's splendid canvases. These philosophers insist on substituting obviously contrived—utterly unsuccessful—perceptual analyses of what we spontaneously say we see in these cases, which do indeed remind us of what we used to say, which would now be regarded as a conceptual mistake according to the lights of these new theorists.

I protest. We don't "make-believe" we see (as one of these new voices has it), that is, make-believe we see Vermeer's pictorial representations of Dutch interiors, or make-believe we see real interiors when we see Vermeer's

paintings; we don't (as another of these philosophers maintains) "see" (in some forced sense of "see," but not otherwise: "seeing-in," as the formula has it), *in* admittedly seeing the painted physical surface of a Vermeer, a Vermeer interior, though we do (as the same argument assures us) trick our eyes as well as we can in order to trace the illusion of "seeing" that interior convincingly *in* what we actually see (the painting's surface); and we surely never need invoke the existence of any rhetorically contrived "artworld" in order to "transfigure," *as* perceptual, what the "eye [literally] cannot descry" so that we can then affirm, figuratively (not fictively) though falsely (if literally), that we do see, *in* seeing a painted canvas, what (for art-theoretical reasons but not otherwise) we correctly "identify" as Vermeer's interiors.

There! I've summarized three closely related conceptual extravagances that manage—well, almost manage—to return us to what we once believed we could literally see (and as I urge, we should still insist we see), namely, Vermeer's pictorial representations of Dutch interiors, Vermeer's represented interiors, Vermeer's interiors. That is, the authors of the celebrated claims I've just flagged—three of the most admired contemporary analytic philosophers of art—have, by turning away from the familiar neighborhood of actually perceiving paintings, invented a conceptual practice that in a simpler age had no need of such contortions. To make their case at all, they would have had to demonstrate that we *don't ever see* Vermeer's represented interiors—which they cannot show. As far as I can see, they never address *that* question; they hurry on instead to market their replacements, come what may.

I believe these maneuvers can be shown to be unqualified mistakes—breeding pointless paradoxes—for at least one supreme reason: they make no sense and offer no advantage *if we can* (as indeed we can) discern perceptually what they deny we ever see. The strange fact is that the perceptual claim they oppose produces no paradox or conceptual disadvantage of its own, whereas their corrections remain forever beset with insoluble difficulties: I mean their fall-back accounts of "make-believe," of what they say "the eye cannot descry," of what can only be experienced as "seeing-in" though never actually seen.

I have a name for these maneuvers: they're "Rube Goldberg inventions" pure and simple, ways of getting ordinary results, or simulating doing so, by preposterous and bewildering complications that, though totally unnecessary, finally deliver something close to what we wanted in the first place—for instance, turning the tap on by organizing the known

habits of all the rats and cats of the city so that by chance one or another sequence of the chase will trip certain contingent sequences prepared in advance that without further human intervention will actually turn the tap on and fill a bottle prepared for that eventuality. (Rube Goldberg, you probably recall, was the creator and draftsman of a fondly remembered American comic strip from the 1930s that specialized in gentle and harmless conceptual nonsense.)

The point remains that we must still gain the original objective we require in order to make sense of what would otherwise be a strange detour. Goldberg's variations—may I call them that?—are still better than "seeing-in" and the rest because "seeing-in" is a deliberate impoverishment of what we actually see, in seeing a pictorial representation, now somehow precluded by the improvements tendered.

Put more seriously, the theories of perceiving pictorial representation that I've sampled so unceremoniously suffer from a well-known philosophical malady: the fear of ever admitting in an unguarded moment what may be difficult or impossible to reconcile with the otherwise fashionable presumptions of the philosophical age to which we belong and to which we may be antecedently committed—say, one or another version of "scientism" or reductionism or extensionalism akin to the once-authoritative pronouncements of early twentieth-century philosophies of science,[1] which among authors like those just sampled needn't (it seems) be explicitly endorsed in their most robust forms. I have no wish to pursue this aspect of the matter here; I wish only to restore an acceptable account of what we see in seeing pictorial representations. But I think we must acknowledge that the views I've barely sampled do signify a widespread growing tendency that gives recent Anglo-American analytic aesthetics an air of hard-edged precision that it has yet to earn. (I think it cannot succeed.)

I've singled out three figures for a closer look. But I venture to say that parts of their strategy motivate, in different ways and with different benefits—sometimes marginally, sometimes eccentrically—many contributors like Monroe Beardsley, Nelson Goodman, Arthur Danto, Richard Wollheim, Kendall Walton, George Dickie, Gregory Currie, Jerrold Levinson, Noël Carroll, Dominic Lopes, and Robert Stecker among a goodly multitude, even though the larger scientism that links their local efforts is not always easily discerned in the scatter of their different inquiries.

The most interesting and important of the three specimen views I've tagged is Wollheim's, because in speaking of "seeing-in," Wollheim never

abandons a "perceptual" emphasis.[2] Even where the other two discussants still speak of the perception of paintings—Kendall Walton (speaking of "make-believe"), Arthur Danto (speaking of the "transfiguration" of the "commonplace" or of what the eye allegedly can and cannot "descry")—they turn away from visual perception to some nonperceptual determination of what we say we "see" *in* seeing paintings or pictorial representations.[3]

I should like to harvest in a careful way the arguments I've seeded in a somewhat spendthrift spirit, almost by impulse, over the entire philosophical field. It may improve the quality of its yield a little, though possibly at the cost of counting some of the berries twice. I've already said more about Wollheim's theory than about Walton's or Danto's with regard to fundamental comparisons that need to be made, though also, perhaps, more about Danto than about the other two, where the deeper strategies make themselves known. I shall set all of this out a little more explicitly than I have and trust you will find what I mean to recover worth the labor. (I allow myself to betray an air of continual exasperation here.) I'll keep as closely as I can to the analysis of pictorial representation.

. . .

Here, then, is Wollheim's formulation:

Seeing-in is a distinct kind of perception, and it is triggered off by the presence within the field of vision of a differentiated surface. Not all differentiated surfaces will have this effect, but I doubt that anything significant can be said about exactly what a surface must be like for it to have this effect. When the surface is right, then an experience with a certain phenomenology will occur, and it is this phenomenology that is distinctive about seeing-in. Theorists of representation consistently overlook or reduce this phenomenology with the result that they garble representation. The distinctive phenomenological feature I call "twofoldness" because, when seeing-in occurs, two things happen: I am visually aware of the surface I look at, and I discern something standing out in front of, or (in certain cases) receding behind, something else. So, for instance, I follow the famous advice of Leonardo da Vinci to an aspirant painter and I look at a stained wall. . . . The two things that happen when I look at, for instance, the stained wall are, it must be stressed, two aspects of a single experience that I have, and the two aspects are distinguishable but also inseparable.[4]

What Wollheim says is reasonably clear, however problematic its claim may be. (It seems to go part of the way in the right direction—but not really.) For example, if seeing-in follows Leonardo's instruction,

then the characterization I've just given of Wollheim's account (that is, that he never abandoned the perceptual emphasis) is probably inaccurate or rests on an equivocation that is never satisfactorily resolved. Wollheim may then mean that seeing-in is *not* a form of actual perception—or better, not a perception *of* what belongs to the actual Intentional structure of a painting, but may be traced out (perceptually, by somewhat hallucinatory means) in its physical surface. If it is not that, it may be a form of visual imagination (which of course Wollheim does not mean). He clearly does not mean that seeing-in is not a form of seeing but only a form of imagined seeing imported for the purpose, *or* a peculiar mix of seeing the painting's physical surface and then imagining the painting's pictorial image triggered by seeing-in, *in the physical surface* of the painting, what *we* thus produce—all within what Wollheim (rather cleverly but fatally) calls "a single experience" rather than a single perception. I don't believe this muddle can be made less muddy. The idea of seeing-in obscures—better, *erases*—the reality of paintings' representations![5]

If you grant this much, you cannot fail to see that *if* Wollheim supposed that in distinguishing between Leonardo's parlor trick and the serious business of *correctly* viewing a painting, what would rightly accord with what the originating artist intended us to "experience" in viewing the painting—a scruple it would be fair to say Wollheim and Danto share in similar (but different) ways and for different (but related) reasons—would have trapped him between the horns of an insuperable dilemma. For if the constraints of "correct" viewing (the right replacement for seeing-in) were based on artists' intentions, Wittgenstein's lethal move against private languages would instantly come into play; and if Wollheim admitted the public practice of making paintings, he would have conceded a condition (the existence of a representational medium) that would preclude the need for the machinery of seeing-in itself. *Tertium non datur.* Hence, normative considerations undermine the entire *jeu*. Wollheim and Danto would have made their "variances" utterly unnecessary—even contradictory.

What I suggest here may not quite capture what Wollheim actually says (and means), which seems to feature a kind of "seeing" *akin to* (but not actually) a gestalt switch between figure and ground, as by visually tracing the "figure" we "choose to see" (more accurately: "choose to experience" as if it were a matter of genuine vision) *in* what we actually do see (in, and as, a painted surface). Both possibilities (the elements of twofoldness) are open to us, of course, but *seeing a Vermeer interior is not like either of*

them. They lack perceptual properties of the pertinent Intentional kind. A mere painted physical surface, you realize, is not as such a representational medium. Nevertheless, both elements are, pertinently, visually discerned in paintings.

Certainly, there is no way of reading what Wollheim says about seeing-in that would not entail linking that sort of seeing to the perception of a mere physical surface. But that yields a double mistake: first, because there is then no specific *perceptual connection*, in addressing the perceptual features of a *given painting*, that joins the two elements of the supposed twofoldness *in the same sense* of perceiving—as opposed to the sense of a single experience; and second, because the perception of the pictorial (or Intentional) representation we normally admit we find *in a painting* would (on Wollheim's view) be admissible only by simulation, only by way of *external* (mentalistic) intentions, effectively by abandoning all reference to the public practice of art history and art criticism. I take this to be a valid reading of the intent of Wollheim's Mellon Lectures.

That would mean that there never were any pertinent Intentionally structured elements *in* the painting (*ante*) that we could rightly claim to see; it would also mean that there never are, there couldn't be, any Intentional structures *in* perceivable paintings as such: all such supposed structures would never be more than *externally* traced by artists and audiences in accord with their own private intentions applied to painted surfaces, even if cleverly enough constructed to be copied by future admiring audiences. There's the reason Wollheim believes he can consistently maintain that paintings are physical objects: they never violate the adequation rule because *they* never possess Intentional properties in the first place. Imagine going to an art museum to trace out, by Leonardo's trick, what we otherwise claim to see directly and what, because of that, assures us that Leonardo's game does not go astray. I don't deny that Wollheim allows the provision to lapse when he discusses actual paintings, but he holds it in reserve nevertheless.

In seeing the Vermeer, we want to say we are not imagining seeing it, or supposing that we see it only because we have tricked the eye in something like the way Leonardo recommends. Nothing of the kind is normally needed in seeing pictorial representations. We need never confuse *our tricking the eye in viewing a mere painted physical surface with actually seeing a Vermeer.* They are two entirely different undertakings. Think of confusing a parrot's voicing sounds that *we* might use as words as if they

were (though we know them not to be) pertinent responses to what we actually say in a running conversation. *We* are trained to see the paintings of our canon in a fluent way: it's part of the acquired phenomenology of viewing paintings. What does Wollheim think a human agent is? Can he really speak a language if, in principle, he cannot paint a Vermeer or grasp it perceptually?

When, to consider another case, I look in the mirror and *see* my reflected image, I am *not* "seeing" the image in the sense of seeing-in—*in* seeing the surface of the mirror—*that* would-be image: I literally *see* the reflected image when I treat the mirror (as I spontaneously do) as a distinct medium of perception akin to but very different from the prepared surface of a canvas. They call for different but related forms of perceptual "know-how." I normally treat mirror images in a realistic way (seeing myself "in the mirror") even when the image is distorted. But *when* I see a pictorial representation in a Vermeer, I never see it (perhaps that's too strong a statement, though I doubt it) as something that can be explained (as by invoking Leonardo's trick) as a parasitic way of "experiencing" some assuredly prior or primary way of seeing the physical surface of a painting. Yet if we admitted that, *neither* of the would-be elements of twofoldness could possibly be viewed in the same phenomenological way in which the pictorial image is normally admitted to be *seen*. They could never be parts of *one* perception; they could only be parts of "one experience."

I say I *see* the surface *and* I *see* the image (in the painting) *in the same sense of "see,"* even where I don't see the "same aspects" or the same details (of what I *see* phenomenologically) when I simply switch from surface to representational image and back again to surface. (Phenomenal discrimination may be reasonably viewed as an abstracted restriction of what we can report we see, phenomenologically.) My point is that the *surface* of the painting, which is not, or not merely, the surface of the *canvas, is seen phenomenologically*, in the very same sense of "see"—*if* we see the image in the painting at all—that Wollheim denies obtains. Wollheim thinks we *don't* see the physical *surface* phenomenologically. (If I understand him rightly, we experience things phenomenologically but *see* things phenomenally!) But if twofoldness holds, we "experience" what we thus "see," phenomenologically. For we fuse the two elements of twofoldness in "one experience," though not in one sensory perception! It's precisely in this sense that Wollheim actually slights the perceptual questions: it looks as if we never really see pictorial representations, according to Wollheim.

Here, I suggest Wollheim and Danto converge much more than is usually admitted, though they do so from completely different vantages.

. . .

It's easier now to fathom the more explicit proposals advanced by Walton and Danto. But if you read Wollheim along the lines Walton and Danto favor (which is hardly unreasonable), there will be rather little to distinguish any one of the three from the other two, though they favor very different strategies. The trouble, as we've seen, is that Wollheim is terribly vague, where precision and clarity are wanted.[6]

Consider Danto very briefly then.[7] I limit my remarks to what bears most usefully on Wollheim's account of twofoldness and seeing-in. Danto strikes me as more explicit and more penetrating on perceptual distinctions, though he, too, is not explicit enough (or not compelling enough in what he makes explicit). What he says in the "Artworld" paper and in *Transfiguration* (which predate the Mellon Lectures) seems almost "reconfigured" by Wollheim in his account of twofoldness. If that's a defensible comparison, then we're well on our way to confirming the common bond between them. I have no confidence in the relative chronology of their respective theories, but I daresay their convergence is not accidental.

I can now offer the knockdown argument wanted by simply citing two small passages from the "Artworld" paper. As far as I know, Danto has not changed his view in any essential way on the issues at stake here. The first passage concerns the important difference Danto introduces between the "'is' of identity" and the "'is' of artistic identification": he never tampers with the standard notion of numerical identity, but he invokes the second in attributing various sorts of intentional and culturally freighted properties that he wishes to impute to artworks and actions—where, for reasons of conceptual consistency, "mere physical things" *cannot* be admitted to be numerically identical with "artworks," as far as viable predication is concerned—since certain attributes that *are* rightly ascribed to artworks cannot (literally) be ascribed to mere physical things: Intentional attributes, of course.

"Artistic identification" designates whatever incompletely specified "relationship" is thought to hold between physical things and "artworks" (if "relationship" is the right term—it seems it cannot be) in virtue of which we are (magically) entitled to impute whatever we rightly do impute to "artworks," though in reality we still (always and only) address "mere real

things." There can, therefore, be no discernible (no actual) relationship between artworks and real things: the difference between them is entirely discursive or conceptual—in fact, rhetorical; *not* substantive at all, unless to say that the difference's not being substantive is itself a substantive distinction.

Put more simply: *if* the Intentional properties predicated of artworks were intended in realist terms, then artworks and mere real things could never be numerically identical. But since in Danto's view they are numerically identical (if they are both real), and since physical objects cannot literally be ascribed Intentional properties, artworks are not real at all but only the "internal objects" of rhetorical ascriptions applied to real things! Danto's admirers have never been able to resolve this astonishing dilemma.

Danto avoids as well as possible assigning any substantive existence to artworks as solid as what he seems to be willing to admit in speaking of mere physical things—which persuades me to suppose that the fairest characterization of Danto's thesis is that the "'is' of artistic identification" signifies a rhetorical or figurative (possibly even a functional—but not a fictional) "identification" *of* a "physical thing" *as* a posited "artwork." But of course, if *that* were true, *assuming that we cannot see what doesn't exist*, it would follow that *no one ever sees an artwork—a painting, say*! To say we "see" a painting might then be to say we "imagine seeing" what we cannot actually see. But then, I don't think this *is* what Danto actually means to say.

I don't believe Danto is committed to any form of make-believe, although he admits a similarity between the use of the "'is' of artistic identification" and the make-believe play of children. I also don't believe he holds that in viewing artworks we are merely imagining that they are actual; or that we are discounting our knowledge that they don't exist, for the sake of our interest in the arts. That would be preposterous.

He means rather that in assuming that a viable realism is ultimately some form of materialism—this is the point of his criticism (in *Transfiguration*) of Wittgenstein's account of the difference between an action and a bodily movement, *and* of advancing his own account of action, *and* of advancing a congruent account of art—there can only be a "rhetorical" overlay of "theory" by means of which we can hope to treat artworks (and actions) in the realist idiom at all. The trouble is, *we can't do* what Danto claims we do regarding art and action *wherever we turn to selves and language and history*. Here, *I* say, if we can't apply the thesis to the latter, we can't apply it to art or action either; and if so, then Danto's rhetoric becomes something altogether different—possibly an incoherent doctrine.

For if art cannot be suitably reconciled with a viable realism, then neither can selves or persons.[8] Of course not. If Danto really believed in some final physicalism or materialism, but knew he couldn't make the case convincingly, he would know he hadn't earned the right to treat selves as real and art as a *façon de parler*. He would know he hadn't justified the opposed treatments of artworks and selves. But the fact remains, Danto has very strong views indeed about the *perception* of paintings, and these would lose their moorings altogether if the transfiguration thesis were abandoned.

I acknowledge that Danto (who, we know, practices as an art critic as well as a philosopher) always speaks of paintings *in* visual terms; but I see no consistent way of understanding what he says unless he means we *see* actual physical things regarding which we visually imagine (rhetorically rather than fictively) *that* the intentional and culturally freighted properties we impute to them (as artworks) *are* rightly thus imputed. Somehow he draws these imputations from a separate knowledge of artists' psychological intentions and craft abilities (and the history of art—now a problematic discipline), by invoking which we permit ourselves to speak of works of art as actually seen. Although, on the argument given, they *cannot be seen*! If we saw them, of course, we wouldn't need the rhetorical prosthesis Danto offers. The incoherence cannot be overcome.[9]

What Danto says provides a more radical option than the one Wollheim seems to favor; for Wollheim speaks unequivocally of perception, which ranges (equivocally) over the dual "aspects" of twofoldness. It's not at all clear that Wollheim *can* hold fast to his own thesis consistently. In any case, if what I've said about Danto is valid, then if he wished, *he* might have introduced (though no less problematically) a more radical account of twofoldness and seeing-in than Wollheim favors—one in which, precisely, *neither* "aspect" need implicate a kind of perception (*of artworks*) beyond whatever was admitted to be involved (according to Danto's account) in the perception of "mere real things."

Here then is the first of the passages promised:

[The "is" of artistic identification, or its cognates for different sectors of the human or cultural world] is in common usage, and is readily mastered by children. It is the sense of *is* in accordance with which a child, shown a circle and a triangle and asked which is him and which his sister, will point to the triangle saying, "That is me"; or, in response to my question, the person next to me points to the man in purple and says "That one is Lear". . . . "That *a* is *b*" [in the sense of the "is" of artistic identification] is perfectly compatible with "That *a* is not *b*" [in the sense of the "is" of numerical

identity], though *a* and *b* are used unambiguously throughout. . . . [T]he *a* stands for some specific physical property of, or physical part of, an object; and, finally, it is a necessary condition for something to be an artwork [*b*] that some part or property of it is designable by the subject of a sentence that employs this special *is* [of artistic identification].[10]

You realize that on Danto's theory as presented here, artworks "possess" physical properties only in the rhetorically restricted sense of the "is" of artistic identification, since *artworks* cannot actually be seen in any sense in which physical things are seen; you must also see then that physical properties and physical parts (the "*a*" of the formula that defines artistic identification) never include any properties or parts that, according to Danto, are predicated of, or rightly imputed to, "artworks" if we are ever tempted to speak in realist terms of artworks at all! (Consider the clever but uncertain wording of the phrase just cited: "designable by the subject of a sentence that.") But just there, I find myself forced to conclude that on Danto's theory, *artworks cannot be perceived at all—paintings can never be seen*—not merely because their "existence" is not suitably supported but because the existence of inquiring persons, human agents, hasn't been suitably secured either! I don't believe you can have the one without the other.

The second passage is probably the single best-known pronouncement in Danto's arsenal:

[T]o see something as art requires something the eye cannot descry—an atmosphere of theory, a knowledge of the history of art, an artworld.[11]

Now, keeping Wollheim in mind, I cannot see how this does not oblige us to conclude that (1) what "the *eye* can descry" answers to some account of visual perception fitted to physical things, without any provision for culturally or intentionally qualified properties—some strong form of phenomenalism I would assume; and (2) none of what we can *say* about artworks, even if in perceptual terms addressed to culturally qualified attributes (expressive, representational, significative, or the like), can—strictly speaking—be more than a fictive or rhetorical or imaginative or alterative way of speaking of what we actually see in the first place ("mere real things"). Here the paradox seems incredible yet, textually, perfectly explicit.

We see that Danto's formula may indeed relieve Wollheim of *his* paradox, but only at the price of a deeper paradox. In any case, I think I have now explained the fair sense in which both Wollheim and Danto return us

to the competence of the perfectly ordinary ability to *see* (in the phenomenologically trained way) whatever we say we see in seeing a Vermeer interior, but now only by way of a Rube Goldberg strategy that cannot actually secure its seeming goal—and appears not to realize that it must fail.

. . .

I need add only a little regarding Walton's alternative strategy. Walton's *Mimesis as Make-Believe* is a genuinely provocative book. But what concerns us is no more than a plank in the conceptual platform on which the whole of its account finally rests. The full theory applies to all the arts, of course; but since we are talking about the perception of paintings here, I shall ignore its wider applications—even though difficulties with Walton's general account of representation adversely affect important applications to the arts beyond the analysis of paintings.

Here I rely on a compelling dictum that is well-nigh universally shared that bears in a very natural way on our theory of pictorial perception: namely, that human beings hear speech comprehendingly, *not* mere sounds *first* that they very cleverly and instantly construe as spoken language. Given the immense variability of spoken English, say, it is quite impossible to suppose we could ever map the entire run of sounds produced in speaking a language, apart from and prior to attempting to match such a mapping with our actual command of a spoken language. Fluency in cultural life is in large part a matter of improvised and habituated consensual tolerance in the service of sequences of shifting practical needs in the here and now, which rarely allow time for deliberate approval of the use of any determinate rule or rules.

There are no rules for "admissible" sounds conveying meaningful speech, except in the Pickwickian sense of relying on linguistic mastery itself; and there, there are no normative rules of any sort that a spoken language could ever be shown to be bound by—even though there are, of course, tolerable and salient (slowly changing) regularities that belong to each local language. More tellingly still, there's good evidence to show that the fluencies of speech are such that we often are not aware of the acoustic features of actual speech when we follow its sense closely. It takes a thoughtful moment to grasp the marvel of such fluency. But it means that we cannot really doubt we hear and understand speech at least as spontaneously as we discriminate sound; and that if that's true of speech, it must be true as well of pictorial representation. In other words, to be a cultural

transform—to be a person or self—is to be adept at processing Intentional phenomena even where it means scanting the physical phenomena in which the other is embodied or incarnate. (Think, for instance, of what that might signify for Darwinian survival!)

In a way then, similar to that in which we learn to hear speech, I say we learn to see pictorial representations: we don't see visual marks or patches first and then (and only then) cleverly "imagine," or "see-in," or rhetorically "transfigure" what we straightforwardly see in the physical world; so that, on the improbable assumption broached for the moment, we may be obliged to say that we imagine or pretend in some perceptually fictive or rhetorical way that we are actually viewing a "world" when we cannot really be doing so. There's a clause too many there. The fact is, we *see* a depicted world in the same sense in which we hear speech: we see it in the same way we see the surface *of the painting* (which is not, I remind you, the same as the surface of a painted canvas, but readily includes it). Seeing the surface of a painting is continuous with seeing its depicted world, of course, just as hearing the sounds of what is said is normally continuous with hearing speech itself; although from time to time, seeing (or hearing) this or that occludes seeing (or hearing) some part of the same perceptual space. What we say we hear as physical sound, in hearing speech, is colored by our hearing speech; and what we say we see as paint on a physical surface, in seeing a painting, is normally qualified by our seeing the painting itself. We have no comparably ramified account of how human beings come to see whatever they see as human beings: our theories of perception hardly reach to a theory of human being. But the fact remains that in matters of cultural fluency, it's the emergent, significative, semiotic, expressive, representational, and presentational "world" that dominates our sensibilities, *not* the would-be phenomenal accusatives of the biological gifts from which they arise. Walton, Wollheim, and Danto have got things backward. Humans are so altered by acquiring language that they couldn't possibly survive unless their cultural world was as real as what they take the physical world to be. But if so, how could Walton possibly be right?

The same trained habits of hearing and seeing are implicated in attending to the dual "aspects" of the perceptible things we report we hear and see as artworks. That is what we signify by calling perception phenomenological: the restriction to the "purely" visual in any ocular or physiological or informational sense is never reportably visual, except by theoretical subtraction *from* within whatever *is* phenomenologically given—what

answers to what we are culturally trained to discern (or report) as given. (There is no satisfactory closure for any purely phenomenal space shorn of Intentional features.) That, if you allow an aside, is precisely what is so remarkable in Hegel's Introduction to the *Phenomenology*. It's precisely what the reductionist aestheticians of our day willfully override, though Hegel is easily as empirically minded as they.

If this be admitted then, as with speech, there are no determinate rules—certainly no rules that must be strictly satisfied *ante*—regarding how to view paintings, if we are ever justified in claiming to *see* a painting's representational content correctly. The whole affair is profoundly informal, though reasonably regular and orderly: much in the way a knowledgeable community of those who learn to see paintings and practice their perceptual skills in a fluent way (possibly as art critics, even if as amateurs) tend to anticipate a wide run of evolving, even diverging responses—of a "confirmably" pertinent kind—*to* the paintings they encounter. That's all! Or all that's needed in order to speak responsibly of seeing paintings (or hearing speech).

I suggest that something of this sort is the most plausible and economical way to understand what happens when we see paintings. Anything more pointed or more detailed is bound to be less important to our question—the question of what is "given" perceptually—no matter how important it may be elsewhere. I venture to say, therefore, without having explicated Walton's theory, that such considerations must defeat Walton's account out of hand. His theory of "make-believe" can't be true and can't be adequate either. He's got the cart before the horse; and what he offers as the cart is no more than one (very slim) possibility among others that are likely to be more adequate. Well, there's the charge at least. You will have to be the judge.

Of course, in saying what I say, I don't deny that Walton is very knowledgeable about the arts. He's prepared to advise us about how to view this particular painting and that. So is Danto and so is Wollheim. But that hardly assures us that their theories of what is going on are actually correct or convincing. In fact, Walton "corrects" Wollheim's account of twofoldness, bringing it into line with his own theory of make-believe:

The duality consists simply in the fact that one uses the picture as a prop in a visual game: one imagines seeing a mill [viewing Hobbema's *The Water Mill with the Great Red Roof*], and one does so because one notices the relevant features of the canvas.[12]

There are two important weaknesses in these remarks. First and most important, Walton's book is premised on our knowing, for reasons that are never actually supplied, that we can explain the perceptual phenomenon of Wollheim's twofoldness by "notic[ing] the relevant features of the canvas." (You realize Walton is speaking of the physical surface.) But if you look carefully at his argument, his primary effort is to assure us that we can indeed, by doing what he says, actually confirm the twofoldness phenomenon itself (in *his* way, against Wollheim) and explain it satisfactorily by treating "the picture as a prop in a visual game" of *make-believe-seeing*, a game of fictive seeing—that is, of doing something that is *not* actual seeing at all! Walton therefore rejects Wollheim's literal formulation and replaces it with an account that candidly features the *perceptible physical properties of the canvas* and a *nonperceptual analysis of "seeing-in."* (If this is what he means, then I would say Walton actually repeats what Wollheim says—but more explicitly.)

I should like to be more generous here. The reading I've just given fits the passage cited from Walton, because just there, Walton links the visual properties of a physical canvas (not yet a painting) with *its* use as a prop in a game of make-believe (regarding the would-be depictions). But there are other passages in which Walton does not really resist the idea that we do see pictorial "depictions" as the representations they are, though in seeing them thus, we also always use them as props in a game of make-believe. The first of these options is little more than a variant of Wollheim's account or an even weaker alternative, since Wollheim seems to insist on a perceptual reading of seeing-in. The second is implausibly strong. For if, straightforwardly, we *do* see pictorial depictions, then there's an end to the matter, except to explain just why our doing so should ever count as a standard form of perception. In any case, it's hard to see how *any* intuitive account of the bare perception of representational pictures would, in the face of widespread denial and disbelief, be said to require the further game of make-believe. No one needs to believe it to make sense of pictorial depiction.

Let me add now, perhaps prematurely but for ease of reference, a brief overview of where we are. Regarding pictorial representation, all three of our theorists begin with the perception of a physical surface. Wollheim relies on a kind of forced viewing, a variant of Leonardo's trick, grounded in the perception of a painted surface. Danto weakens the perceptual element, since he treats artworks rhetorically as ways of talking about "mere

real things"; Wollheim admits real paintings but not perceptually acces-
sible Intentional structures inhering in paintings—except by imputation.
(Or if he allows such ascriptions literally, he does so inconsistently, since
he explicitly holds that paintings are physical objects.) Danto is careful
to extend the perception of painted surfaces rhetorically, according to
our knowledge of "the artworld," so that we can speak, consistently, of
artworks in Intentional terms. Here it seems, the perception of paintings
must be the work of a rhetorical use of some run of visual imagination ap-
plied to the actual perception of painted surfaces. Finally, Walton eschews
the niceties of Wollheim's and Danto's accounts and opts instead for the
straightforward game of actually seeing painted physical surfaces—*and*
fictively seeing their represented worlds as real. All three appear to offer
variants of the same strategy; namely, that there is no literal sense in which
we really *see* the represented worlds *of* paintings. But that is (or would be)
false to the reported (the phenomenological) facts; and besides, it could
never be more than a Rube Goldberg simulation, a contrived reduction of
the perception of the Intentional structures of paintings that we normally
admit to be "given."

I am prepared to qualify my verdict somewhat—though I see no
reason to relent on essentials—because of the fuzziness of what Wollheim
and Walton sometimes say. But it hardly matters. Because there can be no
doubt that neither is prepared to dwell on the perception of Intentionally
qualified structures. There'd be no point in raising the question of pictorial
representation in the first place if the perception of Intentional properties
were never center stage. Wollheim's slippery reliance on Leonardo has, as
its purpose, the evasion of the Intentionality issue; and Walton simply
buries the question in his essentially noncommittal remarks about genres
and style in the familiar traditions of painting. You cannot find enough in
either to get to the heart of the matter.

To return then to the passage taken from Walton's account: as I read
him, Walton's first notion is a close cousin to what Danto offers in the "Art-
world" paper, and the second entails a rejection of *any* perceptual account
of seeing-in—which (as I've already demonstrated) is really quite similar
to what Danto proposes. But I cannot see any reason Walton gives for sup-
posing that we draw the "rules" or "principles" for guiding our perception
of *paintings from* the perceptual layout of the merely physical properties
of the canvas. I'd say that *that* would violate the lesson I've already drawn
from our ability to hear speech. (The "perceptual layout" of a painting

can never be restricted to the perceptual layout of its physical surface; but to admit that our "make-believe" is guided by the Intentional layout of a given painting is already to obviate the need for make-believe itself.)

I see Walton's maneuver, therefore, as a kind of tautology. If we may assume (with Walton) that *we know how to view a painting* (something more than knowing how to view a physical canvas, because, of course, we must already know how to view the details of the canvas as properly matched to the way the painting should be viewed), then what Walton says (in the remark cited above) will simply be vacuously true, as far as making our response *to the painting* "depend" on viewing the *canvas* "correctly"— that is, in noticing "the relevant features of the canvas."[13] Viewing the canvas "correctly" means, of course, viewing it *as the painting it is*! (I can do no more than repeat myself here.)

This brings us to the second weakness promised, which depends on the first. It is not in the least clear (thus far) that the appropriate response *to seeing the canvas is*, indeed, the same as playing a certain game of make-believe *with the painting—or with the canvas*! (Could make-believe possibly count as a variant of Leonardo's trick?)[14] Also, as I've been arguing, if we do see pictorial representations (phenomenologically), then if we choose to play a game of make-believe *with the painting*, that game will be something over and above our seeing the painting itself. It will yield something more than what is seen, even if as a result we happen to see the painting in a way that spontaneously enriches what we see.

Visual imagination, you realize, is not as such a fictive imagining of the visual kind. To speak in the latter way intrudes a clause too many. It's an elementary mistake to think it must be fictive: it's open to the generous exploitation of mere visual possibility; it's hardly confined to the counterfactual. Hence, we have no reason to suppose that seeing the physical properties of a canvas *must* (for reasons bearing on our understanding the tradition in which canvases *are* rightly viewed as—are culturally transformed into—pictorial representations) initiate (in any pertinent sense) a game of make-believe with the "world" of the painting (making-believe that the fictive world is real and really seen).

I myself have seen a great many paintings. We all have. But I have never felt the least twinge of impropriety in not having been tempted to play make-believe with particular canvases or paintings. (Frankly, I think the pornographic possibilities of make-believe are much more compelling than Walton's polite alternative.)

But I need another citation or two to fix the second lesson believably. What I wish to say is that once we see a painting—see its pictorial representation—there's absolutely nothing more that is essential to our seeing it that could possibly depend on playing a game of make-believe. Walton is simply wrong in supposing that when "one uses the picture as a prop in a visual game [of make-believe]," one is simply responding to the "rules" or "principles" that govern the tradition of viewing pictures. Surely that's false—or at the very least, it's an odd choice of words for a common practice of perceptual attention. Because viewing a picture in whatever way we do (when we actually see it) completely obviates (renders otiose) whatever might be supposed to be gained perceptually by *first* playing a game of make-believe; we couldn't play *correctly* if we couldn't explicate what rightly counts as seeing the very painting *to which* we need (or are invited) to respond in Walton's way. In fact, the very idea that the game of make-believe might be needed to constitute a painting in the first place would violate our knowledge of the art traditions on which it must depend! That's what I mean by saying that Walton's got the cart before the horse.

Here then, for the sake of a fuller argument, is how Walton continues the account begun earlier:

> Are the principles [involved in seeing a painting] biologically grounded, as Wollheim thinks the capacity for picture perception is, or cultural artifacts, as Goodman contends? I am sure they are some of both. . . . Evidence that chimpanzees understand pictures or can be trained to, or that natives of an isolated tribe do not understand them without special prompting, is beside the point. What is important for depiction is how the principles are used—whether they are used in appropriately visual games of make-believe—not how they or the ability to use them thus is acquired or who does or does not possess it.[15]

Obviously, Walton believes that a picture "is [essentially or normally] a prop in a visual game" of make-believe. *That is its most characteristic function.* But I see no argument—certainly none that Walton provides—that demonstrates why this is or should be so, or that it is necessarily so, or that make-believe contributes *anything* to the perception of a picture, or even that the detailed "appropriateness" of any make-believe can be straightforwardly confirmed (if it must accord with what we actually see) without addressing the complications of explaining what it is we do see when we see a painting. I don't deny that painting as a "prop" in a game of make-believe calls for imagination rather than perception; but it calls for imagination guided by the pro-

prieties of actually perceiving a pictorial representation (neutrally or at least nonfictively). I confess I am completely unaware of any rules or principles of make-believe that are standardly implicated in viewing canonical paintings.

For some unfathomable reason, Walton believes that if we see a pictorial representation, we are fictively imagining that we really see the "world" of that "depiction." Thus he carefully instructs us in the logic of fictionality; but he somehow conflates doing that with the analysis of pictorial representation. Here's another explanatory remark that's intended to clarify our scruple about fictionality—at the same time it's meant to redirect us to the "principles" and "rules" of seeing pictures:

Is there, for every fictional proposition [or pictorial representation] a requirement that it be imagined? . . . A proposition is fictional, let's say, if it is to be imagined (in the relevant context) *should the question arise*, it being understood that often the question *shouldn't arise*. In normal cases the qualification can be understood thus: If *p* is fictional, then should one be forced to choose between imagining *p* and imagining not-*p*, one is to do the former. When I speak of prescriptions to imagine in what follows, I will take them to be so qualified.

Principles of generation [say, in a game of make-believe or in painting a picture] can in general be construed as rules about what is to be imagined in what circumstances, but only if we are careful to disavow certain likely implications of this term. Calling them rules may suggest that they are established by explicit fiat or agreement and consciously borne in mind in the contexts in which they are operative.[16]

You have to ask yourself whether Walton means to *label* the actual perception of pictorial representations an exercise in make-believe or means to draw our attention to an operative sine qua non for "seeing" representations in the first place. The first possibility, I suggest, is philosophically harmless (and unnecessary); the second is philosophically incoherent. In any case, *if* imagining a pictured world is taken to be fictional, then *that* constraint cannot but be arbitrary *if* the "rules" of painting lead to the production of actual pictorial representations *that are then to serve* as props for the play of imagination; for then, what serve as props are not imagined at all but *actually perceived*!

In fact, when he moves to improve on Wollheim's twofoldness formula, in addressing the question of perceiving "depictions," Walton confounds perception with make-believe once again:

What is that special visual experience? What is a person doing when she sees a dog in a design? She is participating in a visual game of make-believe. What is special about

her experience is the fact that it is penetrated by the thought, the imagining, that her seeing is of a dog (as well as by the realization that it is of a picture).[17]

This strikes me as completely wrongheaded. At the very least, Walton admits that we *see* pictures and that these may include a picture of a dog—whether or not we play a game of make-believe.

Walton's cautions are welcome enough, but they don't touch the essential difficulty—which appears at the very start of his book. I can only cite it in its opening version and say once again that it seems as uncompelling at the end as it does at the beginning. I must remind you, however, that in speaking of rules in his careful way, Walton is signaling that all we need here to make the game of make-believe do the work it does is agree that the rules answer to the artist's original intention or to some adjustment of it in the direction of an enculturing tradition of the art in question—some form of intentionalism, in short, or something very close to it, along Rube Goldberg lines.

In any event, I've made the countercase as well as possible: it's simply that make-believe makes no perceptual contribution and depends, in its passing, on an analysis of perception that Walton nowhere supplies. (It *alludes* to our knowledge of the pertinent traditions and practices.) Here then is the opening remark that assures us that it is also the sense of how the book ends:

In order to understand paintings, plays, films, and novels, we must look first at dolls, hobbyhorses, toy trucks, and teddy bears. The activities in which representational works of art are embedded and which give them their point are best seen as continuous with children's games of make-believe. Indeed, I advocate regarding these activities as games of make-believe themselves, and I shall argue that representational works function as props in such games, as dolls and teddy bears serve as props in children's games.[18]

I can imagine richer possibilities (even of make-believe), but we cannot reach them by merely following Walton's advice.[19]

The decisive point remains as follows: Walton's account requires, for internal reasons, in spite of everything he says, our acknowledging that pictorial representation *can't* be characterized (as such, or first) in terms of fictionality or make-believe. It must be a distinct kind of structure that we actually find in the real world. In fact, when all is said and done, it's clear that the bare need for the sort of grand apparatus our three theorists bring to the analysis of pictorial representation instantly evaporates, once we acknowledge—what any museumgoer straightforwardly admits—*that*

we actually do see, and learn to see, pictorial depictions in a sense that affords a compelling analogue of our obvious ability to hear ordinary speech. None of the obscurities, paradoxes, Rube Goldberg devices that bedevil the accounts I've reviewed are ever needed—or are ever perceptually instructive in any decisive way. The truth is they all spring from the same philosophical wish to reduce, to bring as close to elimination as possible, all reliance on the "metaphysics" of culture in accounting for any of the critical and perceptual (Intentional) complexities of the arts. But that, as I say, would inevitably reduce or eliminate whatever is distinctive of the human self— in effect, the artists and audiences who populate the cultural world. We cannot rightly diminish the nature and perception of artworks wherever we admit the emergent powers of human agents and what they utter.

If you allow a quiet warning: we are in danger here of losing our philosophical moorings.

Epilogue
Beauty, Truth, and the
Passing of Transcendental Philosophy

IN HIS WONDERFULLY LIGHTHEARTED BOOK *Kant after Duchamp*, Thierry de Duve reminds us, by an unmarked implication, of the utterly baffling, improbable, historically inert, all but irrelevant initial pronouncements on taste and beauty that may be found in Immanuel Kant's *Critique of Judgment*—which might have been rectified long ago by an obvious and still needed reform, after all the learned mischief possible has been wrought, by simply replacing the analysis of natural "beauty" by the analysis of "art."[1] It's a change long overdue, now courageously managed through the crazy distraction of Marcel Duchamp's blessed (would-be) submission of his readymade (*Fountain*) for the 1917 Independents' Show in New York (but never shown), which adds some complicating nonsense about "art" to Kant's own nonsense, and which at the right time would certainly have made unavoidable a frontal revision of Kant's aesthetic formula if that had not already been required by events as early as those of the modernist art world of the century following the publication of the third *Critique*.

I don't mean to suggest by this that de Duve's effort is not a serious one. Far from it. But the absurdities in the entire chronicle that spans the reception of Kant's *Critique*, the independent history of Western painting that should have tested the perspicuousness of Kant's original thesis at once, the extraordinary challenge posed by Duchamp both to the perceived coherence of the evolution of nineteenth- and twentieth-century painting and the philosophy of art that shadows that entire story—which de Duve captures in all its bewildering extravagance but which he also skillfully penetrates in an oddly sane way by simply imagining something

like a running exchange between Kant and Duchamp—make us wary of *his* own ingenuities as we consider the potential idiocy of *our* now attempting, early in the twenty-first century, to put the entire matter of truth and beauty in the plain way it plainly deserves. The relentless rationality of Kant's analysis of beauty and the sociopathic possibilities of Duchamp's theatrical intervention, the work of two skeptics of a seemingly kindred sort, have prompted de Duve to substitute, quite deliberately, the term "art" in all of Kant's textual paradoxes originally reserved for natural "beauty," as a quick way (so I surmise) of redirecting aesthetics to its proper business.

The immense scandal created by *Fountain*, a response of an uncertain kind to the innovations of the preceding century, completely disorganized conventional philosophical (even art-critical) conceptions of art, beauty, and taste, which, in spite of a general grasp of the implications of Duchamp's act, has remained, particularly in the Anglo-American academy, at the nagging edge of high philosophical interest down to the 1970s and 1980s (and even now), without disturbing the academy's Olympian treatment of Kant's newly minted discipline of aesthetics (now also called philosophy of art).

The Anglophone effort (possibly a large part of European speculation as well) absorbed Duchamp's mortal joke as if it were a normal event that might arise as a matter of course. De Duve sees in this the possibility of a belated change of focus, quickly arrived at, by displacing the privileged role of Kant's utterly unworkable notion of natural "beauty" by the equally problematic notion of "art," though the idea seems not to have improved the philosophical analysis of either in any noticeable way. De Duve, I think, supports the change with an eye to further subversive or comic possibilities—and may not be overly sanguine about what to count as a correction. Perhaps then I may be pardoned for dawdling a little too long on the seeming bad luck of Kant's beginning the new discipline in the eccentric way he favors. I hope so.

I cannot hide the fact that I believe—I don't mean this in an unkind way—that Kant's discussion of beauty and taste in his account of aesthetic judgment is completely wrongheaded, saved (if that is the right word) by his unmatched recuperative power to snatch philosophical victory (by sensible second thoughts added by a kind of layered prudence) from the unrelenting disaster of his usual executive intuitions—a factor that appears as well in the great first *Critique* (with respect to science) and in the *Founda-*

tions of the Metaphysics of Morals (with respect to morality). You have to read Hegel's *Lectures on the Fine Arts* to appreciate the extent to which Kant was culturally unprepared to discuss aesthetic judgment in the context of the classics of Western painting; or you may read Hegel's critique of Kant's first *Critique* and his analysis of the vacuous Categorical Imperative to see just why, in spite of the obvious truth that, in his magisterial way, Kant always manages to set the crucial philosophical questions for the age— that is, for the two centuries plus that follow his innovations—although it begins to appear that the lengthening history of philosophy will probably follow Hegel's correctives (not Hegel's doctrines), or will as a result at least avoid Kant's outlandish assumptions.[2]

We are hardly more than fledgling philosophers here, replacing, plank by plank, Kant's transcendentalism with one or another increasingly lean reading of the master themes (effectively, Hegel's) of historicity and cultural transformation—a painful, very slow process that slips back two steps with every forward step it takes. If you favor the impolite thought I am trying to present politely, you must realize that the invitation to explain the current state of play in Eurocentric philosophy regarding the linkage between truth and beauty is itself, subversively, an invitation to bear witness to a great muddle that actively resists resolution—and has resisted for more than two hundred years. Historicity and the sui generis distinctions of the cultural world were effectively introduced into Western philosophy at the end of the eighteenth century, flourished for a time, and are now very much in retreat. The very plausibility of Kant's undertaking depends on the ease with which we accept that decline.

In the *Critique of Pure Reason*, for instance, Kant is obviously misled in a headlong way by Newton's excessive, entirely unsecured claims regarding absolute space and absolute time and what he (Kant) thinks his own attack on rationalism (and his acting to save Newton from himself) requires in the way of purely subjectivist resources; in the *Foundations*, he chooses to rely on the supposed concern of a completely invented alien form of reason that benignly occupies itself with the grand labor of explaining how the practical interests of ordinary human beings may be brought into accord with a form of moral necessity that masquerades as freedom and might never have been chosen by human agents who had not already read Kant's explanatory doctrine; and in the matter of beauty and taste, Kant turns to the ordinary pleasures of viewing sunsets and mountains and flowers and animal forms, which he unaccountably transforms

into feelings of pleasure he says are never encumbered by practical interests or critical concepts or historical orientation, which (if true) would simply preclude whatever might be of philosophical interest in our enjoyment of the arts themselves.

No one as brilliant as Kant, or worth comparing claim for claim, was ever quite as obtuse in his initial orientation in the third *Critique*. That's perhaps to say a great deal more than de Duve means to consider. The state of play may be even worse with respect to the issues of the first part of the third *Critique* than arise in the other texts mentioned. Still, I see no convincing way (pace Kant) to separate our topics in the arts from those that concern what we take to be known and real in the sciences, or right and obligatory regarding morality.

You realize that when Kant speaks of the pleasure we take in painting, he is thinking (as his British and German precursors typically do) of the pleasures of mimetic representation—hence, of the dependence of our taste in viewing paintings on our taste in viewing nature. The connection is then made to account for the plausible claim that our aesthetic "feelings" are rightly characterized as the universal response of humankind *and* the explanation of how the gift of artistic genius grounds aesthetic universality and confirms the conceptual linkage Kant finds between art and moral sensibility.

That's quite a lot of trickery. It's hardly a negligible part of Kant's theory that if the inventions of genius should (as they may) exceed by too much the universal response of the "common sensibility" of humankind (*sensus communis*), genius rather than taste will have to yield because the opposite would defeat the universality of our response![3] That, of course, would confirm in spades the intolerable tension between Kantian universality and Hegelian historicity—and the ultracautious resolution Kant actually favors. For the priority of moral universality in Kant's entire system could hardly afford to concede the pertinence of the free play of the historical evolution of *sittlich* practices on which (for instance) a Hegelian alternative would rightly depend. Hegel, I admit, shaves the scatter of history in too sanguine a way. Duchamp is a threat to both.

You may, indeed, recognize a similar worry (and similarly improbable compromise) in Hans-Georg Gadamer's open acknowledgment of the historical diversity of both the hermeneutic and moral orders and, inconsistently, the unexplained convergence (in terms of meaning and morality) upon the classic (largely Hellenic) ideals of human nature that (somehow)

remain essentially the same through all the vagaries of the drift of history.[4] That is undoubtedly part of the price of Eurocentric loyalty, which our own world cannot quite dismiss and cannot swallow whole.

It's in this sense that I admire de Duve's deft way of turning the question of aesthetic judgment from the dead-end of harping on the beauty of nature to our evolving inquiries bearing on the appreciation of artworks. I'm assuming I've caught the point of de Duve's wit: the nice opportunism that spots the drastic use to which Duchamp's burlesque may be put if, whatever may still be usefully drawn from either part of the third *Critique*, we remain as slow as we are at freeing ourselves from Kant's original formula.

I think de Duve means to turn us, finally, in the direction of invoking a historically and art-critically informed sensibility; and that may indeed require an intellectual shock among philosophers. Beyond all that, it's entirely possible that de Duve and I must part company: I can't be sure. (It doesn't rightly matter here.) But I would say (even if *he* would not) that historicity supports no more than provisionally constructed generalizations, never (faute de mieux) substantive necessities or exceptionless universality; and that *that's* always enough for both practical and theoretical concerns, which under the condition of history are ultimately one and the same.

To put the point more effectively, perhaps more cryptically: historicity—the doctrine that thought is an inconstant, evolving artifact of cultural history—arises in a philosophically viable way only in the setting of a constructivist account of realism (which—the latter thesis—is indeed Kant's most daring and far-reaching invention); yet in its rendering substantive necessity and universality impossible to confirm, historicity construes the intelligible world as a flux, not a chaos, and erases any principled disjunction between theoretical and practical reason (which—the latter thesis—proves to be the essential point of Hegel's answer to Kant, the answer of the extraordinarily gifted Kantian that Hegel surely was). If so, then on balance aesthetics is naturally closer to the general strategy that views the whole of truth and validity as the systematic work of inquiring minds who treat every form of objectivity as an artifact of their historied critique of experience. I see this also as close to what de Duve endorses in Duchamp's critique.

The West has always been tempted to think that the psychological and cultural world of human sensibility will be explained, finally, in terms of some form of physicalism—the master theme of what is known as the unity of science program; but the inexorable drift of philosophy's history—in which the analysis of beauty and taste may count as no more than a

small, late clue about philosophy's most promising trajectory—now finds itself attracted more and more insistently to the thought that reductionism cannot be more than a posit of what, for limited purposes, our own uniquely emergent form of encultured intelligence is prepared to identify as the form its own physical sciences must take, even as it admits inquiries that favor an entirely different tack. The question of the relationship between beauty and truth, fixed in the Western mind by the implicit contest between Kant and Hegel, cannot possibly fail to signify the analysis of that same piece of history.

You have only to ask yourself how improbable it would be to prioritize Kant's insistence on natural beauty, or the universality of Kant's technical notion of aesthetic pleasure, in any informed account of what actually interests us in Western painting after Manet, or before the Renaissance in medieval Europe (if we do not permit transcendent symbols to devolve into the merely mimetic), or indeed, how the "aesthetic" (whatever that may mean from time to time, or now) could convincingly occupy the completely changeless, completely *natural* role Kant assigns it in the first part of the third *Critique*.

The matter would be negligible but for the fact that Kant's preposterous (but terribly ingenious) thesis not only continues to exert enormous influence on the analysis of beauty and taste and aesthetic judgment (against the times), but does so in a way that makes no provision for historicity at all or for the contingencies of encultured human life—which, remarkably, are often not even seen to be thus impoverished.

Kant obviously knew exactly what his metaphysical system would tolerate conceptually before he ever bestirred himself to reflect on the saving themes of genius and the educative function of the arts in his moral universe; but even these themes, grand as they are, which develop in the second part of the third *Critique* and which do indeed save Kant's reputation from substantial infelicities, are finally only subsidiary to the monumental issue Kant worries even as he resists the unwelcome insistence of his one-time student, Johann Herder, whom Hegel saw at once was on to an essential theme not rightly acknowledged in, or incorporated into, Kant's all-inclusive aesthetic system.[5]

What, in effect, we witness here is the imminent collapse of a closed conceptual world even before its ink has dried. It's the effect of a conceptual crack seemingly arrested for more than two hundred years of rearguard loyalty to Kant and pre-Kantian thought that has no serious hope of

keeping the world safe from the penetration of the Hegelian themes that begin to collect even before Hegel's intervention.

That alone, you realize, defines the nerve of *anti*-post-Kantian post-Kantian thought—namely, a very large part of contemporary thought. Genius and art's moral function are themselves the admission of the need for prior categories of understanding—let us say—that belonging as they do to the world of historical culture are nowhere provided among the resources of the first *Critique* and cannot be additively reconciled with the categories the third *Critique* affords. That's part of what's inexorably at stake in recovering the conceptual linkage between truth and beauty.

The second half of the third *Critique* shows the fatuousness of the first half but doesn't actually secure the grounds on which it itself counts as an advance over Kant. History and culture are acknowledged but never acquire a systematic role that might begin to compare with the cast of Hegel's thought. Kant's achievement here is a sign of his larger failure, his incapacity to reach the conceptual amplitude of his own "post-Kantian" critics. The question remains whether *we* are prepared to surpass Kant, which is to say, to begin with Hegel (or better, with the Hegelian themes that refuse to countenance the categories, or the legitimation, of transcendental reason)—that is, begin with the profound conceptual innovations of an entire, largely neglected world (the world of human culture) that no one seriously believes can be reduced in physicalist terms: roughly, the world that includes artworks, human selves, history, language, concepts, truth and knowledge, morality, science itself as a human undertaking.

I put the point this way in order to draw your attention to just how much is impoverished or distorted by ignoring the fact that the analysis of truth and beauty is itself a cultural feat of a high order regarding certain sui generis distinctions. I mean this as a gloss on de Duve's clever use of Duchamp as a corrective against Kant—perhaps then, as a continuation of Kant's better impulses. The master theme of Hegel's confrontation with Kant rests entirely with the idea that all the forms of conceptual intelligibility are, finally, transient artifacts of cultural history that achieve different measures of reliable generality; although we do indeed dream of reaching to necessity and universality. Hegel believed an evolving network of changing generalizations must be sufficient for human needs and that Kant nowhere offers a reason to doubt that that is true.

We cannot "improve" on Kant in any tidy Kantian way. The question of how the analysis of the arts fits with our more established discourses

about science and morality requires a fresh legitimation. Perhaps the reverse is true for science and morality as well. But even if we permit ourselves to ask just how any informed inquiry in the arts (or culture or history) might yield confirmable truths or objective appraisals of particular pieces, we would have obliged Kant to give up his tripartite (perhaps, more finely divided) logic of judgment in favor of a completely informal, uncertain continuum of inquiry that admits no settled division of labor involving the partitioned use of concepts, perceptual sensibility, imagination, and feeling that could, in our time, redeem anything like Kant's rigid optimism. The history of Western thought has run its course in such a way by now that we must either run with Kant or with some leaner progeny of the post-Kantian world (probably, with those who favor historicity and enculturation).[6] There you begin to sense the importance of what to say about beauty and truth.

You must consider what Kant means by defining genius as the natural gift—"the inborn predisposition of the mind"—"through which nature gives the rule to art": that is, *not* by applying scientific rules in creating art but by an "exemplary originality" in which (so to say) the would-be rule of production is drawn *from* an appreciation of some unique work itself—as if *its* "rule" could be copied by lesser artists. Hence, Kant maintains that "beautiful art is possible only as a product of genius" (because we cannot conceive the rule by which it is produced); yet it also prompts a certain free play between concepts and imagination, without ever allowing the judgment of beauty to rely on any determining concept (as it would if it were a cognitive judgment). Hence, aesthetic pleasure in the object may be thought to be (but cannot be confirmed to be) universally valid.[7] There you have the gist of Kant's baffling formulation.

Nevertheless, if you see the point of this extraordinary machinery—including the clever way in which Kant makes beautiful art a "symbol" of the universality of freedom and the moral good—you see how much is risked against easy and obvious defeat once we acknowledge that *the history of painting* has completely superseded any necessary mimetic norms. Kant obviously rests his confidence in the universality of the beautiful on the ability of genius to invent ever-fresh forms of what, in retrospect, may be thought to please us in the aesthetic way. Yet if, as much with Manet as with Picasso, Kant's claim (to the effect) that we respond to the beautiful in art as if art were *nature*, though it obviously remains art, would thereupon have to be completely abandoned, we would soon realize just how

preposterously arbitrary Kant's claim must be. Why should we not follow art's actual trajectory?

The argument shows that the history of art obliges us to turn away from Kant to the contingencies of historical taste and talent. Art becomes palpably historicized! Here, let me suggest, *if* you even begin to concede the pleasure of (largely) mimetic painting (supplemented, in whatever way you think reasonable, by considerations of formal design), that you already glimpse how impossible it remains for Kant to escape the *cognitive* constraints of genres and the like. The bare notion of the *relevance* of aesthetic pleasure completely knocks out the ingenuities of Kant's solution—in particular, the distinctive universality of the aesthetic judgment. Nevertheless, de Duve's replacement of "beauty" by "art" anticipates these inadvertences. Seen thus, the application of Duchamp to Kant's doctrine cannot but be subversive, even if de Duve supposes that it is also recuperative.[8]

In short, I emphatically deny that there is any principled compartmentalization among the cognitive achievements of science, morality, and the appreciation of the arts. That was indeed the culminating claim of Kant's conceptual revolution. It took barely a generation to glimpse its falsity *and* the deeper irony that in defeating all the forces of Cartesian thought, it reinvented them—as if to strengthen the least tenable assumptions of early modern philosophy. In effect, it reclaimed what, precisely, it had already defeated! Hegel seems almost to have been born with the insight. But our contemporary world has not yet completely exorcised the original mistake or its protean possibilities. So to respond now to the question before us is to risk a deeper innovation.[9]

Kant's aesthetic theory should have refused any privileging of the beauty of nature over the appeal of the art world: first, because (as in fact Kant's account affirms) the admission of beauty requires some sort of free play between imagination and concepts that never come together in the cognitive way the first *Critique* requires, which thereby inserts a paradox too busy for its purpose in the arts; second, because the distinction between cultural artifacts and natural objects should have been seen to expose the unlikelihood that whatever was needed in the appreciation of artworks could be satisfactorily drawn from the enjoyment of nature, where, if aesthetic pleasure is indeed a sui generis culturally formed mode of appreciation, our enjoyment of nature probably follows our enjoyment of art rather than the other way around;[10] and third, because once the foregoing is admitted, it cannot fail to be a contingent matter what, exactly, interests

us in the arts: whatever that may prove to be is bound to be serially formed and eclipsed by the continuing evolution of cultural experience itself—which would certainly support emerging generalizations of a pertinent kind but hardly any universality of the strict kind Kant favors.

. . .

I've flogged the argument more perhaps than I should have. But Kant is a figure one corrects at one's peril. Viewed in the large, modern philosophy—including *modern* modern philosophy, that is, contemporary, postmodern philosophy at least—cannot advance without superseding Kant. Kant is the Janus figure of the Eurocentric world. He's the final guardian of the most ancient pre-Kantian wisdom he dares recover by reinvention: the drive for invariance, universality, substantive necessity, the systematic conceptual closure of the world, the coherent orchestration of the separate constitutive faculties of cognition and judgment, the primacy of reason, the deepest suspicion of the contingent and the accidental in human history, the fixity and clarity of all the categories and predicates of analysis that determine truth, the science of science, the objectivity of the subjective, the disjunction and unification of the theoretical and the practical.

All this has proved to be completely retrograde, once we've discovered Kant's instinctive avoidance of historicity and the generative flux of cultural life—the bedrock (if you don't mind my saying so) of the human condition itself. Kant's guardian labors are now impossible to validate in their original form; they are in fact undermined by the subversive import of his own mode of recovery. (Think, for instance, of how "transcendentalism" has morphed, in Ernst Cassirer's contributions, into the "philosophy of symbolic forms.")[11] Kant's original labors have become the stuff of alien philosophical dreams, the legend of a discipline's official past rolled up in a neat ball in the third *Critique*, a vision challenged in effect by the minor disturbance of the paradoxes of aesthetic pleasure. Kant risks by that the deeper question of the pertinence of cultural diversity to his own apriorist undertakings, the meaning of the transience and heteronomous scatter of history, the apparent inability of his conceptual system's fixities to assure us of the bare intelligibility of ordinary life. The very oddity of his choice of vehicle in conveying his new argument casts doubt on its literal relevance in any sense in which de Duve's suggestion that we should substitute "art" for "natural beauty" might tempt us.

Kant lifts the transcendental lid a little to test for the possibility of suppler, more informal powers of judgment than he's admitted in accounting for science and morality; but then he shuts it tight again, when he's convinced himself that he can fit beauty somewhere well enough within the play of feeling, among the settled interstices of imagination and the concepts of the understanding, cleverly separated and rejoined, no doubt by Kant himself, in order to disallow any cognitive pretensions in the name of taste: *not* as far as anyone can tell, in accord with the actual ways in which we take pleasure in, and instruction from, *the arts* even more than nature, which, as it happens, the fluency of civilizing practice has raised up to the status of a much-admired public discipline.

Kant succeeds by demonstrating that he can always recover the universality of judgment, come what may: he was apparently worried about that. He fails then for that reason, because he proves the irrelevance of his systematizing success. Think here of Lessing and Winckelmann and of the English essayists of the eighteenth century whom Kant very much admired. They all examine the matter of taste and judgment in the setting of cultural history and the pointed examination of works of art. Taste and even the attribution of truth appear, as we approach our own time, increasingly (and responsibly) as the *constructions* of critical history. For whatever would now appear to be needed to decide the cognitive standing of our different kinds of judgment are systematically marginalized or omitted in Kant's account.

Kant then is finally as backward looking as any pre-Kantian whom he chides. He recovers the pre-Kantian doctrines he prefers by strategies that are brilliantly fresh and forward looking: he invents a new form of de facto privilege—transcendentalism: the search for the synthetic a priori necessities on which all knowledge and valid judgment are alleged to rest—that appear, de jure, to have abandoned the privileged assumptions of the rationalists he defeats. He does this by the simple device of analyzing what is passively or naturally "given" in perception and experience so that *that* is never privileged in the old way he rightly scorns; yet the would-be facultative "conditions" on which what *is thus given* can still be converted into knowledge, can *also* (in their own right) be shown to provide what is necessary and universally sufficient for doing so. Extraordinary!

It turns out, therefore, that a clever adjustment in the third *Critique* makes it possible for Kant to claim that beauty and the judgment of taste may be entitled to a kind of validity without any pretense at all of resting on

cognitive grounds. It's a brilliant maneuver that obviates the need to treat art criticism and the appreciation of art as having any obvious standing at all! Yet in his zeal to justify the universal validity of aesthetic judgments, Kant simply puts out of play the idea of mastering the cultural history of the creation, connoisseurship, and appreciation of the arts themselves.

Kant's answer hangs by a thread, endangers more than he realizes. For in the constructivism that makes his master stroke possible at all (in science and morality), the indissolubility of what is "given" in perception and experience and what is claimed about the world (the inseparability of the subjective and the objective, or of the active and the passive) is never strong enough to ensure the recovery of the transcendental grounds Kant claims for himself. Accordingly, the partisans of historicity (Hegel, most memorably) find no difficulty in demonstrating why Kant is unable to distinguish in principle between what is merely accidental and what is essential in the recovery of objective knowledge. Kant's mistake about the necessary truths of Euclid's geometry and Newton's assumptions regarding time and space ineluctably confirm that the natural sciences are as much subject to historicized conjecture as is aesthetic taste. But if that is so, then truth itself may go the way of taste. Imagine that!

Defining beauty makes no sense in Kant's eyes if it isn't completely captive within the terms of his own conceptual world. But the contingencies of beauty and taste are the most obvious symptoms of cultural diversity and evolving change that can be imagined—and never controlled. How could they ever have been converted into the pillars of conceptual fixity?

There'd be no point to talking about these matters if it weren't for the fact that Kant stands astride the entire Eurocentric world—perhaps then as a sign of weakness, he stands astride the whole world—as no other figure has ever done before or since. He brings us to the river but cannot cross over to the new shore. He overcomes the conceptual separation of the knower and the known, which has remained in force to this day; but he himself resists considering how that single discovery might actually subvert his own theory about the necessary conditions of intelligibility and objective knowledge. To ask now what beauty *is* in the scheme of things, how it might be read as a kind of noncognitive response to a changeless order embedded in a changing world, simply misses what Kant himself set in motion—which was to be radically transformed by Hegel.

The very intelligibility of the world is *our* construction: we cannot prise the world apart from our picture of it, and we cannot see ourselves as

separable from the conditions of that picture's "possibility." Kant is never entirely clear about this. We construct ourselves as we construct our picture of the world; accordingly, our picture of ourselves and of the world keeps changing relentlessly: that is, we never see the eye's seeing what it sees! Beauty and taste are the fragile signs of human constancy; but then, they're also the most certain symptoms of inconstancy. But if so, then I should make amends by beginning again in a more promising way. My best suggestion, I'm afraid, may be even more brazen than before.

Just think of beauty, I advise, in a way that goes completely contrary to Kant's intuitions: you'll come closer to an acceptable account of aesthetic interest and judgment than anything Kant works out. *He* elevates the most improbable possibility as our most likely option; so *we* must press in the opposite direction. Beauty in the human body, let us say, characteristically answers to our abiding interests, both natural and artifactual: perhaps then, beauty is originally grounded sexually or linked to animal vitality and strength and fluency of bodily movement, or to the effects of such strength and fluency. (To say this, however, is not yet, of course, to analyze beauty—or taste for that matter.)

Kant insists, perversely, that beauty in the aesthetic sense is necessarily disinterested, whereas we are now concerned to test the advantage of saying the opposite. But what could Kant have meant by the "disinterested" if that entails no pertinent or criterial use of concepts at all? I say the idea's incoherent: I think, for instance, of the beauty of certain ingenious arguments in Euripides' tragedies that only someone reasonably informed about the Greek theater could possibly identify and appreciate. Think of how, in the *Hippolytus*, Euripides originally has Phaedra seduce Hippolytus by means of an argument that proves that the seduction is for his own good! Spectacularly pretty as an argument that might easily belong to the sophistic practice of the times—not, of course, as a moral recommendation. The Athenian audience of Euripides' time would have been delighted with the Aristophanic farce at the heart of the tragedy. The authorities found the idea unacceptable and (we are told) obliged Euripides to assign the speech to Phaedra's nurse. I have no wish to make too much of this; but isn't it clear that a handsome argument is handsome in its proper context? Beauty, like goodness, will always hold in some regard or other; will need a cognitive side; will be debatable if it is at all settled by judgment—but hardly on universal grounds.

How would the beauty of Nefertiti, represented in the Berlin head,

or the beauty of the Taj Mahal, make any sense if neither were considered critically against the backdrop of a run of encultured taste, or as the yield of a certain cultural history? I've seen both beauties and find my own taste made stronger and more coherent as a consequence. But both are the result of the development of a contingent style. You must be suitably instructed to catch their beauty in a spontaneous perception.

I see no inning at all for Kant's theory of disinterested, natural, ahistorical, conceptionless, aesthetic pleasure. It's a poor joke that once distracted one of the great minds of Europe. Even that would not be terribly serious if it were not for the appalling fact that the Eurocentric world seems to have gone over the cliff with Kant!

De Duve's summary of the four "moments" of Kant's analytic of the beautiful in the third *Critique* is helpful:

Kant was the first to point out, once and for all, the contradictory—antinomic, he said—character of an aesthetic judgment. He was talking about the judgment of taste, in other words, about the evaluation of beauty, mostly in nature. When you say, for instance, looking at the sunset, "it's beautiful," you express a personal feeling. You are free to have such a feeling, therefore your neighbor should be just as free to experience this sunset as in no way beautiful at all. Yet you didn't say, "I like this sunset"; you said that it was beautiful, *as if* its beauty were objective. Saying so implies that it should be, and it ought to be, beautiful for everyone, *as if* the sunset's beauty were both a natural fact that should be recognized and a moral quality that ought to be approved, although it is neither, being merely the result of your feeling. (Hence beauty as a symbol of morality, and the faculty of aesthetic judgment as a cognitive power even though it "cognizes" nothing.) You therefore are asking for universal acceptance of your judgment of taste. . . . You therefore attribute to all of humanity a *sensus communis* which is nothing other than the capacity to make aesthetic judgments.[12]

I don't know when I've seen a more agreeable piece of subversion mingled with astute correction. De Duve means of course that, on Kant's terms, if your neighbor finds unbeautiful what you find beautiful, he has as much right to take the universality of his own judgment in vain as you do in taking yours. Which is to say, the argument of the third *Critique* is a mug's game if it is allowed to stand. Hegel had long ago played the same trick on Kant's *Foundations of the Metaphysics of Morals*,[13] in turning the would-be exceptionless rule of property against itself; and the least reflection on Kant's intuitions would confirm that Kant turned too quickly to a transcendental reading of the conceptual conditions of the possibility of

Newton's theorems: he should have turned instead to the streetwise doubt that doubts that Newton had any grounds at all for his extravagant claim. He might have anticipated Hegel in a less flamboyant way.

De Duve demonstrates that the antinomic theme of Kant's analysis plays out just as well in the reception of Duchamp's naughty act as in Kant's banalities about the sunset. We see, therefore, that the problem posed has nothing to do with securing the universality of judgments of any kind or, for that matter, formulating the conditions of truth in any sphere of inquiry at all—once we abandon transcendentalism.

The lesson to be drawn—the single most important lesson of late eighteenth- and early nineteenth-century philosophy, perhaps then the most important lesson of the whole of "modern" modern philosophy—is this: that universalism in every sector of inquiry *is* now being systematically replaced, and *ought* to be, by a rigorous historicism. Both universalism and historicism are constructivist options—one seeking closure and necessity, the other opposed to anything of the sort.

Alternatively put: what's good for beauty is good for truth. Together, they confirm the insuperable informality of science, morality, and the appreciation of art; the demotion of universality from constitutive rule to unrequited hope; and the dawning rigor and adequacy of our *passages* of generalizations continually fitted to the flux of history. But if you give Kant up, which is not easy to do, it turns out that the informalities of taste need no longer be paradoxical. It was never true that taste must be judged by the higher certainties of science and morality: it's never been demonstrated that there must be any such higher certainties. It seems closer to our history to say that aesthetic judgment, scientific truth, and moral norms rise and fall together.

Notes

Prologue

A slightly enlarged and revised version of this prologue will also appear in a forthcoming book edited by Susanne Jansson and to be published by Thales (Sweden).

1. Compare, for instance, Myles Burnyeat, "Protagoras and Self-Refutation in Plato's *Theaetetus*," *Philosophical Review* 85 (1976); and Hilary Putnam, "Materialism and Relativism," in *Renewing Philosophy* (Cambridge, Mass.: Harvard University Press, 1992).

2. I offer a fuller account of this "contest" between Kant and Hegel in a forthcoming article, "The Point of Hegel's Dissatisfaction with Kant." See also the Epilogue to this volume.

3. See G. W. F. Hegel, *The Phenomenology of Spirit*, trans. A. V. Miller (Oxford: Clarendon, 1977). John MacDowell may be the most suggestive recent English-language analytic philosopher to broach the matter. But MacDowell remains, on his own declaration, a Kantian and a Platonist (a naturalized Platonist). He introduces what appears to be the Hegelian (or Gadamerian *Bildung*), but he makes sure that it never exceeds the Kantian formula. See his *Mind and World* (Cambridge, Mass.: Harvard University Press, 1976). See also the Epilogue to this volume.

4. See Edmund Husserl, *Ideas: General Introduction to Pure Phenomenology*, trans. W. R. Boyce Gibson (New York: Macmillan, 1931), §32; and *Cartesian Meditations: An Introduction to Phenomenology*, trans. Dorion Cairns (The Hague: Martinus Nijhoff, 1960), Fifth Meditation.

5. On Aristotle's biological tracts, see Allan Gotthelf and James G. Lennox, eds., *Philosophical Issues in Aristotle's Biology* (Cambridge: Cambridge University Press, 1987).

6. See John H. Zammito, *Kant, Herder, and the Birth of Anthropology* (Chicago: University of Chicago Press, 2003).

7. See G. W. F. Hegel, *Aesthetics: Lectures on Fine Art*, trans. T. M. Knox (Oxford: Clarendon, 1975), 1:56–61.

8. See Martha C. Nussbaum, "Flawed Crystals: James's *The Golden Bowl* and Literature

in Moral Philosophy," in *Love's Knowledge: Essays on Philosophy and Literature* (New York: Oxford University Press, 1990); and "Non-relative Virtues: An Aristotelian Approach," in *The Quality of Life*, ed. Martha C. Nussbaum and Amartya Sen (Oxford: Clarendon, 1993).

9. See Joseph Margolis, *The Unraveling of Scientism: American Philosophy at the End of the Twentieth Century* (Ithaca, N.Y.: Cornell University Press, 2003).

10. See Gregory Vlastos, "The Socratic Elenchus: Method Is All," in *Socratic Studies*, ed. Myles Burnyeat (Cambridge: Cambridge University Press, 1994).

11. See Michael Oakeshott, *Of Human Conduct* (Oxford: Clarendon, 1995).

12. See Thomas R. Flynn, *Sartre, Foucault, and Historical Reasoning*, 2 vols. (Chicago: University of Chicago Press, 1997, 2005), particularly I:chap. 7, and "Foucault Responds to Sartre," in *Foucault Live (Interviews 1966–84)*, ed. Sylvia Lorringer, trans. John Johnston (New York: Semiotext(e), 1989), cited by Flynn.

13. See Hegel's account of the *Antigone*, in *Aesthetics*, 1:220–21.

14. See Ernst Cassirer, *The Philosophy of Symbolic Forms*, trans. Ralph Manheim, 3 vols. (New Haven, Conn.: Yale University Press, 1953–57).

15. For a compendious account of the pertinent literature, see W. K. C. Guthrie, *The Sophists* (Cambridge: Cambridge University Press, 1971), chap. 4.

16. See Noam Chomsky, *New Horizons in the Study of Language and Mind* (Cambridge: Cambridge University Press, 2000); and Margolis, *Unraveling of Scientism*, chap. 1.

17. See Georg Henrik von Wright, *Wittgenstein* (Minneapolis: University of Minnesota Press, 1982).

18. This merely identifies the single most elusive difference between the *Tractatus* and the *Investigations*.

19. For a sense of recent speculation about Wittgenstein's notion of the *Lebensform*, see Newton Garver, *This Complicated Form of Life: Essays on Wittgenstein* (Chicago: Open Court, 1994). There seem to be very few clues about what, precisely, Wittgenstein intended by the idea.

20. Ludwig Wittgenstein, *Philosophical Investigations*, trans. G. E. M. Anscombe (Oxford: Basil Blackwell, 1953), I:§241.

21. Contrast the view of Paul M. Churchland, *A Neurocomputational Perspective: The Nature of Mind and the Structure of Science* (Cambridge, Mass.: MIT Press, 1989), chap. 1.

22. See Martin Heidegger, *Being and Time*, trans. John Macquarrie and Edward Robinson (New York: Harper and Row, 1962), §12; also, *Ontology—The Hermeneutics of Facticity*, trans. John van Buren (Bloomington: Indiana University Press, 1999). Heidegger and Wittgenstein seem to me to be fundamentally opposed, even though both tend to focus on the analysis of the "everyday world."

23. See Frederick A. Olafson, *Naturalism and the Human Condition: Against Scientism* (London: Routledge, 2001); Hubert L. Dreyfus, *Being-in-the-World: A Commentary on Heidegger's Being and Time*, Division 1 (Cambridge, Mass.: MIT Press, 1991).

24. Consider, for example, the strange turn (the *Kehre*) of Heidegger's "Letter on Humanism," trans. Frank A. Capuzzi, in Martin Heidegger, *Pathmarks*, ed. William McNeill (Cambridge: Cambridge University Press, 1998).

25. For a general sense of the argument, see Joseph Margolis, *Historied Thought, Constructed World: A Conceptual Primer for the Turn of the Millennium* (Berkeley: University of California Press, 1995).

26. See Jacques Monod, *Chance and Necessity*, trans. Austryn Wainhouse (New York: Vantage, 1971).

27. See Richard Dawkins, *The Selfish Gene*, rev. ed. (Oxford: Oxford University Press, 1989), and *The Extended Phenotype: The Long Reach of the Gene*, rev. ed. (Oxford: Oxford University Press, 1999).

28. See Thomas S. Kuhn, *The Structure of Scientific Revolutions*, exp. ed. (Chicago: University of Chicago Press, 1970), especially §X.

29. See W. V. Quine, "Epistemology Naturalized," in *Ontological Relativity and Other Essays* (New York: Columbia University Press, 1969).

30. See Wittgenstein, *Philosophical Investigations*, I:§§241, 481; compare Ludwig Wittgenstein, *On Certainty*, ed. G. E. M. Anscombe and G. H. von Wright, trans. Denis Paul and G. E. M. Anscombe (New York: Harper and Row, 1972), §110.

31. Marjorie Grene, "People and Other Animals," in *The Understanding of Nature: Essays in the Philosophy of Biology* (Dordrecht: D. Reidel, 1974), p. 358. The phrase "extensions of ourselves" catches up the best of Merleau-Ponty.

Chapter 1

A reduced and somewhat altered version of this chapter appeared as a chapter in Peter Kivy, ed., *Blackwell Guide to Aesthetics* (Oxford and Malden, Mass.: Blackwell, 2004), 215–29. Copyright 2004 by Blackwell. Reproduced by permission of the publisher.

1. The idea of "equilibrative" thinking is rather a nice one—insuperably informal of course. It is explicitly featured by Nelson Goodman in *Fact, Fiction, and Forecast*, 2d ed. (Indianapolis: Bobbs-Merrill, 1965).

2. Romains's sense of what is transiently collective is captured very trimly in his little novel *Mort de quelqu'un*. I find an affinity between this aspect of Goodman's work and Wittgenstein's "method," though otherwise there is very little that Goodman and the Wittgenstein of the *Investigations* share.

3. See Hans Belting, *Likeness and Presence: A History of the Image before the Era of Art*, trans. Edmund Jephcott (Chicago: University of Chicago Press, 1994).

4. Concerning primitive art, see H. Gene Blocker, *The Aesthetic of Primitive Art* (Latham, Md.: University Press of America, 1993).

5. James Elkins, *The Domain of Images* (Ithaca, N.Y.: Cornell University Press, 1999), p. 4.

6. See John White, *The Birth and Rebirth of Pictorial Space*, 3d ed. (Cambridge, Mass.: Harvard University Press, 1987), chap. 9; and Samuel Y. Edgerton Jr., *The Renaissance Rediscovery of Linear Perspective* (New York: Harper and Row, 1975), chap. 2.

7. The best introduction to the new disputes about the nature of visual perception that I know is afforded in Alva Noë and Evan Thompson, eds., *Vision and Mind: Selected Readings in the Philosophy of Perception* (Cambridge, Mass.: MIT Press, 2002). Noë and Thompson champion their own views, of course, but the collection they offer gives a good sense

of the disarray of the entire field. It's in this spirit that I think a thoroughly constructivist account is likely to be best, in particular one that elaborates the contribution of the cultural world. That is precisely what I mean by favoring Hegel over Kant.

8. Marr attempts to build an adequate theory of visual perception compositionally, *from* perceptions' supposed physiological conditions. See David Marr, *Vision: A Computational Investigation into the Human Representation and Processing of Visual Information* (New York: W. H. Freeman, 1982). There's a rather good analysis of the problematic nature of Marr's model of perception given in very general terms bearing on the idea of a cognitive science, in John R. Searle, *Consciousness and Language* (Cambridge: Cambridge University Press, 2002), chap. 7. But see also, for a more pointed discussion, Robert A. Wilson, *Boundaries of the Mind: The Individual in the Fragile Sciences* (Cambridge: Cambridge University Press, 2004), chap. 7. Marr's theory proceeds bottom up; but Marr does not explain the methodological significance of having to construct, explanatorily, a bottom-up account of what yields the top-down phenomenological reports of "folk" perception. The puzzle is regularly ignored in sensorily spare notions of phenomenal perception. For example, the speculation usually fails to come to terms with the "penetration" problem already bruited.

9. See Hubert Damisch, *The Origin of Perspective*, trans. John Goodman (Cambridge: MIT Press, 1994), pp. 130–31.

10. Erwin Panofsky, *Early Netherlandish Painting: Its Origins and Character* (New York: Harper and Row, 1971), 1:3, 7.

11. Damisch, *The Origin of Perspective*, pp. xiii, 446–47.

12. See Erwin Panofsky, *Perspective as Symbolic Form*, trans. Christopher S. Wood (Cambridge, Mass.: MIT Press, 1991).

13. See Michel Foucault, *The Order of Things: An Archaeology of the Human Sciences*, trans. (New York: Vintage, 1970), chap. 1; Damisch, *The Origin of Perspective*, pp. 425–32; and Leo Steinberg, "Velázquez' 'Las Meninas,'" *October* 19 (Winter 1981) (cited by Damisch). See also John R. Searle, "Las Meninas and the Paradoxes of Pictorial Representation," *Critical Inquiry* 6 (1990), which favors a very unlikely thesis.

14. For a brief summary of the early history of Italian perspective, see Karsten Harries, *Infinity and Perspective* (Cambridge, Mass.: MIT Press, 2001), pt. I, chap. 4; and Paul Feyerabend, "Brunelleschi and the Invention of Perspective," in *Conquest of Abundance: A Tale of Abstraction versus the Richness of Being* (Chicago: University of Chicago Press, 1999).

15. Rudolf Arnheim, *The Power of the Center: A Study of Composition in the Visual Arts* (Berkeley: University of California Press, 1988), p. ix, chap. 11.

16. See Rudolph Arnheim, *Art and Visual Perception* (Berkeley: University of California Press, 1974).

17. To my mind, a decisive confirmation of the "penetration" thesis is implied in Meyer Schapiro, *Words and Pictures: On the Literal and the Symbolic in the Illustration of a Text* (The Hague: Mouton, 1973). It needs to be noticed that although Schapiro writes as a "semiotician," his description of key images (notably, his analysis of Giotto's treatment in the Arena panels of the matched gazes of Jesus and Judas in the betrayal) is unquestionably "phenomenological." Semiotics favors externally imputed functions, whereas phenomenol-

ogy requires culturally penetrated (internalist) transformations of perception. The contrast helps, by the way, to explain the difference between Schapiro's and Nelson Goodman's approaches to pictorial perception: Goodman is primarily a semiotician, never a phenomenologist; hence, Goodman's improbable mistakes in airing "resemblances" among paintings and depictions. (One is tempted to say that Goodman simply couldn't see the things that Schapiro saw, which is not a problem of physiology or the analysis of signs.)

18. Karsten Harries, *The Meaning of Modern Art* (Evanston, Ill.: Northwestern University Press, 1968), chap. 4.

19. Marx W. Wartofsky, "Picturing and Representing," in *Perception and Pictorial Representation*, ed. Calvin F. Nodine and Dennis F. Fisher, p. 272 (New York: Praeger, 1979). See also Marx W. Wartofsky, "Pictures, Representation, and the Understanding," in *Logic & Art: Essays in Honor of Nelson Goodman*, ed. Richard Rudner and Israel Scheffler (Indianapolis: Bobbs-Merrill, 1972).

20. Compare Kendall L. Walton, *Mimesis as Make-Believe: On the Foundations of the Representational Arts* (Cambridge, Mass.: Harvard University Press, 1990).

21. We begin to glimpse here the natural contest, at the explanatory level, between the supposed adequacy and inadequacy of a purely biological explanation of culturally significant changes. For a rather early, but distinctly perceptive account, see Grene, *Understanding of Nature* (see Prologue, n. 31). Grene provides, intriguingly, an evolutionary niche for the emergence of cultural processes. Her account is much clearer, for instance, than Arnheim's, though she does not attempt to analyze paintings at all. She does touch on the fatal weakness of J. J. Gibson's theory of sensory perception—he "make[s] the sense wholly passive" (p. 23). I would think she would find Arnheim's physiological model similarly deficient.

22. See E. H. Gombrich, "The 'What' and the 'How': Perspective Representation and the Phenomenal World," in *Logic & Language: Essays in Honor of Nelson Goodman*, ed. Richard Rudner and Israel Scheffler, pp. 10–19 (Indianapolis: Bobbs-Merrill, 1968).

23. Ibid., p. 129.

24. See Nelson Goodman, *Languages of Art: An Approach to a Theory of Symbols* (Indianapolis: Bobbs-Merrill, 1968), pp. 10–19.

25. Gombrich reports a letter from Goodman supporting this judgment, though frankly I find that Goodman backtracks here when he pointedly objects to the view that "the standard rules of perspective embody the one native and easiest way of achieving and reading a realistic depiction"; cited in E. H. Gombrich, "Image and Code: Scope and Limits of Conventionalism in Pictorial Representation," in *The Image and the Eye: Further Studies in the Psychology of Pictorial Representation* (Oxford: Phaidon, 1982), p. 284. See also E. H. Gombrich, *Art and Illusion: A Study in the Psychology of Pictorial Representation*, 2d ed. (New York: Pantheon, 1961).

26. Gombrich, "Image and Code," p. 278.

27. Goodman, *Languages of Art*, pp. 4, 5.

28. See ibid.; and Diana Raffman, who spells out Goodman's mistake in unmistakable terms, "Goodman, Density, and the Limits of Sense Perception," in *The Interpretation of Music: Philosophical Essays*, ed. Michael Krausz (Oxford: Clarendon, 1993).

29. See Alan Tormey and Judith Farr Tormey, "Seeing, Believing, and Picturing," in *Perception and Pictorial Representation*, ed. Calvin F. Nodine and Dennis F. Fisher (New York: Praeger, 1979).

30. See J. J. Gibson, *The Ecological Approach to Visual Perception* (Boston: Houghton Mifflin, 1979), pt. IV, particularly p. 270. For a critical review, see Jerry A. Fodor and Zenon W. Pylyshyn, "How Direct Is Visual Perception? Some Reflections on Gibson's 'Ecological Approach,'" *Cognition* 9 (1981).

31. Panofsky, *Perspective as Symbolic Form*, p. 66.

32. Ibid., pp. 67–68.

33. See Feyerabend, "Brunelleschi and the Invention of Perspective."

34. See Margolis, *Historied Thought, Constructed World* (see Prologue, n. 25).

35. Dominic Lopes, *Understanding Pictures* (Oxford: Clarendon, 1996), pp. 185, 32. See also the remark about Gibson, p. 30.

36. Ibid., p. 31 (italics added). Lopes subscribes here to Gareth Evans's proposal that "informational states are non-conceptual," which Christopher Peacocke extends to "perceptual states." See Gareth Evans, *The Varieties of Reference*, ed. John McDowell (Oxford: Oxford University Press, 1982); and Christopher Peacocke, "Perceptual Content," in *Themes from Kaplan*, ed. Joseph Almog, John Perry, and Howard K. Wettstein (New York: Oxford University Press, 1989). I find the idea dialectically very weak and theoretically contrived: we always need to be clear about what we can report perceptually.

37. See Fred I. Dretske, *Naturalizing the Mind* (Cambridge, Mass.: MIT Press, 1995).

38. Panofsky, *Perspective as Symbolic Form*, p. 68. This explains the import of his adopting Cassirer's trope.

39. Jerrold Levinson, "The Work of Visual Art," in *The Pleasures of Aesthetics: Philosophical Essays* (Ithaca, N.Y.: Cornell University Press, 1996), pp. 135–16.

40. See Donald Davidson, "A Coherence Theory of Truth and Knowledge," in *Truth and Interpretation: Perspectives on the Philosophy of Donald Davidson*, ed. Ernest Lepore (Oxford: Basil Blackwell, 1986); and Richard Rorty, "Pragmatism, Davidson, and Truth," in ibid. The idea forms the basis of Davidson's theory of action—and is very close to Danto's theory of action.

41. Levinson, "The Work of Visual Art," p. 134.

42. Panofsky, *Early Netherlandish Painting*, p. 7. See also Panofsky, *Perspective as Symbolic Form*, §IV.

43. I've deliberately omitted anything more here than a passing reference to Danto's theory about the same issues because I've pursued his account in some depth elsewhere. See Joseph Margolis, *Selves and Other Texts: The Case for Cultural Realism* (University Park: Pennsylvania State University Press, 2001), chap. 2. But I would not be candid if I did not confess that I cannot see any fundamental difference, generically, between Danto's and Levinson's accounts; though there's all the difference in the world between their respective arguments. I offer a sustained account of Danto's philosophy of art in Joseph Margolis, *Aesthetics: An Unforgiving Introduction* (Belmont, Calif.: Wadsworth, forthcoming).

44. Arthur C. Danto, "Description and the Phenomenology of Perception," in *Visual Theory: Painting and Interpretation*, ed. Norman Bryson, Michael Ann Holly, and Keith

Moxey, p. 205 (New York: Harper-Collins, 1991). Garry Hagberg's perceptive comments on Danto's lecture (1987) appear in *Visual Theory* as well and are incorporated into his *Art as Language* (Ithaca, N.Y.: Cornell University Press, 1995).

45. Danto, "Description and the Phenomenology of Perception," p. 204.

46. Ibid.

47. See, for instance, Robert A. Wilson, *Boundaries of the Mind: The Individual in the Fragile Sciences* (Cambridge: Cambridge University Press, 2004), pts. II–III.

48. Danto, "Description and the Phenomenology of Perception," p. 206. Compare Gregory Currie, *Arts and Minds* (Oxford: Clarendon, 2004), chap. 4, particularly p. 77.

49. Danto, "Description and the Phenomenology of Perception," p. 214.

50. See Prologue.

51. On Danto's theory, see further Margolis, *Selves and Other Texts*, chap. 2; and Margolis, "A Closer Look at Danto's Account of Art and Perception," *British Journal of Aesthetics* 11 (2001).

52. Hagberg, *Art as Language*, p. 143. See further Arthur C. Danto, *The Transfiguration of the Commonplace* (Cambridge, Mass.: Harvard University Press, 1981). See Wittgenstein, *Philosophical Investigations*, I:§§282–85, §390 (see Prologue, n. 20).

53. Richard Wollheim, *Painting as an Art* (Princeton: Princeton University Press, 1987), p. 9.

54. Ibid., p. 26.

55. Ibid. "General style," I should add, is essentially a nominalization ranging over the particulars of period style and the like—hence, not interesting in any way that compares with "individual style" (in Wollheim's account).

56. Ibid., p. 27.

57. Ibid.

58. Wollheim, *Painting as an Art*, p. 46.

59. Ibid., p. 47.

60. Ibid., pp. 70–80.

61. Ibid., p. 73.

62. I have benefited considerably from John Brown's (University of Maryland) unpublished notes of an analysis of Wollheim's distinctions. Brown is very careful about what and how one perceives in perceiving paintings. My sense is that he does not find Wollheim's treatment clear enough or particularly perspicuous. But I cannot hold him responsible for my own reading of the text, and he may well not agree with my verdict.

Chapter 2

This chapter has appeared in a slightly different form in Michael Krausz, ed., *Is There a Single Right Interpretation?* (University Park: Pennsylvania State University Press, 2002), 26–44. Copyright 2002 by the Pennsylvania State University. Reproduced by permission of the publisher.

1. See Margolis, *Unraveling of Scientism*, chap. 2 (see Prologue, n. 9).

2. P. D. Juhl, *Interpretation: An Essay in the Philosophy of Literary Criticism* (Princeton: Princeton University Press, 1980), pp. 199, 199–200n11.

3. See E. D. Hirsch Jr., *Validity in Interpretation* (New Haven, Conn.: Yale University Press, 1967); Hans-Georg Gadamer, *Truth and Method*, trans. (rev.) Joel Weinsheimer and Donald G. Marshall, 2d rev. ed. (New York: Continuum, 2002), pp. 369–79. See also the Epilogue in this volume.

4. See Monroe C. Beardsley, *The Possibility of Criticism* (Detroit: Wayne State University Press, 1970).

5. See, for instance, Robert Stecker, "The Constructivist's Dilemma," *Journal of Aesthetics and Art Criticism* 4 (1997).

6. For a would-be example, which fails on internal grounds, see Antonin Scalia, "The Role of United States Federal Courts in Interpreting the Constitution and the Law," in *A Matter of Interpretation: Federal Laws and the Courts*, ed. Amy Gutmann, with commentaries by Amy Gutmann et al. (Princeton: Princeton University Press, 1997).

7. See, for instance, Beardsley, *The Possibility of Criticism*; and Robert Stecker, *Artworks: Definition, Meaning, Value* (University Park: Pennsylvania State University Press, 1997).

8. See, for instance, Michael Krausz, *Rightness and Reasons* (Ithaca, N.Y.: Cornell University Press, 1993); and the rather different account given by Paul Thom, *Making Sense: A Theory of Interpretability* (Lanham, Md.: Rowman and Littlefield, 2000).

9. I regard this as the fatal weakness, for instance, of Danto's account of art and interpretation. See Arthur C. Danto, *The Transfiguration of the Commonplace: A Philosophy of Art* (Cambridge, Mass.: Harvard University Press, 1981). I don't deny that Danto *believes* that artworks are "real" and that interpretation is "objectively" constrained, but I see no basis for either claim in Danto's published work. See further Margolis, *Selves and Other Texts*, chap. 2 (see chap. 1, n. 43). I must add here a word of general agreement with the thrust of Peter Lamarque's "Appreciation and Literary Interpretation," in Michael Krausz, ed., *Is There a Single Right Interpretation?* (University Park: Pennsylvania State University Press, 2002). The bearing of some of Lamarque's more detailed discussions of intentionalism and confusions about the interpretation of literature (confined to verbal meaning) I find particularly congenial. My own emphasis is also on the adequational issue: that is, regarding what may be called the semiotic and the ontic (within a constructivist or, let me suggest, a hermeneutic account).

10. I have pursued these matters—relativism and the single-interpretation thesis—in some depth elsewhere, most recently in *Interpretation Radical but Not Unruly* (Berkeley: University of California Press, 1995); *Historied Thought, Constructed World* (see Prologue, n. 25); and *What, after All, Is a Work of Art?* (University Park: Pennsylvania State University Press, 1999).

11. See F. W. Bateson, "Gray's *Elegy* Reconsidered," in *English Poetry: A Critical Introduction* (London: Longmans, Green, 1950); and Cleanth Brooks, "Irony as a Principle of Structure," in *Literary Opinion in America*, ed. Morton D. Zabel, 2d ed. (New York: Harper, 1951).

12. See Juhl, *Interpretation*, pp. 70–89, 199–202. The dispute is also remarked in Beardsley, *The Possibility of Criticism*, and in Hirsch, *Validity in Interpretation*.

13. See Torsten Pettersson, *Literary Interpretation: Current Models and a New Departure* (Åbo, Finland: Åbo Academy Press, 1988); and Morris Weitz, *Hamlet and the Philosophy of Literary Criticism* (Chicago: University of Chicago Press, 1964).

14. J. W. O'Malley, *Praise and Blame in Renaissance Rome: Rhetoric, Doctrine and Reform in the Second Oratory of the Papal Court, c. 1450–1521* (Durham, N.C.: Duke University Press, 1979), cited in Leo Steinberg, *The Sexuality of Christ in Renaissance Art and in Modern Oblivion* (New York: Pantheon, 1983).

15. These are mentioned by John W. O'Malley in a postscript included in Steinberg, *The Sexuality of Christ.*

16. Steinberg, *The Sexuality of Christ,* p. 14.

17. Ibid., p. 6.

18. See Sigmund Freud, "Leonardo da Vinci and a Memory of His Childhood," in *The Standard Edition of the Complete Psychological Works of Sigmund Freud,* Vol. XI, trans. and ed. James Strachey, with Anna Freud, Alix Strachey, and Alan Tyson (London: Hogarth Press and The Institute of Psycho-Analysis, 1957); and Meyer Schapiro, "Leonardo and Freud: An Art-Historical Study," *Journal of the History of Ideas* 17 (1956).

19. Steinberg, *The Sexuality of Christ,* pp. 18, 20.

20. Meyer Schapiro, *Words and Pictures: On the Literal and the Symbolic in the Illustration of a Text* (The Hague: Mouton, 1973), p. 46.

21. I cannot forbear recommending a tolerant analogy between the open-ended (but obviously disciplined) explanatory suggestions of Steinberg's and Schapiro's interpretations and what I call Wittgenstein's elenctic "meander" among conceptual connections in the "everyday use" of natural-language discourse. I don't mean this in the way of contesting their sense of rigor—which to my mind is superb—but only to draw attention to a larger vision of the entire world of human culture that my own argument is meant to support.

22. Beardsley, *The Possibility of Criticism,* p. 44.

23. On the meaning of "objectivism," see Richard J. Bernstein, *Beyond Objectivism and Relativism: Science, Hermeneutics, and Praxis* (Philadelphia: University of Pennsylvania Press, 1983).

24. Arthur C. Danto, *The Philosophical Disenfranchisement of Art* (New York: Columbia University Press, 1986), pp. 44–45.

25. See, for instance, Hirsch, *Validity in Interpretation,* chap. 3.

26. See Danto, *Philosophical Disenfranchisement of Art,* chap. 3.

27. Ibid., p. 47.

28. See further Arthur C. Danto, "Responses and Replies," in *Danto and His Critics,* ed. Mark Rollins, p. 201 (Oxford: Blackwell, 1995).

29. I have already mentioned Robert Stecker, who champions bivalence in interpretation without providing a convincing account of those aspects of the nature of an artwork that could possibly support the thesis; in a very different spirit, Michael Krausz professes to be open to competing conjectures regarding "singularism" and "multiplism," but he apparently believes the argument (that is, this particular argument) can be adequately pursued without reference at all to the determinative nature of artworks themselves. That is precisely what I deny. (The generous concession that an artwork's "nature" may be relevant to the logic of interpretation "somewhere" seems to me beyond dispute.)

30. I can offer an illuminating tale from an unexpected source. Duns Scotus was the most celebrated medieval discussant of the distinction Scotus himself called *haecceitas*

("this-ness"), said to mark the singularity of whatever could be rightly individuated. (*Haecceity* is not a kind of quiddity.) Scotus spent a good part of his career trying to isolate what the term actually captured so as to explain how individuation worked. I had occasion to correspond with a young associate of Allan Wolter, DFM, the English-language transla-tor of Scotus and a specialist on his philosophy. I wrote my intermediary, asking whether Wolter (whom I'd met briefly) thought Scotus believed we could actually discern *haecceitas* effectively. "Yes," said Wolter, "but not in this life!" (Marvelous answer!) My own view is that the right solution cannot but be informally dependent on the tolerance we invest (collectively) in our referential *practices*—it can never be determined by the satisfaction of any formal rule intended to fix such practices. I take this to be a fatal blow (one of many) against the illusions of an adequate extensionalism.

31. For example, in the manner advanced by Thomas S. Kuhn, *The Structure of Scientific Revolutions*, 2d ed. enl. (Chicago: University of Chicago Press, 1970), §X; and by Paul K. Feyerabend, "Explanation, Reduction, and Empiricism," in *Scientific Explanation, Space and Time*, ed. Herbert Feigl and Grover Maxwell, Minnesota Studies in the Philosophy of Science, vol. 3 (Minneapolis: University of Minnesota Press, 1963). Interpretive ascriptions in the arts usually involve, I suggest, the fitness of every epithet discretely addressed to a particular work; whereas natural-kind predicates tend to be regularized in intensionally linear ways *for* further contingent attribution.

32. See further, on "embodied" and "incarnate," Margolis, *Historied Thought, Construct-ed World*.

Chapter 3

1. I take *Bildung* to be a more perspicuous and more ample model of how artworks function in our lives, morally as well as in other ways, than Kant's account in the second part of his third *Critique* of artworks functioning as moral "symbols" (see Epilogue in this volume).

2. I mean to suggest here that the metaphysical difference between fiction and real-ity does not come to terms as such with the continuity, in imagination, between what is presented in fiction and in history or "real life." To see this is to see that the difference (respecting truth) between any propositional account of fiction and the real world deflects us from a fruitful analysis of "the moral function" of literature and motion pictures most particularly. This counts partly in favor of, and partly against, the line of argument ad-vanced in Peter Lamarque and Stein Haugom Olsen, *Truth, Fiction, and Literature: A Philo-sophical Perspective* (Oxford: Clarendon, 1994); see particularly chap. 13. In this sense, the *imaginative* appreciation of literature need make no commitment to real-world *or* fictive reference. That is often overlooked: that is, the minimal condition of the phenomenology of understanding and appreciating the imaginable worlds literature discloses. (There need be no visual difference between, say, imagining a fictive friend and imagining an actual friend.) It's also here that the "moral function" of the arts is rightly grounded. It belongs to imagination first and only secondarily to fiction and the real world, because imagination collects the perceivable possibilities of the real world beyond whatever we might disallow on evidentiary grounds.

3. See Johan Huizinga, *Homo Ludens: A Study of the Play Element in Culture* (Boston: Beacon Press, 1955); and Friedrich Schiller, *On the Aesthetic Education of Man*, trans. Elizabeth M. Wilkinson and L. A. Willoughby (Oxford: Clarendon, 1987). Compare Lamarque and Olsen, *Truth, Fiction, and Literature*, chap. 3; and Walton, *Mimesis as Make-Believe* (see chap. 1, n. 20).

4. This, as we shall see here and in Chapter 4, goes utterly contrary to Kendall Walton's doctrine of "make-believe."

5. Theories of vision that proceed in the way David Marr does, which intend to capture visual perception bottom up by way of theoretical constraints affecting the way the eye functions, invariably put the cart before the horse. See David Marr, *Vision: A Computational Investigation into the Representation and Processing of Visual Information* (New York: W. H. Freeman, 1982). Speaking more generally, I would say that new technologies—for instance, regarding photographs and films—require the learning of new possibilities of seeing, new phenomenological possibilities. I see no reason why, if the photograph extends the ways in which we see things, paintings may not be regarded as the products of new technologies for presenting what may be seen—in ways normally more daring and more inventive than what the photograph usually provides. What Patrick Maynard cites from Edmund Carpenter's account of New Guinea natives' first experience with still photographs, motion pictures, and tape recordings helps us see how quickly all of us learn to see paintings as a varied set of evolving technologies of pictorial presentation—Manet's as much as de Kooning's, extremes of very different sorts, which surely must be learned to become readily seen. See Patrick Maynard, *The Engine of Visualization: Thinking through Photography* (Ithaca, N.Y.: Cornell University Press, 1997), pt. 2. (Walton discounts the importance of such points.)

6. The pertinent conception of phenomenology intended here is effectively sketched for the first time in Hegel, *The Phenomenology of Spirit* (see Prologue, n. 3), though the idea appears earlier. It's a theory utterly irreconcilable with Husserl's phenomenology, though I acknowledge that it must also be liberated from Hegel's extravagances. In any case, the phenomenology we require cannot rightly admit any disjunction between the empirical and the phenomenological—unless dependently.

7. This goes entirely against the "scientistic" line of speculation favored by Dominic Lopes, following an argument developed by Gareth Evans and Christopher Peacocke. See Dominic Lopes, *Understanding Pictures* (Oxford: Clarendon, 1996). It also outflanks Kendall Walton's account of make-believe, which Lopes also opposes for reasons that I find less than cogent (the argument from nonconceptual perception). See pp. 81–92, 182–87; also see Chapter 1 in this volume, particularly regarding Marr's views. I think it is always problematic to construe perception primarily in "informational" terms, especially if information is defined "nonconceptually," as invariant, impenetrable, and usually operative below the level of conscious (phenomenological) reporting. This is not to demean "information" but to question the grounds on which it may be invoked to *explain* the perception of paintings. Compare the extreme view championed by Zenon Pylyshyn, "Is Vision Continuous with Cognition? The Case for Cognitive Impenetrability of Visual Perception," *Behavioral and Brain Sciences* 3 (1999). Lopes's objections to Walton's theory, however, are genuinely interesting.

8. I take this to mark the decisive clue regarding the deep implausibility of Danto's well-known account of the perception of paintings. See Danto, *Transfiguration of the Commonplace* (see chap. 2, n. 9). The short argument runs as follows. Perceptual reasoning requires the admission of something "given" perceptually, though without privilege or necessary ontic or epistemic import. What is given cannot, therefore, depend on any theory that does not itself rest on what is given; empiricist, entirely non-Intentionalized, ocular, neurophysiological, informational data cannot be given in the requisite sense. Furthermore (following Wittgenstein), intentionally (or Intentionally) qualified visual attributions made of the "content" of inner mental states cannot be coherent or reliable if they are not already conceptually linked to what is perceptually manifested in the public world. Hence, artworks cannot be construed as mere physical objects somehow "endowed" with intentionalized perceptual properties (by whatever rhetorical means) on the basis of the private intentions of artists, or somehow suitably amplified in cognate ways among informed viewers. Furthermore, since reductionisms of the pertinent sort are known to be defective, we cannot but favor a phenomenology of the plausible kind developed here.

9. The "supervenience" of the mental on the physical, and of the "intentional" on the "nonintentional," is the last refuge of reductive materialism. Under the best circumstances, it cannot possibly be shown to be valid. There is, for instance, no supervenientist account of language (of grasping the meaning of stretches of language), and thus no supervenientist account of perception of the phenomenological sort. See further Jaegwon Kim, *Supervenience and Mind* (Cambridge, Mass.: Cambridge University Press, 1993).

The limitations of Kim's position are extremely important and revealing. I find them at their clearest in Kim's *Physicalism, or Something Near Enough* (Princeton: Princeton University Press, 2005). The caveat in the title concerns certain difficulties in the analysis of consciousness and the reduction of the mental. These are not negligible, though I have no need to press them here. The more frontal challenge is already implicit in Kim's "Synopsis of the Arguments." For he says there that "the two principal challenges confronting contemporary physicalism . . . are mental causation and consciousness" (p. 1). He means to solve these problems, as he makes clear, in accord with the following summary: "The position we [will] have arrived at may be called *conditional physical reductionism*, the thesis that if mental properties are to be causally efficacious, they must be physically reducible. . . . [So] considerations . . . offered in support of the view that cognitive/intentional properties, such as belief, desire, and perception, are functionally characterizable [and hence] physically reducible" (p. 5). But precisely, this misses the entire possibility that the challenges to physicalism include all the aspects of enlanguaged, encultured, historicized "mind" that are emergent with respect to, and indissolubly incarnate in, physical processes of one kind or another, which, if admitted, show the sense in which the mental need not be viewed as simply nonphysical—in which, that is, the mental may be causally efficacious even if not physically reducible and in which the functional is not an adequate characterization of the mental at all. I gladly acknowledge Kim's dialectical skill in meeting the objections of those he engages, but it seems clear to me that he's impoverished the range of the problems that must be met in order to vindicate physicalism at all—"or something near enough."

10. I recommend a careful reading of John T. Bonner, *The Evolution of Culture in Animals* (Princeton: Princeton University Press, 1980), for a thoughtful overview of the concept of the evolution of culture among animals, seen from the vantage of evolutionary biology. It's particularly attentive and instructive about the continuum between biology and culture, without reductive pressures and without extravagant philosophical sorties.

11. For a sketch of the line of thinking favored here, see Margolis, *Historied Thought, Constructed World* (see Prologue, n. 25).

12. See Richard Wollheim, *Art and Its Objects*, 2d ed. (Cambridge: Cambridge University Press, 1980). I take the prioritizing of the physical over what may be phenomenologically reportable—over the general lines of Hegel's account, for instance—to be a philosophical mistake of the greatest importance, which perceptually is characteristically matched by prioritizing the empirical (or empiricist or physiological or informational aspects of perception) over what is phenomenologically perceptible. This is the point of insisting on the "given" (without privilege). The empiricists cannot meet the implications of such a constraint.

13. Levinson follows theorists like Danto and Wollheim here; but he manages to make the error more salient than they do by his own example. See Jerrold Levinson, "Intention and Interpretation in Literature," in *The Pleasures of Aesthetics* (see chap. 1, n. 39).

14. See further Margolis, *Interpretation Radical but Not Unruly* (see chap. 2, n. 10); and *What, after All, Is a Work of Art?* (see chap. 2, n. 10).

15. For a sense of the profound mystery of these matters, see the exceptional discussion in A. G. Cairns-Smith, *Evolving the Mind: On the Nature of Mind and the Origin of Consciousness* (Cambridge: Cambridge University Press, 1996), and *Genetic Takeover and the Physical Origins of Life* (Cambridge: Cambridge University Press, 1982). Compare the evolutionary strategy in Bonner, *Evolution of Culture in Animals*.

16. Ruth Millikan proposes a very odd alternative here in *Language, Thought, and Other Biological Categories* (Cambridge, Mass.: MIT Press, 1984). Compare Eddy M. Zemach, "Look! This Is Zeus!" in *Interpretation, Relativism, and the Metaphysics of Culture*, ed. Michael Krausz and Richard Shusterman (Amherst, Mass.: Humanity Books, 1999).

17. See Gregory Currie, *Arts and Minds* (Oxford: Clarendon, 2004), chap. 1. Currie's mistake is an analogue of confusing the physical surface and the prepared surface of a painting.

18. For a sense of the possibilities in musical analysis and interpretation, see Theodor W. Adorno, *Essays on Music*, selected by Richard Leppert, trans. Susan H. Gillespie (Berkeley: University of California Press, 2002). See particularly "Music, Language, and Composition" and Leppert's extremely helpful commentary.

19. See further, on the interplay between the pictorial and the literary, Meyer Schapiro, *Words and Pictures: On the Literal and the Symbolic in the Illustration of a Text* (The Hague: Mouton, 1973).

20. I draw the problem from Steinberg's discussion. See Leo Steinberg, *The Sexuality of Christ in Renaissance Art and in Modern Oblivion* (New York: Pantheon, 1983).

21. This is one of several fatal mistakes in Robert Stecker's *Interpretation and Construction: Arts, Speech, and the Law* (Oxford: Blackwell, 2003). See particularly Stecker's analysis

of one of William Blake's poems. The correction bears directly on Currie's distinction (mentioned earlier) between text and work.

22. Compare Lamarque and Olsen, *Truth, Fiction, and Literature*.

23. This is now the general theme of a fashionable meta-interpretive industry, but it is an arbitrary and impoverishing proposal that has never rightly addressed the question of why the immensely varied inventions of the literary world should be thought to abide by anything like H. P. Grice's "conversational implicatures" or Dan Sperber and Deirdre Wilson's somewhat Gricean alternative. The most forceful recent application of the idea appears in Gregory Currie's *Arts and Minds*, for instance, in chap. 1: Currie's commitment does seem to explain his impoverished treatment of literary texts (and the disjunction of text and work). See also Paul Grice, *Studies in the Way of Words* (Cambridge, Mass.: Harvard University Press, 1989); and Dan Sperber and Deirdre Wilson, *Relevance, Communication and Cognition*, 2d ed. (Oxford: Basil Blackwell, 1995). A better intuition holds that a poem or novel is a construction of some kind rather than a conversation of any kind. Literature is linguistically (and imaginatively) intelligible—communicative, of course, but not necessarily "a communication," as in the conversational context.

24. For a heroic but failed sense of the usual measures intended to overcome the inherent inadequacies of all such would-be programs, see Daniel C. Dennett, *Consciousness Explained* (Boston: Little, Brown, 1991); and Jaegwon Kim, *Philosophy of Mind* (Boulder, Colo.: Westview, 1996). Neither shows more than the formal coherence of his reductive program; neither confirms the reasonableness of buying into the project.

25. See, for instance, Monroe C. Beardsley, *The Possibility of Criticism* (Detroit: Wayne State University Press, 1970); and E. D. Hirsch Jr., *Validity in Interpretation* (New Haven, Conn.: Yale University Press, 1967).

26. See Margolis, *Interpretation Radical but Not Unruly* (see chap. 2, n. 10).

27. This counts against Walton's theory. See Chapter 4 in this volume.

Chapter 4

1. See Margolis, *Unraveling of Scientism* (see Prologue, n. 9).

2. Wollheim's account appears in Wollheim, *Painting as an Art*, pp. 46–75 (see chap. 1, n. 53), and "On Pictorial Representation," in *Richard Wollheim on the Art of Painting: Art as Representation and Expression*, ed. Rob Van Gerwen (Cambridge: Cambridge University Press, 2002).

3. See Walton, *Mimesis as Make-Believe* (see chap. 1., n. 20); and Arthur C. Danto, "The Artworld," *Journal of Philosophy* 60 (1964), and *Transfiguration of the Commonplace* (see chap. 2, n. 9).

4. Wollheim, *Painting as an Art*, p. 46. John Brown (University of Maryland) was kind enough to share some excellent notes of his on twofoldness. I'm very grateful to him but won't hold him to my own view. Brown's account is a careful one. He is particularly helpful in explaining why, for instance, pictorial perspective cannot be explained in terms of the "configurational" properties of the surface alone. See also Jerrold Levinson, "Wollheim on Pictorial Representation," *Journal of Aesthetics and Art Criticism* 56 (1998).

5. Except for its uncertain boggling between acknowledging the imagined but not

always imaginary represented "world" of a novel or drama and its tendency to treat the imagined world as fictional, I find very attractive and philosophically adventurous Peter Kivy's "Speech, Song, and the Transparency of Medium: A Note on Operatic Metaphysics," *Journal of Aesthetics and Art Criticism* 52 (1994), which is itself an extension of an earlier discussion of Edward T. Cone, "The World of Opera and Its Inhabitants" in Edward T. Cone, *Music: A View from Delft: Selected Essays*, ed. Robert P. Morgan (Chicago: University of Chicago Press, 1989). By introducing the notion of "hearing in" in opera and drama, Kivy draws attention to the effective perception of the actual *medium* of an artwork (now, in view of the foregoing discussion, an extremely complex notion). We are made to understand therefore—this is not Kivy's intention—that Wollheim's ulterior purpose is indeed to deny *the reality of the medium* (of representation) qua medium, in order to ensure the *physical* nature of paintings; whereas Walton converts the medium into a "prop" (for a game of make-believe), which then makes conceptually necessary (arbitrarily so) *the fictionality of its represented world*. Kivy's uneasy—insufficient—resolution affirms: "The metaphysician has spoken of how things *are*. We [Cone and Kivy] of how things *are experienced*" (p. 68). But the deeper truth affirms that "how things are" *includes* the reality of the representational medium and its capacity to disclose its "world" to a trained audience, and "how things are experienced" *is* itself essential, among artworks, to the articulation of "how things are."

6. See Wollheim, *Painting as an Art*, chap. 2.

7. I have examined Danto's views on the perception of pictorial representation a number of times. See, for instance, Margolis, *Selves and Other Texts*, chap. 2 (see chap. 1, n. 43), and "A Closer Look at Danto's Theory of Perception" (see chap. 1, n. 51). A fuller account of Danto's views appears in Joseph Margolis, *Aesthetics: An Unforgiving Introduction* (Belmont, Calif.: Wadsworth, forthcoming).

8. Wilfrid Sellars saw this difficulty in a way that has rarely been bettered, but he never solved it. See Wilfrid Sellars, "Philosophy and the Scientific Image of Man" and "The Language of Theories," in *Science, Perception and Reality* (London: Routledge and Kegan Paul, 1963).

9. Compare Jerrold Levinson's sketch of how to handle the distinctions needed. See Levinson, "The Work of Visual Art" (see chap. 1, n. 39).

10. Danto, "The Artworld," pp. 576–77.

11. Ibid., p. 580.

12. Walton, *Mimesis as Make-Believe*, p. 301.

13. See Kendall L. Walton, "Categories of Art," in *Art and Philosophy*, ed. William Kennick (New York: St. Martin's Press, 1979).

14. You may ponder here Walton's citation from Leonardo's *Treatise on Painting* (itself cited from Michael Baxendall). The truth is, Walton's entire account may have been disadvantageously cast by Walton himself by conflating "imagination" and "fictionality." In fact, Walton defines fictionality thus: "[A] fictional truth consists in there being a prescription or mandate in some context to imagine something. Fictional propositions are propositions that are *to be* imagined—whether or not they are imagined" (p. 39). But all of this is really quite extraneous—and unnecessary—and confused. For one thing, as I've already argued, imagination (including visual imagination) need not make any ontic commitment

to fiction or reality; for another, the would-be fictionality of the represented "world" (in Walton's account) ought to have nothing to do with establishing the perceived (the real) representation that is the painting—as distinct from the representation *of* anything real; for a third, the question of what we can perceive in a painting is entirely independent of the logic of "fictional truths"; and for a fourth, it's no use treating the perception of a pictorial world as fictional, if perceiving that "world" is not *imagined* but actually obtains (even where it requires visual imagination). It's the confusion of these distinctions that seems to have ensured the central importance of make-believe in Walton's account. But I don't see how Walton can possibly recover the *real pictorial representations* that paintings very often are—*if* fictionality counts as the executive assumption on which alone they are brought into play: it distorts the essential issue.

15. Walton, *Mimesis as Make-Believe*, pp. 301–2.

16. Ibid., p. 40.

17. Ibid., p. 300.

18. Ibid., p. 11.

19. I draw your attention, finally, to an intriguing reference to some early papers of Walton's offered by Daniel Dennett—in the service of a richer (but by no means more convincing) reduction of consciousness developed in Dennett's well-known theory of mind. See Daniel C. Dennett, *Consciousness Explained* (Boston: Little, Brown, 1991), p. 428. Dennett suggests, in effect, just how Walton's account might be strategically helpful in advancing an uncompromising reductionism. (I think the association is not negligible.) See Kendall L. Walton, "Futures and Make Believe," *Philosophical Review* 82 (1973), and "Fearing Fiction," *Journal of Philosophy* 75 (1978).

Epilogue

This epilogue comes from a paper I presented at a conference the proceedings of which were published in Daniel S. Hamilton, ed., *Which Values for Our Time?* (Washington, D.C., and Lisbon: Center for Transatlantic Relations / Calouste Gulbenkian Foundation, 2007), 155–72. Pro forma permission granted by the Calouste Gulbenkian Foundation.

1. Thierry de Duve, *Kant after Duchamp* (Cambridge, Mass.: MIT Press, 1996).

2. I've spelled out the argument regarding Hegel's critique of Kant's first *Critique* in a paper, "The Point of Hegel's Dissatisfaction with Kant," to be included in a forthcoming collection reexamining the connection between Hegel and analytic philosophy.

3. See Immanuel Kant, *Critique of the Power of Judgment*, ed. Paul Guyer, trans. Paul Guyer and Eric Matthews (Cambridge: Cambridge University Press, 2000), §50. This is one of the telltale passages of the First Part of the third *Critique*—the sign of Kant's conservative intent.

4. See Hans-Georg Gadamer, *Truth and Method*, 2d rev. ed., trans. Joel Weinsheimer and Donald C. Marshall (New York: Continuum, 1989).

5. See, for an extended overview, John Zammito, *Kant, Herder and the Birth of Anthropology* (Chicago: University of Chicago Press, 2003).

6. See further for an instructive overview of Kant's and other eighteenth-century views of beauty and genius, Paul Guyer, "Exemplary Originality: Genius, Universality, and Indi-

viduality," in *Values of Beauty: Historical Essays in Aesthetics* (Cambridge: Cambridge University Press, 2005). I've relied on Guyer's expertise in this huge literature. But I have no reason to think he would be attracted to my conclusions.

7. Kant, *Critique of the Power of Judgment*, §46. In effect, Kant's elevating nature above art baffles the very effort to understand the "metaphysical" distinction of history and culture.

8. For a marvelous romp through the principal implications de Duve draws from applying Duchamp to Kant—replacing "beauty" by "art," as in the antinomy of taste—see the essay "Kant after Duchamp," in *Kant after Duchamp*. I am unable to judge how seriously de Duve follows Kant in the claims of the first *Critique*, but the post-Duchampian Kant is clearly not the Kant of the third *Critique*: he is, rather, an interesting creature who couldn't have been invented if there hadn't been a Kant before him.

9. Kant's aficionados often confine themselves to ensuring the internal coherence of Kant's own accounts and the correction of textual misreadings of Kant's actual doctrine. They are usually not interested in the validity of Kant's arguments. With respect to the third *Critique*, the clearest example of this textual practice that I know of belongs to Paul Guyer, "The Harmony of the Faculties Revisited," in *Values of Beauty*. Guyer is very good indeed. But I would be guilty of reporting inaccurately if I did not say that in his *Kant and the Claims of Taste*, 2d ed. (Cambridge: Cambridge University Press, 1997), Guyer *does* venture definite and important criticisms of Kant's theory, reasons for challenging the entire doctrine.

10. I have in mind Kant's well-known remark, in the *Critique of the Power of Judgment* (§95), to the effect that nature is beautiful if it also looks like art, and art is beautiful if, though it is art, it also looks like nature. Although what Kant says here may be ingeniously used to support his account of aesthetic judgment, I cannot see that it helps us understand the nature of aesthetic criticism vis-à-vis actual artworks or natural objects—and therefore cannot explain the judgment of taste once we oppose the adequacy and primacy of Kant's notion of aesthetic pleasure.

11. See Ernst Cassirer, *The Philosophy of Symbolic Forms*, trans. Ralph Manheim, 3 vols. (New Haven, Conn.: Yale University Press, 1953–57).

12. De Duve, *Kant after Duchamp*, pp. 452–53.

13. See G. W. F. Hegel, *Natural Law*, trans. T. M. Knox (Philadelphia: University of Pennsylvania Press, 1975), pp. 77–78.

Index